West Midland
MURDERS

West Midland
MURDERS

Michael Posner

AMBERLEY

First published 2010

Amberley Publishing
The Hill, Stroud
Gloucestershire GL5 4ER

www.amberley-books.com

British Library Cataloguing in Publication Data.
A catalogue record for this book is available from the British Library.

ISBN 978 1 84868 314 3

Typesetting and Origination by FONTHILLDESIGN.
Printed in Great Britain.

CONTENTS

FOREWORD

I have had the pleasure of knowing the author for over thirty years and his character shines through this excellent collection of short, highly personalised insights into past murder trials.

His views permeate and illuminate the pages and help us to re-live dramatic court cases of yesteryear when trials were much shorter and sentences far more severe, including the ultimate sentence – death!

It is well researched and fills a gap in the library of all those who, like myself, are interested in the investigation, trial and punishment phases of a murder. A good read and hopefully this will be the first of many.

Gareth Evans QC,
No. 5 Chambers,
Birmingham

INTRODUCTION

Taking someone's life in a criminal enterprise has, during the past twenty-five or thirty years, become increasingly brutal and savage. Killers are more ruthless and show little pity towards their victims. Murders which, four or five decades ago, would have made the main story on the front page of the majority of newspapers, now are lucky to make one or two paragraphs.

Life in many instances has become cheap and there are an increasing number of voices in the community urging the reintroduction of hanging. But sadly capital punishment would not solve the problem simply because very few juries would want to convict just in case a mistake was made and nothing could be done after the hangman had carried out the sentence.

For this book I visited numerous libraries and scoured the pages of newspapers from the eighteenth and nineteenth centuries to find the most unusual homicides. Some are pretty barbaric. Others, for want of a better word, are sad committed by people who lived at a time in our history where the haves had plenty and the have nots had no idea where the next penny or meal would come from.

To steal would bring the full strength of the law down on the heads of those who were caught and death by hanging was the only sentence. The stories I have chosen cover a fairly wide part of the social spectrum so I leave it to readers to decide which is the worst.

An enterprise like this cannot succeed without the help of others. I would like to thank most sincerely Lynne Posner for all the coffee breaks she spent reading each of the stories, correcting errors and making suggestions; Sarah Flight, the publisher for her infectious enthusiasm; and Gareth Evans QC for his time after a busy day to read each story and write a foreword. Thank you all.

Michael Posner,
April 2010

The Genuine LIVES and CONFESSIONS of

James Townsend, and John Davis, alias Hodgets,

Who were Executed at Sandyford, near Stafford, on Saturday the 29th of March, 1788: The former for House-Breaking, and the latter for Horse-Stealing.

Confession of JAMES TOWNSEND.

AS the world in general, read with great curiosity, the solemn Declaration of Dying Men, especially of those who they judge have been guilty of many & complicated Crimes—I JAMES TOWNSEND, as an easement to my own troubled breast, judging it (though small) some attonement to the injured laws of my country, do confess I am guilty of the offence for which I suffer; hoping that God will forgive me, and receive me into his Mansions of Bliss, thro' the merits and meditations of our Lord and Saviour JESUS CHRIST.

I was born of creditable Parents, at Sheffield, in the county of York, but never had the advantage of an education. At six years of age I went to work at the Silk mills, in Sheffield, and continued there 'till I was 14; was then put apprentice to Thomas Samuel, Cutler, with whom I staid but a few months, and went home to my friends. I returned to my former employment for a little time; soon after was again put apprentice to a Manufacturer in the Button and other Branches; was bound, and continued there about five years, but absconded twice in that time; and from a profligate of being more diligent, was taken in again. I at times robbed him of divers goods, which I immediately sold, much under value, to a person who I was encouraged by in such business. I once took some Half Crown Pieces, a Pair of Silver Buckles, and some Linen, but was not suspected, and for which one Rebecca Magra, a servant of my master's, was taken up and examined, but as no property was found upon her, she was set at liberty, and discharged from his service. I about a month after that, had an accident of breaking my leg, of which I was sent home for about three months: I got better, but never settled to any business in that neighbourhood since.

After this I got acquainted with a Cocker, who advised me to follow Hens and Cocks, which I did for some time, and we got very intimate. I found, by his Wife, they had money in the house; and when she was gone out one day, I broke in, and robbed them of 25 Guineas, &c but they got 15 back again. I was taken up and tried for that offence, but was fortunately acquitted.

Some time after that, I became acquainted with one Jones, who informed me, he could help me to some money, if I would go with him for a few days and nights, which I did. We broke into several houses in the counties of Derby and Lincoln, in particular one where he had lived at, but got nothing of much value. Continued following this course of life for some years, 'till I was advised by my friends to leave his company, for they told me he would be my ruin, and as I was out of work, they wish'd me to go to Birmingham, which I did, and where I worked at the Button Business for some time; 'till getting acquainted with a gang of loose men, I betook myself to my former bad course of life, and committed many robberies in that neighbourhood, but was never detected.

In October last, in company with some of my Old Companions, I broke into the house of Mr. Charles Ray, and stole thereout, several Articles of Wearing Apparel, which we got clear off with; but I on offering some of the goods to pawn, was detected; for which offence I suffer, and am quite resigned unto it; hoping that my unhappy fate, may be a warning to youth, from keeping bad company, and following the examples of loose and abandoned men.

Taken this Morning, March 29th, 1788.
His
JAMES X TOWNSEND.
Mark.

A NARATIVE of the LIFE of JOHN DAVIS, alias HODGETS.

I JOHN DAVIS, alias HODGETS, was born in the year, 1763, at Elmton, near Eccleshall, in the county of Stafford; my parents were poor labouring people, who had it not in their power to give me an education; I was therefore brought up to hard labour, and taught to earn my bread by the sweat of my brow. I seldom neglected attending church on a Sunday, and I had (considering my want of education) a tolerable idea, from the good discourses I heard of the Christian religion; but as I grew up, fell into bad company, both of men and women; neglected going to church, and became idle and desolate. I grew fond of attending wakes, going to Wakes, &c. to support which, I made a practice of robbing people of their property, but don't chuse to mention particulars.

At the age of 21, I married a Woman of good character, by whom I have one child now living, I resolved to lead a new life, but my resolution failed me, and a short time after I fell into the same abandoned company, and committed many acts, that my conscience told me was wrong; yet the hand of justice never overtook me, 'till I committed these last offences; one of which, for stealing a Mare, the property of Mr. Buckley, I must suffer this shameful and ignominious death. I had taken the Mare to Goofall, and having some fears of being detected, sold it to a person there for a few Shillings, though worth several pounds; but told him it was in a dying state and wished it might be immediately destroyed. I thus left him, but his suspicion arising, and finding the Mare in a better situation than represented, did not destroy it. Enquiry being made, the Mare was found and owned, and a description given of the person he had it from, by which it was known to be me; but I avoided their search, and was not detected for that crime; but was taken for stealing two Pigs, in February last, the property of Mr. Joseph Smith, for which I was committed to goal, but was tried for the former offence.

On trial, there appeared not the least doubt of the guilt of these poor unhappy men; but the human heart cannot fee their fellow creatures suffering for their crimes, (however justly,) but we must pity them, for being drawn from the paths of rectitude and virtue; and it should be a lesson to all, that should be never absent from their Minds;—to avoid the least and first appearance of doing wrong!

The above Criminals were visited by the Chaplain of the goal every day, and behaved in a penitent manner, acknowledging the justness of their sentence.

In the morning of their Execution, they received the Holy Sacrament. At the usual hour the cavalcade began from the goal, attended by the Sheriffs Officers, &c. When arrived at the fatal tree, they prayed fervently for some time; and after addressing themselves to the surrounding multitude, hoping their exit might be an example to youth, to avoid bad Company, which was the cause of their untimely death. They were then both launched into abovesaid Aternity, calling upon the Lord to receive their souls.

THE FEAR OF MAGIC

For centuries, the mysteries of magic have held people enthralled and fascinated. The ability of someone skilled in the art of practising illusions, sleight of hand and playing tricks on the unsuspecting was an accomplishment that took years to master but ended with a talent that was the envy of those who were bewildered by what they saw.

It was spellbinding wizardry that created a magnetic fascination for those who watched, but were unable to work out how it was done. Probably the oldest trick in the world is the Indian rope trick where a boy climbs a stiffened rope to disappear, yet reappear unharmed, without anyone guessing how it was done.

Merlin, the most famous of wizards, was able to perform tricks with a look or special sorcerer's powder. Virtuosos who followed improved on what they had learned and came up with new tricks, one with only three cards to fool watchers as they were skilfully moved around and finished up with the ace in a place it was not expected.

In the early 1800s, people believed implicitly that conjurors who practised these magical arts had the skill to find lost property, and at the same time disclose to the loser the person who had helped himself or herself to what was stolen and then hopefully it would be recovered.

One such case led to the death of a twenty-year-old girl from the Staffordshire village of Ranton. History and the years hide many bizarre incidents and one in particular would have remained unnoticed but for a chance discovery where it was tucked away discreetly at the bottom of a newspaper article written in the 1830s. The practise of the magical arts attracted Mary Evans who, in her simplicity, decided to go to a conjuror to track down her lost property.

It was a decision that would cost her her life; she was drowned face down in a ditch not far from her home and injured on her head with a blow from a rock weighing two pounds.

Christmas 1831 was only ten days away, and villagers in the small farming community of Ranton, Staffordshire, were busily preparing for the festive season. Neighbours and friends in the village, only six miles away from the county town

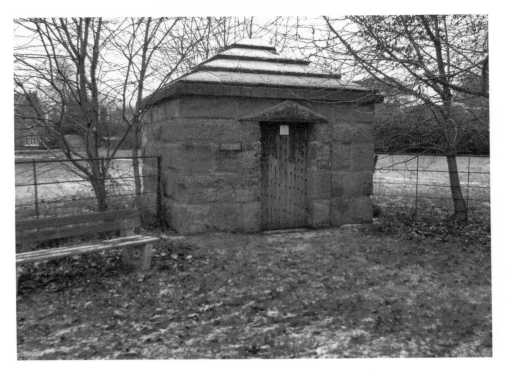

The lockup near Stafford in which Richard Tomlinson spent some time.

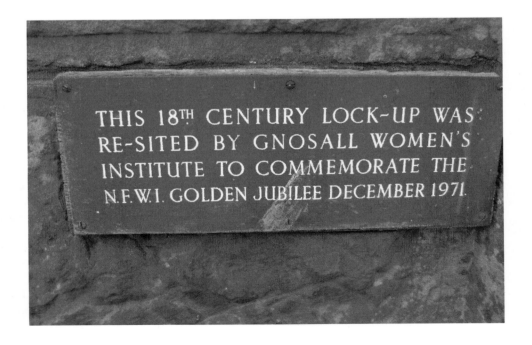

THIS 18TH CENTURY LOCK-UP WAS RE-SITED BY GNOSALL WOMEN'S INSTITUTE TO COMMEMORATE THE N.F.W.I. GOLDEN JUBILEE DECEMBER 1971.

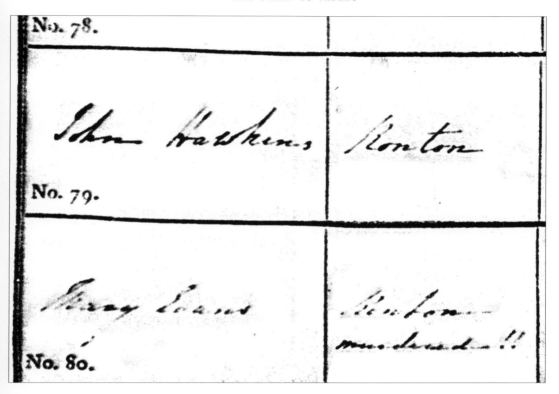

Mary Evans' entry number 80 in the burial register of St Luke's Church, Ranton.

of Stafford, met up with each other in their cottages to while away a few hours, to share a drink after milking once all the daily chores had been completed. But on 16 December, a bitterly cold winter's day, a terrifying, chilling discovery was made which would have a lasting effect on those in the village until the day they died and for a generation after.

Mary Evans, an attractive young woman in her early twenties, lived in the remote village with her father, Joseph, the clerk of the parish of Ranton, and was described by locals of the small community tucked away in farmland, who knew her well, as someone possessing 'considerable personal attractions.' She had a bright future but in a few seconds of uncontrolled violence a killer brought rapidly to an end the life she had.

The cluster of houses built from sandstone were not far from All Saints' Church, and close to roads that led to Gnosall, Knightly, High Ercall and the county town of Stafford, about six miles away.

16 December was a Sunday; at around midday, a local waggoner about his business in the lanes and bypasses of the village and wrapped up against the biting cold, came upon a sight which made his flesh crawl. There beneath, as he looked

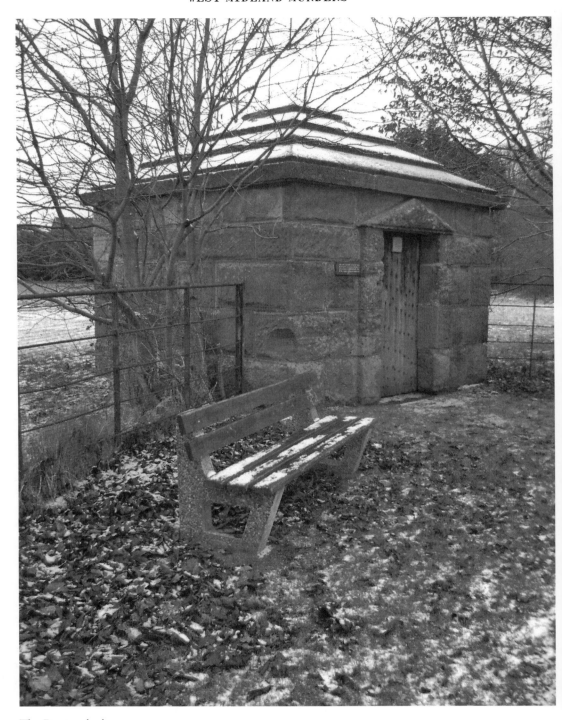

The Ranton lockup.

down from his wagon, was Mary's body in a ditch, lying lengthways and face down in about five inches of water.

After she was found, a journalist working for the *Staffordshire Advertiser* wrote: 'The secluded village of Ranton will, from henceforth, be distinguished as the scene of a murder unparalleled in many of its circumstances, in the annals of crime.' A little over the top, maybe, but when it came to selling papers there was nothing better than a good old killing, especially when a newspaper headline described it as 'Murder of a Young Woman by her Paramour.'

Young Mary's body was about 200 yards from the nearest house and close to All Saints' Church. One of her legs was stretched out and the other tucked under her body. 'Her bonnet was very much crushed and her cloak in a disordered state over her shoulders as though she had been struggling. Her umbrella lay behind her in the ditch,' wrote the newspaper's reporter.

The waggoner, having assessed the situation, called for help and Mary's still warm body was removed from the narrow ditch. The corpse was then put on to a cart and taken to the home of Thomas Tildesley, whose wife was the deceased's sister and at whose house Mary had been living for several weeks. She had left there to meet up with her boyfriend who later became her killer 'in a state of perfect health and in the bloom of youth and beauty.'

Word soon spread and locals from the small stone houses soon left their homes to gather in groups to talk quietly about the gruesome discovery. It was not too long before a suspect became known and within a short while a search started for twenty-year-old Richard Tomlinson, a former Marine, who had been seen frequently in the company of Mary Evans.

He was described as 'stoutly made but not tall; his face is plump and his head large and round; and he has a very unintellectual expression of countenance.' It was then that a bizarre and remarkable disclosure was made – Tomlinson's mother had, allegedly, a decade earlier, poisoned her seventy-year-old husband John, on 1st November 1822, with arsenic in his oatmeal porritch (porridge). He had been buried a week when a decision was made to disinter his body. When it was cut open at another post-mortem examination by surgeon R. Hughes, he discovered traces of the deadly poison in Mr Tomlinson's stomach.

An inquest was ordered, and for two days the coroner took evidence from many witnesses. The *Advertiser* claimed that Mrs Tomlinson, twenty years her late husband's junior, became the main suspect 'and the wretched woman was confined to bed with the jaundice when the alleged un-natural crime was perpetrated.'

The *Advertiser* continued in its daily coverage of the hearing: 'We believe proof was given that she had ordered one of the children to bring the porritch for her husband's supper, to her bedside and that she shook something out of some paper into it. The ill-fated man was taken ill in the course of the night and died the next day.'

Other so called 'suspicious circumstances were elicited' but the *Advertiser* did not disclose any further details to support the allegations it carried. The coroner's jury conferred and quickly returned a verdict of wilful murder and Mrs Tomlinson was committed to the county jail in Stafford to await her trial.

But fate stepped in and on Thursday, 21 November the wretched Mrs Tomlinson died in prison of her illness. The newspaper, without disclosing how it came to know

Stafford County Prison,

MARCH 18th, 1834.

I RICHARD TOMLINSON, of RANTON, do upon the Word of a DYING MAN, acknowledge the Justice of my Sentence, and most solemnly declare that the HORRID VICES of DRUNKENNESS and SABBATH BREAKING, as well as WICKED COMPANY have brought me to the dreadful DEATH which I am now about to suffer for MURDER, and I earnestly entreat all my Fellow Creatures to remember the Words of a Dying Penitent:—*"Except ye repent ye shall all likewise perish."*

Richard Tomlinson.

Morgan, Printer

the attitude of Mrs Tomlinson in her prison cell somewhere behind the walls of the gaol, told its readers: 'She manifested the utmost indifference to the lamentations to the chaplains, but asserted her innocence to the last.'

On the death of his parents, Richard Tomlinson was about twelve years old and left Ranton to live with relatives for a year or two before it was believed he enlisted in a regiment of foot soldiers. He was discharged after some alleged undisclosed misconduct or transferred to the Marines. In the spring of 1832, he bought himself out of the army and returned to Ranton. His father had left him some land worth about £250 and Tomlinson soon turned his inheritance into hard cash.

Like many people not used to large amounts of money and without the ability to understand prudence, commonsense and good judgment, his cash soon rapidly disappeared like water down a drain. He led what was described as a 'very dissolute life' and according to Rev. Lloyd, clergyman to the parish of Ranton, he attributed Tomlinson's ruin to 'frequenting beer shops.'

After the recovery of Mary Evans' body, Richard Tomlinson was believed to have hurriedly disappeared from Ranton. While one horseman took after him it later turned out that all the time Tomlinson was still in the village, drinking in a beer shop kept by his sister's husband and where he had been living for about six months. Two hours after Mary was recovered, Tomlinson was arrested and allegedly confessed to farmer John Betteley of Park Nook Farm, Ranton, that he had 'perpetrated the diabolical deed.'

He had been keeping company with her for many weeks before her death and was believed to have been the last person who saw her alive after he met her at her sister's house. They were planning to walk four miles to the house of another of Miss Evans' sisters, when, according to Tomlinson, there was an argument and he attacked the unfortunate young woman.

Farmer Betteley, who was not aware of the murder, had seen Tomlinson two hours earlier walking along a footpath not far from where Mary Evans was found. He later met up with him in the beer shop. When he was called to give evidence at the inquest, Mr Betteley told the coroner's jury: 'I was crossing a field yesterday morning about half past eleven or twelve o'clock and saw Richard Tomlinson walking along a footpath in an adjoining field in the direction of the beer shop and

from the place where I afterwards learnt the body of Mary Evans was found from which he was then distant about a quarter of a mile.

'Tomlinson stopped and looked at me. We did not meet. About two o'clock the same day I went into Phillips' beer shop and Tomlinson was there drinking. I had not then heard of the murder. I sat down by the side of him and he asked me to have a glass of ale with him, which I had. He then said something to me which I did not understand; and immediately invited me to go out of doors as he wanted to speak to me in private.

'I then went with him to the cart-house. He then said to me: "Did you see me murder Mary Evans?" I replied: "No." He said: "But I have murdered her and left her in a ditch under an oak tree."' Mr Bettelely told jurors: 'I told him I did not believe him but he repeated it two or three different times. Our conversation was interrupted by a person up (who came in) and we returned into the house. Tomlinson was sober when he made his confession and he made it in a voluntary manner. When we got into the house again there was some whispering that the constable was coming to take Tomlinson into custody on the charge of murdering Mary Evans.'

Shortly afterwards a man named Arkinstall, the constable of Gnosall, arrived to arrest Tomlinson and take him to the local lock-up for safety. A while later, the Rev. W. H. C. Lloyd of nearby Norbury, who was also a magistrate and vicar of Ranton, heard of Tomlinson's arrest and arrived at the lock-up. He said he was distressed and concerned that Tomlinson was in custody on a charge of murder.

Mr Lloyd claimed Tomlinson told him: 'I did it. I am ready to die for it. I only wish I may be laid by her side.' The *Advertiser* suggested that Tomlinson wanted to make a confession and claimed the accused man was taken from the Gnosall lock-up to the Horns, a nearby public house. It was here that the distraught man again confided in Mr Lloyd that he killed Mary Evans and his alleged confession was taken down in writing.

The *Advertiser* later admitted in did not have a copy of the 'confession' and that such a document admitting guilt was not produced at the inquest. However, the newspaper reached a decision which, at its lowest, was a gross breach contempt of court but felt there was nothing wrong with publishing Tomlinson's remarks to Mr Lloyd.

However, when Tomlinson went for trial the judge was unaware of the *Advertiser's* decision to publish Tomlinson's comments and influence any prospective juror. The newspaper supported its dangerous decision to publicise Tomlinson's 'confession' simply because it alleged he had repeated his guilt to the constable and others. It said: '... as the prisoner repeated his confession ... we are not aware that there will be any impropriety in our publishing what we understand to be the substance of it.'

If the *Advertiser's* claim that Tomlinson's 'confession' was accurate, then Mary Evans died because she accused her friend of being a thief and stealing property that belonged to her. They were planning to go to nearby High Ercall to consult a conjuror, of all people, to try to find out where the missing items had gone. The newspaper alleged that Tomlinson said he had been taken poorly while they were out walking and he would not be able to visit the conjuror. Mary Evans' response to this was that it was proof that Tomlinson had helped himself to her property which had been stolen.

The conjuror was also described as a 'wise man' with the amazing ability to discover who stole some clothes Mary Evans claimed had been taken without her permission.

They decided to return to Ranton and on the way Tomlinson lost his temper and the couple began to argue. This convinced Mary he was the thief. He complained she had stolen a watch and some sovereigns. 'They continued thus to criminate and re-criminate each other. They were both in a violent passion; and as they were coming down the road from Ranton Hall she reproached him by reminding him that his father was poisoned and his mother died in gaol,' reported the *Advertiser*.

With passions by now firmly aroused, these comments inflamed an already dangerous situation for the welfare of Mary Evans, and the couple continued to argue. Her comments about his parents 'exasperated him to an excessive degree' and he told her, according to the *Advertiser*, if she repeated those words he would knock her down. She did repeat them and he knocked her into the ditch with his fist. She shouted out: 'You've murdered me.' Upon which Tomlinson replied: 'If I have not, I will do it.'

The newspaper claimed that in this alleged confession to the Rev. Lloyd, Tomlinson continued: 'I immediately jumped upon her back as she lay with her face downwards in the ditch. I then stepped on the bank and she scrambled up on her hands and knees and laid her head, with her hands on either side of it, on the ditch bank. I then left her and whether she fell into the ditch or not I cannot say.'

The *Advertiser* commented: 'Such is the detail given by Tomlinson of this horrible transaction. From the evidence taken before the coroner it would appear his statement is not quite correct. When the body was discovered, a large, rough stone weighing at least two pounds was observed lying upon the right hand (of Mary Evans). A wound on the back of the deceased's head had evidently been caused by some blunt instrument applied with considerable force and the inference is that the stone in question was used for that purpose.

'Tomlinson denies, we believe, having used a stone and says that the wound must have been made by the heel of his shoe when he jumped upon the body.'

The *Advertiser* was not averse or unwilling to go further with character assassination against someone who was still awaiting trial and, under English law, was innocent until proved guilty. It said of Mary Evans: 'The young woman whose tragic death forms the subject of our narrative did not, we fear, possess principles of the strictest virtue, as her connection with Tomlinson would imply.'

An inquest was opened on Monday, 17 December, at the home of Mr William Trickett, known locally as The Gate. Ten jurors were sworn and Mr P. Seckerson, the coroner, said it would not be necessary for him to address any observations to them because the circumstances would be developed by the evidence 'and would come with greater force and with far more propriety from the witnesses themselves.'

The small room used as the official court was crowded, with the coroner and jurors taking up most of the space available, and little if any space left for curious people who wanted to know what was going on.

The first witness was Thomas Tildesley, the dead woman's brother-in-law, at whose home she had lived for six weeks. He told the jury that Richard Tomlinson kept Mary Evans company during the time he lived at his house. 'Tomlinson and

the deceased were frequently together at our house – two or three times a week or oftener – and he used to remain with her all night. He had done so on Saturday night last,' he said.

'I never heard any talk of Tomlinson intending to marry the deceased. They never acknowledged each other to be man and wife. They were away from Ranton together sometimes for several days. They seemed to be quite friendly on the Sunday before they started. There had been no quarrelling between them. There appeared to be a good mutual understanding between them when they left our house.'

John Dabbs, who lived at nearby Knightley, and was another brother-in-law of the dead woman, said she arrived at his house with Tomlinson. 'The report had been that they were married and as she had a ring on her finger, I supposed that was the case. I had seen him twice before. They stayed all night and slept together,' he said.

He said on the morning of the day she died (Monday 16th December) Mary Evans decided to visit a conjuror by the name of Light, who lived at High Ercall, to find out if he could tell her who had stolen several articles from her. 'I agreed to accompany the deceased and Tomlinson thither,' he said.

'We started about seven o'clock. Tomlinson lagged behind, hung his head down, and remained silent. When we had gone about two-miles-and-a-half Tomlinson got over a stile into a field and laid himself down on the grass with his face downwards. The deceased and I turned again and coming up to the place where he lay the deceased asked him what was the matter with him several times. But he never spoke. She then said to me, I being in the road, she being on the other side of the hedge in the field close at his feet.'

Dabbs said Mary Evans cried out: 'My sister told me that he was the man who took my things and now I believe that he is.' He told the jurors that Tomlinson did not say anything. He said he left them to return home and later the couple turned up at his house and that was the last time he saw Mary Evans alive.

Charles Harper, the waggoner who found Mary the following day, said he had been taking a load of barley to a maltster in Ranton, and was returning about eleven o'clock or twelve o'clock, when he saw the body of a woman lying face downwards in a ditch by the side of the road. 'The water in the ditch covered parts of the face and head. The body lay lengthways in the ditch. It was rather drawn up. One leg was extended, the other was under her body. The hands were spread out on each

side of the head close to it. The body was quite lifeless,' he said.

Once the evidence at the inquest had been completed, the coroner, Mr Seckerson, addressed the jury and said evidence showed that there had been a close connection between Tomlinson and the dead woman from an early hour on the Monday morning until a very short time before the 'fatal transaction.' The jurors were reminded the evidence given by a steady stream of witnesses showed that Tomlinson had been near to the spot where the body was found 'and also near to the time where the fatal deed must have been committed.'

He said, if under these circumstances jurors were of the opinion that he was the cause of the 'unfortunate woman's death', they would then have to decide among themselves how Mary Evans met her death. The coroner said there was no tangible evidence which had been produced of the actual blow which killed her. They were told they had to rely, therefore, on the evidence of a surgeon who carried out a post-mortem and decided that the fatal blow had been caused by a stone which had been produced during the inquest inquiry.

The jurors were told they had to reach their verdict 'unflinchingly, fairly and impartially.' They had been sitting from three o'clock that day until ten p.m. without meal or rest breaks and were tired. They huddled together in their jury box and reached their decision of wilful murder very rapidly. Tomlinson was remanded in custody to Stafford Prison to await his trial in March of 1832.

However, before the inquest started and evidence was taken, Mr Seckerson said it would be 'quite unnecessary' for him to address any observations to the jury at the outset respecting the circumstances likely to be developed by the evidence.

What he did say next was telling and should have been a warning to the *Advertiser* reporter to be careful of what the newspaper carried in its reports. He said that all he should do would be to request them 'to dismiss from their minds all the reports which they might have heard respecting this unfortunate case.

'Such reports were apt to create prejudices on the mind and it would perhaps be with some difficulty that they could divest themselves of impressions prematurely made.'

He urged them to make sure 'to allow no report to weigh with them unless confirmed by the evidence of the witnesses who would be called.' The coroner said it was absolutely essential to dismiss from their minds any prejudices created against the person who was under accusation. He finally warned the jurors, before calling evidence, to draw their conclusions from the consideration of the whole of the evidence when brought before them.

It was only days later, after the coroner had made this clear to everyone and in the presence of the *Advertiser* reporter, that the newspaper carried the alleged confession made by Tomlinson.

In the same edition of the paper which carried a lengthy report of the inquest, the following article appeared. 'The readers of this narrative will no doubt be anxious to learn how the wretched man, who is charged with having committed this atrocious crime, conducted himself after his apprehension, naturally concluding he would be overwhelmed with remorse of conscience and prey to the most acute and tormenting feeling.

'What, then, will be their surprise on hearing that up to the time of his being delivered at the County Gaol on Wednesday, he had not betrayed the slightest

emotions of distress since the perpetration of the awful deed! To the constables he talked of the matter as a person would of the most unimportant occurrence and requested when taken from Gnosall to Ranton to be present at the inquest that he might pass the place where the body was found.

'There, he pointed out the exact spot where he threw his victim into the ditch without evincing the least degree of sensibility.

'During the inquest he sat in an adjoining room and although he did not say much unless spoken to yet when questioned he answered any inquiry respecting the murder with incredible indifference of manner. When brought before the coroner and jury he was equally unmoved and he listened to the reading of every part of the evidence, his countenance remaining the whole time in a single muscle.

'We understand he intimated his desire to see the corpse of the unfortunate woman before coming to gaol and the constables complied with his wish by allowing him to call at Tildesley's and view it. Even then his obduracy was not overcome although we are told he kissed the body, shook one of its hands and asked its forgiveness.'

Again the report contained unnecessary and uncalled for comments which undoubtedly would have some effect on the mind of a prospective juror who read the article and was called to sit in judgment at Tomlinson's trial.

Tomlinson's trial started the following March at the Staffordshire Spring Assizes in the Shire Hall, Stafford, built in 1797 and which dominated Market Square of the county town.

He was escorted into the dock of court one by warders from the nearby jail and was arraigned and asked to plead. He at first pleaded guilty but when told by the judge, Mr Justice Patteson, that he 'would be inevitably hanged' Tomlinson changed his plea and denied the murder of Mary Evans.

It was here that the *Staffordshire Advertiser* compounded its earlier reporting mistakes because it told readers: 'We consider it unnecessary to give the evidence by which the charge was most satisfactorily brought home to the prisoner, having detailed it at great length in our report at the inquest.'

(In the present day an inquest on a person who has died by unusual causes is usually opened by the coroner for identification and a burial certificate. It is then adjourned until the completion of a crown court trial before the inquest is reconvened and any evidence is heard.)

Evidence at Tomlinson's assizes trial was called on his behalf because it was claimed he was insane.

Mr John Walter and his wife, who ran a beer house in nearby Derrington, and Mr John Collier, a publican from Stafford, were asked to support the defence submission that he was seriously mentally deranged.

It was said that while Tomlinson was in the Walter's beer house he attempted to fire a gun up a chimney and throw a pound of gunpowder into the fire. It needs little wit to imagine how much damage would have been caused by the exploding force of a pound of gunpowder in a confined space. It is almost certain that Tomlinson and those who gave evidence on his behalf and any other person sitting in the beer house would have blown to smithereens.

Needless to say, the defence of insanity failed to hold any water and the jury took five minutes of deliberating before returning a verdict of guilty of murder.

Tomlinson was sentenced to death and the *Advertiser* reported that he 'appeared more indifferent whilst the awful sentence of death was pronounced, than almost any other person in court.'

The only reference made to Mr Justice Patteson's summing up was his 'astonishment that persons could be found, in the nineteenth century, so ignorant and stupid as to think of consulting a conjuror.'

Within three days Tomlinson kept his appointment with the hangman and was taken from his cell at Stafford Prison, with his hands tied behind his back, to the gallows outside the main gates. He was accompanied by the prison chaplain and together they climbed the wooden steps to the rope waiting for him.

In front of him stood the usual crowd of men, women and children from many parts of the county who looked forward to the regular hanging days with great anticipation. That was Tomlinson's last sight on earth as a hood was placed over his head.

He stood there at eight o'clock in the morning, motionless by fear and as the hangman pulled the metal lever to release a trapdoor beneath his feet, Tomlinson dropped out of sight and the rope tightened, snapping his neck, and despatching him into eternity. He died almost instantly and was later cut down and buried within the prison walls.

Religion took over Tomlinson's life after his conviction as he tried to make peace with God in long sessions of prayer. He acknowledged the justice of his sentence and confessed that Sabbath-breaking, drunkenness and bad company had been his ruin.

At no time did Wilkinson ever say he was sorry for killing Mary Evans who may, bizarrely, have been his wife.

I KILLED MY DAUGHTER

The killing of a child provokes unbelievable feelings of loathing and revulsion. The death of a child at the hands of a parent deepens those emotions, but the cold-blooded murder of a youngster by a mother is something people cannot begin to understand.

That is what Ann Wycherley did. The twenty-eight-year-old single mother deliberately killed her three-year-old daughter, also called Ann, by throwing her naked little body, still alive and warm, into a pit on a farmer's field and left her to drown in a foot of dirty, grey water on a freezing winter's day in December 1837.

When her tiny frozen corpse was found eight days later by a farmer on his way to collect some sheep he 'perceived something like a pig' in a pit-hole but then realised it was a child.

At the time of the murder Ann Wycherley was at the lowest level of poverty and distress, living with her two children, Ann, and her baby sister, Jane, who was about twelve months old in the workhouse* in the Shropshire market town of Market Drayton, the last place she wanted to be. They left the workhouse close to the Staffordshire border on 14 December and it was eight days later that little Ann's body was found in the pit where she lay imprisoned in a thin sheet of ice.

Within a day of the murder an inquest was held before the coroner, Mr W. Harding, and a jury, at the Loggerheads Pub not too far from where little Ann was recovered by two farmers who pulled her body out of the water with a long, hooked pole.

Wycherley was there at the inquest among people she did not know and strangers she had never seen who were making allegations against her, without the law giving her the right to legal representation. She may have had the guidance of the coroner who could have helped her but nowhere in the record of the inquest did he offer a helping hand to this miserable, pathetic individual.

The first witness, William Poole of Cheswardine Marsh, a village not too far from where little Ann was found, was a labourer on a farm owned by Joseph Butter, and he said that on 22 December he went to a field to drive out some sheep. He said he saw something which looked like a pig in a pit-hole and when he looked closer, thought it was the body of a child.

He went and reported the situation to Mr Butter and between them they used a hook pole to lift out the child whom Mr Poole said looked to be about three years of age. The body was taken to a nearby house where it was left, while the local constable was sent for.

Mr Poole said there was a cut on the child's forehead which looked as though it had been caused by a penknife. There was another cut on the left temple and other wounds which might have been caused by some tiles thrown in after the body had been dumped.

William Critchley, the governor of Drayton Workhouse, said that Ann Wycherley and her two children were inmates up until 14 December when the woman, of her own accord left, taking the youngsters with her. He said Ann, the oldest child, was about three years old and her sister, Jane, about a year old.

He said he recognised the dead child and obtained a warrant for Ann Wycherley. She was found at a house at Baldwins Gate, a small settlement nearby, where she was living as a servant. 'I asked her where her children were and she replied "at Fair Oak",' he said. (All the settlements and villages were in close proximity to each other.)

He asked her if both children were at the house but she refused to answer. Mr Critchley and the local constable, John Simister, took Wycherley to the lock up at Market Drayton, where she stayed until the following morning. She was then taken to the house where her daughter, Ann, was lying and allegedly confessed: 'I put the child in the pit myself whilst living. I used no violence nor did I inflict any wound.

'I was met by Charles Gilbert near Chipnall Mill and he persuaded me to do it. But I went near Fair Oak where he met me again then I turned back to the pit.' She was later alleged to have added: 'I threw the child in the pit and Charles Gilbert threw some soughing tiles (drain tiles) on it.'

John Simister, the constable, was called to give evidence, and said he arrested Wycherley two days before Christmas. He claimed she told him: 'It would never have happened provided I had never been persuaded. I never cut it, or abused it or laid violent hands upon it. I put it the pit and left it there alive.'

Constable Simister told the jury of something that would be called hearsay evidence and not admissible but Wycherley was not to know. He claimed the mother of two told another woman that Charles Gilbert was the father of her illegitimate youngest daughter and had persuaded her to kill young Ann. The story told by Wycherley suggested that Gilbert expected to come into some money when an uncle's farm was sold and they should do well. It was never explained why killing little Ann would help after Gilbert received his windfall.

A surgeon who examined the girl's body said she had probably been in the water for about a week. He believed the cause of death was submersion or suffocation.

Gilbert, who was also on the same charge of murder but later discharged, gave his evidence and told the coroner that he spoke to Ann Wycherley at the Market Drayton Workhouse, and wanted to know if she could visit the house where he lived with his father. She said she could not because they were locked up. He said he saw her two days later at his father's house. 'I asked if she was going back to the workhouse and she said yes if she could get a place for her child,' he said. 'That was the last I saw of her.'

With the evidence complete a bewildered Ann Wycherley was committed to the Staffordshire Assizes for the wilful murder of her daughter. The jury accepted Gilbert took no part in the girl's death and he was discharged.

The public gallery in the dreary Number One court of the impressive Shire Hall in Stafford's Market Square, was packed when the legal proceedings started almost five months later in May 1838. They waited in excited anticipation for the trial of Ann Wycherley to get under way.

There was no pity on the faces of those who looked down on the dock with its narrow staircase which went down to the cells in the bowels of the court. Wycherley appeared a bedraggled, sad figure of a young woman, whose face betrayed all the misery that had taken over her life in such a short period of time.

The *Staffordshire Advertiser* reported at the opening of the trial, as she stood silently waiting for proceedings to start: 'On entering the dock the wretched woman appeared little affected by the dreadful circumstances in which she was placed and being called upon to plead to the indictment, answered in a firm voice: "Not Guilty". Although her countenance did not exhibit much that was very pre-possessing, yet there was the absence of everything indicative of a purpose so deadly as that which she had carried into fatal effect.'

Murder is the most serious offence on the criminal calendar but Wycherley was not represented by a barrister. For someone like her to be left exposed and clearly floundering helplessly in a legal minefield on her own, without some form of legal support, was shameful. The judge should have appointed a barrister from within the court to represent her in what was called a 'dock brief.'

How could someone so poorly educated, with only the workhouse protecting her and her children, be expected to defend herself against such an offence in front of a High Court judge and a prosecutor, a barrister trained in the art of the law?

The witnesses called at the coroner's inquest followed each other at regular intervals to repeat their evidence in front of the jury which added little or nothing to what they had earlier recounted. There was, however, one witness, Sarah Newbrook, who lived at Fair Oak, and took the oath: 'I swear by Almighty God that the evidence I give will be the truth, the whole truth and nothing but the truth.'

Then the prosecutor started asking questions and Mrs Newbrook told him that on Thursday, 14 December, Wycherley had visited her house about six o'clock in the evening. She asked if she could stay because she was very tired. 'She had one child with her which was in her arms and about fifteen months old,' said Mrs Newbrook.

'I gave her some meat and about seven o'clock she left the house. I had asked her if she had any other children to which she replied she had one more which she had buried a week or nine days before she came out of the workhouse.'

Mrs Newbrook continued her evidence and said that Wycherley returned two days later and asked if she would nurse the younger child. She agreed to look after the toddler for two shillings a week (10p). The next time she saw Wycherley was after she had been arrested.

Mr Critchley, the governor of Drayton Workhouse, was called again to give evidence; he said he went to a house and saw the body of little Ann and that he recognised it as

one of the two children Wycherley had with her. He said he had a warrant to arrest the young mother and found her working as a servant at Baldwins Gate.

He told the jurors he asked her where the children were and she told him they were both at Fair Oak, a tiny farming community not far from Bishops Wood – once used for hunting by the Bishops of Lichfield when they came to the area for a holiday. 'I asked if they were both there and she hesitated and when she did I told her I would show her her handiwork in the morning,' he said.

'When she saw the child in the morning she appeared disinclined to touch it. I said: "Come, come you used to be very fond of it when it could feel, touch it now it cannot". Then I put her hand on it. I asked her why she had killed the child and she said she would not have done it if Charles Gilbert had not persuaded her.

'She said afterwards that she had put it in the pit and that Gilbert threw the soughing tiles at it. She said she had not been kind to the child whilst in the workhouse.'

Another constable, whose name was not given, said he spoke to Wycherley and that she told him she undressed her daughter before she threw her still alive in the pit.

There was a steady stream of prosecution witnesses none of whom were questioned by Wycherley until it came to the evidence given by Catherine Biffin, when she objected to some of the things she told the jury. Biffin said she was at the Workhouse at the same time as Wycherley. She said she heard her say before she left the Workhouse on 14 December no person knew what was on her mind 'but in a fortnight or three weeks they would all know it.'

Biffin added: 'The child dirtied the bed and she used it badly and put it in a pail of water. She said she would kill the child. She wouldn't fall into sin any longer for the child. This was a morning or two before she left the workhouse.'

It was at this stage that Wycherley, for the first time during her trial, said anything when the judge asked her if there was something she wanted to say. She replied: 'It is a falsehood what that last woman has said. I never said anything of the like. I shouldn't have done it if Charles Gilbert had not made me do it.'

Two doctors then gave evidence and each said that little Ann had died from drowning.

That was the end of the prosecution's case. It was now the turn of Ann Wycherley to have her say. A defendant, in any case, does not have to say anything or give evidence on his or her own behalf. The prosecution presents the allegations and it is up to the person who does that to prove her guilt, not for Wycherley to disprove it. She maintained her right of silence and said nothing

The judge summed up and gave directions to the jury on the law which they had to accept. The witnesses' evidence was entirely within the jurors' domain and theirs alone. Within a minute a murder verdict was returned. It beggars belief that jurors – who held the life of one person in their hands – could sit and listen to evidence and then calmly deliver a guilty verdict within sixty seconds.

Once the verdict was given the *Staffordshire Advertiser* reporter commented on Wycherley's reaction. 'She heard the verdict returned without betraying the slightest emotion. Her countenance remained unchanged and whatever may have been her inward perturbation, there was no outward expression from which a real consciousness of her situation could be inferred.

'She stood unsupported amid the stillness of death and when the clerk of arraigns put the usual questions whether she had anything to say why sentence of death

should not be passed upon her, she answered in an unfaltering tone: "I hope, my lord, you will have mercy upon me".'

The judge put on the black cap and told Wycherley: 'You have been found guilty of murder on the clearest and most satisfactory evidence and what has greatly aggravated that crime in your case is that it was the murder of your own child – a child that ought to have been endeared to you.

'You have taken it from the place where it might have received protection and with merciless hands destroyed it. It is impossible for me to hold out to you the hope of mercy. Your crime calls for vengeance and all I can do is implore you to employ the short time which you have to live in this world in seeking that mercy at the hands of your God which the law cannot extend to you.'

There then occurred a most bizarre and perplexing situation that took everyone in the court totally by surprise. Wycherley made a quiet comment heard only by those close to her. When the judge asked her what she had said she replied: 'I am with child.'

The judge was astounded and taken aback and immediately ordered that all doors into the court should be closed while he started an investigation into Wycherley's claim. He then ordered that a jury of matrons should be empanelled from among women spectators in the public gallery.

The women went into the press bench and also took seats in some rows behind which had been cleared to make room for them. A forewoman was appointed and the jury was sworn to examine Wycherley and decide whether she was 'quick with child' and due to give birth soon.

The ladies with the judge's instructions clearly understood retired to another room in the building with his lordship's words ringing in their ears that they were not to 'receive fire or food' until they had completed their investigation and returned with a verdict.

Wycherley was taken to join the women who, after a brief examination, decided they needed the expert assistance of a doctor. A local surgeon who was in the building went to the room where the matrons waited for him. Eventually, after carrying out a further examination, they all returned to court three quarters of an hour later.

The surgeon told the judge he estimated that Wycherley was not even 'two months gone.' The jurors were told to return a verdict on what they heard from the doctor and what they had decided of their own accord. The forewoman stood and firmly told the judge that Wycherley was 'not quick with child.'

The judge continued his sentencing and told Wycherley she would be executed within two days outside the walls of Stafford Prison, half a mile away. But as a show of last hope her execution was delayed for a short time on the appointed day, just in case the mail coach from London had brought a reprieve from the Home Secretary.

The *Staffordshire Advertiser* reported the execution and told its readers: 'At an early hour the solemnities were announced by the knell of death. During the preparatory arrangements she conducted herself with great propriety of demeanour. She attended to the exhortations of the chaplain with becoming earnestness; partook of the sacrament with much apparent devotion and declared that she did not fear to die for that she was much happier than those who had been instrumental in bringing her to her sad fate.'

Wycherley quietly consented to being pinioned without any emotion and 'went through the whole dreadful proceedings with extraordinary firmness. About nine o'clock the mournful procession moved slowly towards the fatal spot.' The mother who killed her little daughter climbed the steps of the scaffold towards the waiting hangman and was placed on the trapdoor. As the final prayers were being said a hood was put over her head and the noose around her neck; the hangman pulled the lever 'during which she was turned off and in one minute ceased to live.'

It never became evident why Wycherley killed her little girl, only that she murdered her. Maybe it was the hard, never ending conditions of toil and extreme poverty in the workhouse which turned a once-loving mother into a heartless killer. The way in which she killed her daughter was cruel in the extreme. To strip a little girl naked and throw her still alive into a pit of cold water and leave her to die alone in the middle of winter, was a savage and callous act.

The Committee of the Society for the Diffusion of Information on Capital Punishment said that the arguments against taking human life for crime 'are too numerous to allow more than a concise enumeration of the ones on the present occasion.'

The committee's comments were not made in connection with the execution of Wycherley in particular, but just a general observation. 'It partakes the nature of revenge which man is not allowed, by the Divine law, to practice on his fellow creatures. The penalty of death is moreover, as an example, momentary and of no beneficial effect. It disgusts the good and brutalises the bad who witness the spectacle of man cruelly destroyed by man. It teaches violence to the people as an act of deliberate homicide.'

Workhouse: Under the Poor Law system of England, Scotland, Ireland and Wales, a workhouse was a place where people who, unable to support themselves, could go to work and live. The Oxford English Dictionary's earliest reference to a workhouse dates to 1652 at Abingdon in Oxfordshire.

Food was not the best. The diet was described as dreary but nutritionally adequate. The workhouse master could often reward and punish to maintain discipline. Workhouse conditions were deliberately harsh to deter the able-bodied poor from relying on them. Men and women were segregated and children were separated from their parents.

Most workhouses were run on a shoestring budget and in many ways the treatment in the workhouse was little different from that in prison, leaving many inmates feeling they were being punished for the crime of poverty.

The terrible conditions in some workhouses may have led to depression. Some women would not speak and children would refuse to play. Visitors reported rooms full of the sick and elderly inmates, with threadbare blankets and windows wide open to the freezing weather.

Work was provided to keep the inmates busy. It was usually boring, hard and degrading and included crushing bones for fertiliser, stone breaking and picking oakum – a cone with sap that was turned into tar mixed with fibre ropes for caulking and packing joints in the timber of wooden vessels and the deck planking of steel and iron ships. In one workhouse, starving paupers were reduced to sucking marrow from the bones to supplement their meagre diets.

TWILIGHT ZONE KILLING

Sikhs are a proud people, conscious of a rich, religious heritage founded half a millenium ago. Its creator, the Guru Nanak, encouraged his followers into a state of purity and to accept a binding principle that men and women must be looked upon as being equal by those who followed in his footsteps and teachings.

His law was laid down with a dogmatic authority but when the sanctity of the culture was threatened in an alien environment in which non-believers could not understand, the majority had to be protected and the sinner would face the ultimate punishment – death, in a particularly brutal and savage way, regardless of the manner.

For many years Sikhs have lived in Britain and their culture has survived and blossomed with many temples being built in all parts of the United Kingdom. They wear the highly recognisable turbans of white, blue or orange with each twist of the material carefully layered into the impressive headgear westerners are used to seeing, and a neat beard held in place by a hairnet because Sikhs are not allowed to cut their hair.

But in recent times, young female members of families have rebelled against the strictures of conformity and have challenged their elders as they tried to establish their rights in a society which offered them no definite cultural choice. Their religious laws, created in a continent thousands of miles away which they had never seen, urged upon them demands they felt they were unable to accept.

In one Midland family the old way could not be jeopardised and the foundation had to be protected. A father had to protect these beliefs with measures so extreme that he would be prepared to sacrifice his daughter's life to preserve the doctrine of his religion. There was no choice. If a daughter was going out with someone of whom her father disapproved her life was at stake. Her resultant death led to what was one of the first so-called 'honour killings' – a brutal, savage murder committed to maintain a set of moral obligations and principles, and at the same time to overcome and put right a deep sense of shame.

Jagjinder Singh Gill was aged forty-six and a deeply pious Sikh who wanted to maintain generations of tradition by choosing the man his daughter was to have as

her husband. It was his sacred religious right and part of his authoritarian, spiritual law which gave him the ultimate right to decide and his decision had to be accepted without question.

But in the twilight zone of conflicting east and west cultures in which she was born and brought up, the young woman disobeyed her father and by committing the ultimate sin paid with her life.

The daughter's disobedience shamed and disgraced her father in the eyes of his family and other members of the closely-knit Sikh community. His standing in the culture, cultivated by a long line of ancestors over the centuries, was his sacred birthright which had to be protected and was something which no young woman – not even his daughter – could be allowed to a take away. She had to die so that he could maintain respect.

It overwhelmed him to such a fanatical extreme that as a prosecutor, judge and jury he ordained his daughter's death and became her executioner. Whatever went through his mind as he reached his decision must have been a tragedy for the whole of his family. It was something that a Western father could not understand. A man's love for his child can only be understood by other fathers, but it was at this stage that cultures gave way and Charrangjit Kaur Gill's death sentence was set into motion.

But killing his daughter did not end there. Her body had to disappear and in accordance with Sikh custom and tradition it meant that her human remains had to be cremated or cast upon water.

With the help of his wife – Amrit Kaur Gill – Jagjinder Singh Gill made plans for the cold-blooded killing of his daughter. As the night came for the murder of the young college student, husband and wife silently waited outside the bedroom she shared with a younger sister, who was later to tell a judge, jury and people in the public gallery in court number one at Birmingham Crown Court the horrific act carried out by her father in the name of religion.

As Jagjinder Singh Gill crept quietly into his daughters' bedroom he took with him a length of rope for the brutal, savage killing of a daughter he loved but also to protect a culture that had ruled his life from the day he was old enough to understand it. With the only light in the room coming from a street lamp outside, Jagjinder Singh Gill set about his gruesome task quickly and skilfully; he looped the rope carefully around the neck of his sleeping daughter and with both hands slowly and gradually began to pull it tight, squeezing the life out of the child he fathered seventeen years earlier.

In her death throes her arms flailed as she tried to pull the rope away from her neck. Her fingers snatched at the rope as it cut into her neck stopping the flow of life-giving oxygen, and her nails left abrasions on her neck. She woke her younger sister as she fought with her fingers to remove the rope that was was draining her life away. But as she began to lose her strength the rope began to tighten as Jagjinder Singh kneeled astride his daughter's body to slowly end her life.

Shortly after she died, Jagjinder Singh Gill and his wife set about preparing her for the final act of desecration. While their younger daughter was awake and close to the dead body of her sister, they stripped off her nightclothes and began to dress her in her day clothes of a blouse, slacks and a fawn raincoat. As they completed

their gruesome task their only son, Baljit Singh Gill, a twenty-year-old student at Wolverhampton Polytechnic, arrived home from one of his regular visits to his older sister who lived nearby.

Immediately his father ordered him to go to the family car, and within a short while, the girl's body was brought from the family house and bundled into the boot of the vehicle. The boot lid was slammed shut and, with Baljit Singh Gill behind the wheel, father and son drove a silent fifteen miles from their home to the historic Shropshire town of Bridgnorth, where the body of his daughter was removed from the boot and unceremoniously dumped into the murky waters of the River Severn where it slowly floated away.

The first indication of something being wrong came the following day when Baljit Singh made another of his regular visits to the home of his eldest sister, Dhanjit. Her normally talkative brother was unusually quiet and withdrawn. He was unable to eat, was edgy and spoke little. His sister found it difficult to talk to him and when he did speak he made little sense. The evening continued in the same way, and then Baljit Singh went home.

A day later, on 31 January, 1977, Dhanjit and her English husband, Alan, learned the secret of her brother's sombre silence and uncharacteristic behaviour when they were visited by her younger sister, sixteen-year-old Verinder Kaur Gill, who was sleeping in a bed next to her dying sister. The girl was asked about the family and if there was anything wrong at home. Verinder was gently questioned and pressured, and as time went by, she was no longer able to keep the horrific secret of the night before. She told her sister how their father came into her bedroom, and of the strange noises and struggling made by her sister Charrangjit, in the room they shared.

Dhanjit had heard enough to make her fearful for Charrangjit's safety and so she with Verinder to Wolverhampton's Birmingham Road Police Station where they were taken to an upstairs office of Detective Chief Inspector Bill Squires. He was an experienced, well-liked detective with a hard-earned reputation and a level of skill which had helped him to reach the top of his profession.

A sixth sense borne from experience and gut reaction put him on his guard and from the moment the two sisters started to speak he knew they had something terrible to tell him.

As the young Verinder sat opposite him she unfolded a nightmare story, the evil of which had not been matched by many of the murder cases he had worked on during his long career in criminal investigation. He listened for more than hour as the girl, gently encouraged by her older sister, disclosed to him the dreadful secret she had shared only with Dhanjit and her brother-in-law. By the time she had finished Detective Chief Inspector later told me: 'I knew it was a case of murder as soon as they came into my office.'

With speed essential, Bill Squires contacted Superintendent Thomas Banks, head of the West Midlands Police Criminal Investigation Department, and the superintendent's right hand man, Detective Chief Inspector Bob Roberts, who was later promoted to become head of the West Midlands Police Commercial Branch or fraud squad. Both men retired several years ago.

The first thing DCI Roberts did was to go the Wolverhampton Polytechnic to meet with Jagjinder Singh's son, Baljit Singh. Other arrangements were then made

to contact two close friends of the now presumed dead Charrangjit. One was a young West Indian boy with whom she had been friendly and the other was a close girlfriend.

They were taken to Wolverhampton's Birmingham Road Police Station where senior detectives questioned them closely and carefully and sympathetically about their friendship with Charrangjit. At the same time, a couple of miles away, other detectives went to Wolverhampton Polytechnic where Baljit Singh was brought from a classroom lecture to meet with Detective Chief Inspector Roberts.

From the moment Bob Roberts introduced himself, young Baljit Singh shook uncontrollably and later the detective was to say he had never seen anyone shake so violently. By the time Baljit Singh was encouraged to relax and concentrate on what he had to tell DCI Roberts the young Sikh had said enough for him to be taken back to Birmingham Road Police Station. There they met up with Detective Superintendent Banks who decided Baljit Singh should be left in the care of the custody sergeant. The two detectives then made their way to 66 Curzon Street, where Charrangjit had been murdered only hours earlier, to meet with Baljit's father, Jagjinder Singh Gill.

Confronted by two detectives who more or less had an incriminating confession from his son, the middle-aged Sikh broke down in tears and confessed to how he had killed his daughter. Jagjinder Singh and his wife, Amrit Kaur, were arrested, read their rights and then taken in a police car to Birmingham Road Police Station, where they were both charged with murder. Baljit Singh was, at the same time, charged with assisting in the disposal of his sister's body.

The fate of Charrangjit Kaur Gill was one that could have happened to many other girls with her upbringing, in the strict confines of a demanding Sikh religion where East and West cultures overlapped. Unable to cope with either one or the other they had little choice in this twilight zone of conscience conflict. They could choose one or the other but if they made the wrong choice their life would be at risk. Other girls, through no fault of their own, could have ended their lives prematurely in the fast-flowing waters of another river because a father put religion above his daughter's life.

And there may have ended for all time the mysterious fate of a beautiful, young girl who wanted only what was desired by her friends, had it not been for the pitiful, remorseful conduct of a brother who could not bear to live with the disappearance of his sister on his conscience.

One thing was certain. Baljit Singh had no knowledge that his father, in the name of religion, was to kill his sister. But because of paternal power and a natural reaction to obey without question the head of the family, Baljit Singh became unwillingly involved and was forced to hide to the murder of his younger sister.

Charrangjit Kaur had been put to death at the hands of her father at about one in the morning, and it was shortly after his return home from an evening at his elder sister's home that Baljit Singh was to become unknowingly entwined as a victim of circumstances surrounding his younger sister's murder. But it was shortly before four in the morning that father and son managed, with difficulty, to move the girl's body from the terraced house and into the boot of the family's car parked outside the front door.

It was believed they waited so long because nearby, one of the neighbours was hosting a noisy party with guests coming and going. To take the girl's body outside wrapped in a big bag with so many people around would have aroused someone's curiosity and suspicion.

While they waited, the sad, young Baljit Singh was beside himself with grief as he tried frantically for three hours to try to bring his sister back to life. Maybe the noisy party was a fortuitous event if only to delay the inevitable. Had Jagjinder Singh been able to leave his home two hours earlier the crime may have come to light a few miles from Bridgnorth. It was here that the police were investigating another crime near the historic Shropshire town and had set up a road block. They had searched cars, and it was only the interceding hand of fate which had guided Jagjinder Singh's car away from the area.

Within hours of the girl's disappearance a major search for her body was launched and a team from the West Midlands Police Underwater Squad, along with experts from the Severn-Trent Water Authority, started a search so intense that it lasted for four days. The swirling, fast-running waters of the River Severn, swollen by rain and melting snow from the Welsh hills, hindered their search which became a hazardous and dangerous experience for the police frogmen, who were beaten and physically battered by powerful under-water currents that swept them dangerously close to the supporting structure of a bridge that carried a road into the town of Bridgnorth.

The various forces of nature began to take their toll on the underwater investigators and within several days they had to abandon their search. But almost eight weeks later and several miles downriver, a scene which could be replayed in many parts of the country when people were missing, gave detectives their first major break. A man was out walking with his dog close to the water's edge of the Severn. A few feet from the bank he saw a small whirlpool created by the fast-running currents, and gently bobbing in the centre appeared to be what he thought was a log. But, as he moved closer, he recognised the shape of a human body.

Quickly scrambling up the slippery bank and losing his footing occasionally, the man made for a nearby phone box and dialled 999. Within moments his call was answered and minutes later a local police in a patrol car, alerted by the emergency operator, were on their way to the river's edge.

One of the police officers confirmed the discovery was a human body. A further call was made and a recovery unit turned up a short while later. As one of the policemen carefully made his way into the water with a safety rope around his waist the bloated corpse was recovered and carefully brought on to the river bank.

When Baljit Singh later learned that his dead sister's body had been recovered he was overcome by such a terrible remorse that he tried to punish himself and begged the police to be allowed to see her remains. But what was left of a once beautiful young woman was in such an unrecognisable state from being weeks in the water, that detectives refused to let him see the grisly remains.

It was estimated that Charrangjit's body had lain on the river bed for many weeks. Her clothes were covered with mud and silt had seeped through her raincoat and into her underclothes and skin. At Jagjinder Singh's trial which started at Birmingham Crown Court on 19 October, 1977, a post-mortem autopsy report prepared by Home Office pathologist, Dr Alfred Marshall, was read to the jury.

The trial judge, Mr Justice Cusack, one of the most senior High Court judges in England and Wales, urged jurors to attach as much importance to what was being read as though Dr Marshall was giving evidence on oath from the witness box. It was read because the prosecution and defence barristers accepted his evidence and indicated neither would wish to question his findings.

His statement said: 'On March 21 at 12 noon I was shown a body removed from the Severn and taken to Wednesfield (near Wolverhampton) mortuary. The body was wearing a fawn coloured raincoat, a blouse and rust-coloured trousers. The hair was almost gone. The face was bloated and the skin was falling off. The body was bloated, muddy and slimy. There was the mark of a rope about half an inch deep round her neck on the right hand side. In the presence of the police and solicitors I performed a full post-mortem. In view of the condition of the body I cannot be sure whether she died of strangulation or drowning."

Jagjinder Singh Gill had experienced disobedience on an earlier occasion when his eldest daughter decided that her allegiance to her father and his religion were not strong enough to overcome the love she had come to share with an outsider – a white man she met when she, too, was a schoolgirl.

Dhanjit Kaur Gill and Alan Davies, both nineteen, were childhood sweethearts and met four years earlier while attending Penn Secondary Modern School in Wolverhampton. The western culture which was their lives was too strong for the Sikh religious doctrine and against her parents' wishes and despite the numerous objections they put in her way, they married.

They regarded their daughter's marriage as a disgrace to the family and a blemish to their name. They knew it would cause them great shame in the eyes of the Sikh community, not only in Wolverhampton, but throughout the country and also thousands of miles in the homeland villages of their many ancestors. But eventually Jagjinder Singh Gill and his family came to terms with the situation and grudgingly accepted Alan Davies as their son-in-law. But for the devout Sikh it was the beginning of a time in his life which would end with the destruction of his teenage daughter all in the name of religion.

Jagjinder Singh Gill was an earnest and devout follower of Guru Nanak who founded the Sikh religion a little more than 500 years ago. The middle-aged Sikh's devotion to his religion bordered on a mild fanaticism and the passion he expressed in his belief was a zeal and piety that wholly embraced his wife and family.

It was more than just a way of life and something more than just a religious belief. He adopted the pressure for a complete acceptance of the rules decreed and laid down by Guru Nanak for his followers, and placed heavy demands for obedience on his children, particularly his daughters in their adolescent years. Because of this they lived in an environment with a totally alien and opposing set of beliefs – a twilight zone.

There was the inevitable lack of understanding by his children who failed to comprehend why their father would not accept the existence of two extreme cultures with their radical differences of socio-religious influences. To him Sikhism was not only a doctrine but a way of life that was not to be questioned but had to be maintained and preserved – at all costs.

The preservation of a Sikh's day-to-day dignity, integrity and standing in the eyes of other devout followers of the religion was of paramount importance. To Jagjinder Singh Gill anything that failed to meet the demands of such a high code of practice and purity created shame and disgrace, and forced him to hide his self-imposed guilt by staying away from the Sikh temple and his friends, and to seek comfort in the sanctuary of his own home overwhelmed by grief.

He had already faced the torment of deceit and disobedience when Dhanjit married Alan Davies and left home. The shame and disgrace then was a severe and damaging blow to his Sikh pride. But seeking consolation in the understanding and sympathy of his wife, he prepared himself to accept what was to be another devastating blow to his beliefs.

Because of the insular life he led he became unable to maintain a strong defence against outsiders. The east-west conflict was ready to strike another blow to his religious pride because he failed to encourage his two eldest daughters to follow his lead. Dhanjit started the erosion which, although small, was a shattering blow to a devout Sikh who vowed to preserve at all costs the demanding principles of his religion.

Jagjinder Singh Gill was an intelligent man born in the Punjab on 12 February, 1928. He was well educated in Calcutta and attended the Jadaupur Engineering College in the same city where he later obtained a bachelor of science degree in engineering. He moved to Wolverhampton in 1966 and for five years worked hard and diligently as a bus driver with the Midland Transport Company. In 1971 he was made redundant but later managed to get himself a job with the West Midland Passenger Transport Board – a position he held until his arrest in March 1977.

He appeared before local magistrates and was eventually committed for trial to Birmingham Crown Court. This was the first time people in his adopted town of Wolverhampton really heard about the man who killed his daughter because of her association and friendship with a man who did not get his approval. He spent nearly eight months in custody after his arrest and kept himself to himself in prison where he had little to do with other inmates and his religion became his soul-mate and saviour in such unusual surroundings.

As his trial date drew nearer the inevitable interest heightened in Wolverhampton and so frequently during quiet, subdued conversations among many people of different religions and racial backgrounds made brief references to Jagjinder Singh Gill as the man who killed his seventeen-year-old daughter because she went out with a man he did not like.

When eventually the trial got underway at Birmingham Crown Court on 17 October, 1977, the public gallery at the rear of the dark wooden, austere atmosphere of court number five, was crammed with the interested and curious, and the press bench was filled as people waited for the emotional drama to begin as the real story of a man's love-hate relationship with a daughter would be told in public for the first time.

The trial judge, Mr Justice Cusack, would make his appearance in court at the appointed time of 10.30 a.m., and he expected everyone to be ready at that hour and to play their part in what was about to take place.

At the appointed time there was a forceful double rap on a door at the side of the judge's bench and when it opened Mr Justice Cusack walked in determinedly to

his high-backed dark red leather chair. It was carefully pulled backwards for him by his clerk, who followed the judge in and then quickly moved ahead of him to do his duty as the judge positioned himself in front of his spacious wooden bench, on which he had his large red notebook and an ample supply of ball-point pens to write down what witnesses were saying and coloured pencils to highlight important parts of their evidence.

Before the judge sat down his clerk said in a clear voice: 'All those having anything to do before my lords the Queen's justices draw near and give their attendance.' That meant any barristers who had any business to conduct before the judge would be allowed to do so during his stay.

Mr Justice Cusack looked splendid and sartorially elegant in his red gown with his cuffs finished off with white ermine to match the long strip of ermine down the front of his gown – court attire which has changed little over the past 500 years. He wore a tye or bench wig with one curl on a tail at the back. In the centre of his wig was a round patch which could be clearly seen when he bowed to counsel on entering or leaving court. It represents a medieval coif or close-fitting white head covering worn by judges under their wigs several centuries ago, and is the last link with sergeants at law.

He carried in his hand a pair of white leather gloves and the black cap – actually a small, square piece of black material which dates back to the Tudor times – was placed over the judge's wig as he repeated the words of the death sentence. He also carried a nosegay – a small bunch of flowers – reminiscent of the days their lordships were able to use the sweet-smelling posy to cover up the unpleasant smells arising from Newgate Prison next to the Old Bailey.

The judge made himself comfortable and surveyed all those seated below and in front of him from his position of authority. Mr Justice Cusack was a no-nonsense judge and made it clear, in the simplest of words, that he was in charge and wanted everything to start smoothly and carry on without let or hindrance until the end of the case.

The jury panel was ushered into court and sat on benches in an area set aside for those who would judge the case. All the jurors, in excess of thirty, had been randomly picked from the local voters' list by computer. None of them knew each other but they were together to perform one of the oldest tasks in the British legal system – to sit in judgement on a fellow man, someone they did not know; a complete stranger. But it was up to the twelve eventually selected, again at random by the clerk of the court, to take their places in the jury box to listen and judge.

As each juror was called by name to take the oath he or she repeated: 'I swear by Almighty God that I shall well and faithfully try the defendant and give a true verdict according to the evidence.' Those who wanted to affirm because they had no religious belief were allowed to say: 'I do solemnly, sincerely and truly declare and affirm that I shall well and faithfully try the defendant and give a true verdict according to the evidence.'

Once the jurors were comfortable in their jury box Mr Justice Cusack addressed the jurors and told them they and they alone were the judges of the facts and he was responsible for the law. He told them if they were unsure of what they heard or needed something to be explained they should raise their hand and he would listen.

Once all the preliminaries were completed and all the Is were dotted and the Ts crossed the trial started. The case for the Crown was presented by Mr Isylwyn Griffiths, an eminent Queen's Counsel chosen by the Director of Public Prosecutions to put the evidence against Jagjinder Singh Gill and prove that he killed his daughter.

Mr Griffiths faced the twelve jurors now comfortably seated in the jury box and peered at them over the top of his gold, half-frame glasses and in a matter-of-fact voice said: 'The charge here is one of murder and the victim of that murder was a seventeen-year-old daughter of the accused. The facts of this case can be put very shortly and they are as follows.'

Barristers in court are unable to define their oft-used phrase 'very shortly' and while a layman with good cause would conceivably regard 'very shortly' to mean just that, a barrister loses the ability to judge the passage of time and more often than not his calculation falls very short of his good-intentioned estimate. Barristers are verbose and repetition is their stock in trade. Mr Griffiths was no exception and he took the judge, jury, court officials, the press and members of the public through the prosecution's account of the incidents leading up to the horrific death of a young woman.

He continued: 'During the late hours of Saturday or the very early hours of Sunday morning on the night of January 29-30 this year, the victim had gone to bed and the accused at the family home in Wolverhampton, strangled her she was in bed and thereafter with the assistance of other people undressed the body from its nightclothes into its day clothes then laid the body in a motor car and drove to Bridgnorth where the body of the daughter was thrown into the River Severn. These are bald facts.

'Let me give you some of the background. The accused, together with his wife and son, aged twenty, and five daughters, lived in Wolverhampton. They came to this country from India in about 1965-66 and all of the children, other than the youngest child, were born in India. But, of course, all the children were educated, and some of them are still educated in schools in this country.

'They settled down in Wolverhampton at number 66 Curzon Street and the children went to local schools. It is a perfectly ordinary house. On the first floor is a back bedroom with a single bed occupied by the son. A middle bedroom was occupied by the accused and his wife and the front bedroom was shared by four unmarried daughters. The background may explain the rather tragic circumstances.

'The father and the mother adhered strictly to the Sikh faith and traditions. And, of course, as frequently happens, where the children are brought up in a background which is different the children – and more particularly the older children – do become Westernised. And they, in fact, challenged and disagreed with a number of traditions – the Sikh traditions which were adhered to by the accused. And it is from this fact that this particular case arises. In particular, the Sikh tradition says that the father of the family is the person who chooses the husband for his daughter and the daughter has very little or no say in the choice of bridegroom.

'Invariably the bridegroom is a Sikh and invariably the bridegroom comes from the same caste as the father. And it is right to say that accused's own marriage was arranged in this traditional way. You will be told by an expert in Sikh law that it is

unthinkable for a Sikh girl to marry against her father's consent because the fact of doing so is to bring disgrace, not only upon the girl, but upon the father and upon the rest of the family. And you can be well aware that any situation where marriage is arranged, once a disgrace of this kind occurs, it does obviously make the marrying of all the younger daughters of that disgraced family much more difficult.

'The first blow to the Sikh tradition was sustained when the eldest daughter, who had gone to school in this country, met a young man and they became friendly with each other and began to court one another and it is right to say that the father disapproved very strongly of this association – not that he objected to the young man as such, but he objected to the association and made every effort to break down that association. So much so that the elder daughter left home and in the end married in December 1976 in a Christian church and it is right to say that the entire family, except the father, attended. He gave his reason for not attending that he would have lost face in the Sikh community and it would make it very difficult to marry off his remaining daughters to respectable Sikh families.

'The eldest daughter was not the only attack on his parental authority. The second girl, Charrangjit, the dead girl, was also causing him trouble. She had spent her formative years in Wolverhampton and she had gone to schools where people of a number of races were at these schools and she mixed with all kinds of people.

She had left school and taken up a job as a shop assistant at a local Co-op. She became friendly with a young Sikh. What was with that, you may ask? Two things. First an association before marriage is not acceptable at all and, second, and perhaps even more of a disability, was the fact that the young man in question came from a caste lower down the scale than the caste of the accused.

After getting to know of the association he tried and tried and tried to break it up by explaining to the daughter of the Sikh traditions of not associating before marriage. The girl was westernised and was not prepared to accept Sikh traditions or have a husband chosen for her. She wanted to choose her own man.'

Mr Griffiths knew by now that the jurors were deeply interested as he carefully outlined the prosecution's case and continued: 'Members of the jury, that association was bad enough. Towards the end of 1976, and it is difficult to be precise, her affection changed to a young West Indian – a perfectly respectable young man she had met at school.

'They began to go around together and no doubt the association was a close one. Once again, the father, when he got to hear of it, although the daughter took a great deal of trouble to conceal it, was very upset about it. She did, in fact, leave home on about Thursday, January 20, and was away from there for three or four days. But it is right to say her father was under the impression that she was still fond of or in love with the young Sikh.

'The father went to see her at the place she was living and persuaded her to come home. He believed the young Sikh was the object of her affection. He agreed she should see him from time to time. But that night she telephoned and spoke to the accused and said she was no longer associating with the young Sikh but was, in fact, in love with the young West Indian. Her father's reaction was to say: "Well, it does not matter". But inwardly it mattered a great deal, and he found it difficult, if not impossible, to accept the situation.

'We now come to the Saturday – the last Saturday of that child's life. She had worked late. Quite late, stocktaking, and the arrangement was that the following day she and her boyfriend should, in fact, spend the day with her married sister and her brother-in-law. She came home and everything appeared normal. She had a meal and watched television. Then she and her younger sister went upstairs, undressed and went to bed in the front bedroom.

'The bedroom was shared with two younger sisters aged twelve and seven. But on this occasion, and you will have to make up your minds, they were not in their usual bedroom. They had been moved to the middle bedroom and they had been sent to bed in that room. You will, members of the jury, have to make up your minds whether that was an accident, a fortuitous event, or whether it was something which indicated a degree of preparation.

'You will hear from the sister that she went to sleep and the next thing she can remember she was woken up by her sister's convulsions and her grabbing her arm. She woke up and thought her sister was having a nightmare. She looked up and although there was no light on, there was a certain amount of light in the bedroom from the street outside. She looked up and saw her mother in the room. Her mother removed Charrangjit's arm and told her to go back to sleep. She saw her mother clearly and also was aware that not only was her mother present but her father was there as well.

'She heard a thump, members of the jury, and the Crown will be saying that it was her sister's body falling from the bed on to the floor. As her sister's body fell to the floor her sister must have grasped the quilt because it was suddenly ripped off. After the bump she heard from the floor something she described as a gurgling noise. You will, members of the jury, have to ask yourselves the question was that noise perhaps that young girl of seventeen in her death throes?

'A large sack was brought in. The girl was undressed and dressed in her day clothes and her sister saw her father drag the sack from the bedroom. The car was brought by her brother and the body was loaded into the car. The father was interviewed by the police and he admitted using a piece of rope to strangle Charrangjit. In a statement he said: "I found she was going with a Jamaican. I took up rope. I moved her and she was still. I thought she might be dead".'

Mr Griffiths reached the end of his opening to the jury and made it clear that what he just told them was not evidence. He said his remarks would help jurors understand and know what had gone on. It was part of a jigsaw which would be made complete when all the prosecution witnesses had given their evidence.

The first witness was Charrangjit's sixteen-year-old sister, Verinder. She asked if she knew what telling the truth meant then took the oath before telling the jurors of the fateful night when her sister was killed. In a quiet voice in a hushed courtroom with all eyes on this small girl, she began to tell the jury of the night her sister died. 'My three sisters and I used to share the front bedroom of the house. There were two double beds and I shared one with Charrangjit. The two younger ones shared another bed. Dhanjit, my elder sister, was married. My father did not like it. I can't remember what he said about it. Charrangjit was going out with an Indian boy. I think he was a Sikh. Then she started going out with a West Indian youth. She left home but I don't think my father said anything.'

The girl reminded jurors that her sister had left home for several days but later returned and told her father that she intended to continue seeing the young West Indian. Verinder told the jury that on the night her sister died Charrangjit got home from working late at the local Co-op store.

She continued her evidence in a quiet voice and said: 'We went to bed about 11 p.m. My younger sisters were sleeping in another room. That was unusual. They were sleeping in my father's room. I was surprised that the youngsters were not in my bedroom. They were awake and I went into my father's room to speak to them. I went back to my room and undressed. Charrangjit changed into her nightdress. We got into bed and talked for a bit then went to sleep.

'The next thing I remember she grabbed my left arm. I just woke up. I asked: "What's the matter?" but there was no answer. There was quite a lot of light in the bedroom from the outside. I opened my eyes and first of all I saw my mum. She was just behind the bed. She told me to go back to sleep. I turned over. I did not go to sleep. There was someone else with her. It was my father. I was turning over and I got a glimpse of him. I heard a big thump and my sister fell on the floor. As I heard the bump the eiderdown was pulled off me but it was put back by my mother.'

Mr Griffiths then asked the girl: 'Did you hear an unusual noise coming from the floor?' – 'Yes'.

'Tell us what you heard' – 'I don't know how to say it. It was sort of a gurgling noise.'

The youngster was unable to take the story any further and the next witness was the head of the Criminal Investigation Department in Wolverhampton, Detective Superintendent Thomas Banks. He said that on Monday, 31 January, he went to Jagjinder Singh's home in Curzon Street with two other detectives shortly before three in the afternoon and spoke to the middle-aged Sikh. He said he asked him if he had a daughter and Jagjinder said he had. He was further questioned and asked:

'Where is she now?' – 'She go away.' 'When did you last see her?' – 'Last Saturday.' 'When last Saturday?' – '10.30.' 'When she went to bed.' – 'That's right.' 'Did you see her the following morning?' – 'No, she leave home.'

Detective Superintendent told Jagjinder Singh that he was concerned about the teenager's well-being. He said: 'I have reason to believe she has been murdered and I would like you to accompany me to Birmingham Road Police Station' to which he replied 'Yes.'

'Why did your daughter leave home?' – 'She go with a coloured boy. I don't mind her going with a white boy or Indian boy but I don't like her going with a coloured boy.'

'Your son said that you killed your daughter yesterday and that the body is in the River Severn at Bridgnorth. Is that true?' The detective said that Jagjinder Singh gave a vacant stare. I repeated 'is it' and he said – 'Yes.'

'How did you kill her?' – 'I strangled her with a rope.'

'I would like you to show us where you put her in the river.' – 'Yes.'

The accused, with detectives, was then driven to Bridgnorth and when they reached the town made several turnings before they reached a roadway known as Riverside. They carried on for a further 300 yards near to a wooden seat and

Detective Chief Superintendent Banks told the jury that Jagjinder Singh got out of the police car with detectives on either side of him, pointed towards the water and said: 'That is where we put her in the river.' The police chief said a search was back at the river bank but nothing was found so the group returned to Birmingham Road Police station in Wolverhampton, and went into DCS Banks' office where Jagjinder Singh was told to sit down, again questioned, and asked if he would like to explain why he killed his daughter.

Detective Superintendent Banks continued his evidence and occasionally referred to his notebook so that he could refresh his memory of questioning which had taken place nine months earlier. He faced the jury and said: 'Would you like to tell us how this came about?' Jagjinder Singh replied: 'Yes. There was some Jamaican boy. I told her not to go out with him. I did not tell my wife. Me and my wife went to bed. I went in alone and killed her. I think it was about 1.30.'

The senior detective said Jagjinder Singh told him that the rope he used to kill Charrangjit was kept in a bag with string used to tie up rubbish.

DCS Banks then said that as the interview continued in his office Jagjinder Singh told them: 'We went to a small canal but left that place because it was too small and they find her there so I put her in the river. My wife got up in the morning but I could not tell her. What I have done I have told you. She had nothing to do with it.'

Mr Banks then said to Jagjinder Singh: 'But your wife was with you when you murdered your daughter.' The Sikh replied: 'But she has not done anything. She does not know anything.'

Mr Michael Dillon QC, who later because a judge on the Midland and Oxford Circuit, led the defence for Jagjinder Singh, and claimed that he was suffering from diminished responsibility at the time he killed his daughter and, therefore, could not be guilty of murder. Mr Dillon's assertion was that Jagjinder Singh was not in a balanced mental condition to realise what he was doing.

But Mr Griffiths, for the prosecution, called several medical witnesses to rebut Mr Dillon's claims and offer contrary arguments. The first was Dr William Lawson, a psychiatrist, who said when he examined Jagjinder Singh he did not find any symptom of depression. Any feeling of gloom and inadequacy experienced by Jagjinder Singh had lifted rapidly because of the solution to the problem which had bothered him.

'He objected more strongly to his daughter's association with the West Indian boy more than the Indian boy,' said Dr Lawson. 'When rigidity and inflexibility took over that was not depression. There was no abnormality of mind at the time of the killing.'

By now the prosecution had completed its case and the defence was given the opportunity to present evidence to support its proposition that Jagjinder Singh's mind was in an abnormal state at the time he killed his daughter.

One of the first defence witnesses was Dr Fazal Rahman. He told the court that he held a diploma in psychological medicine and was medical officer at Birmingham's Winson Green Prison, where Jagjinder Singh spent several months in custody prior to his trial. He was called to give evidence and to comment on the defendant's medical condition during the time he examined over six months at the prison.

He said he carried out psychological tests and a clinical investigation and interviewed Jagjinder Singh on a number of occasions. He said they talked at length about his past history and spoke of an incident when he was sixteen years old and tried to commit suicide following a family disagreement. 'He is quite intelligent and behaved rationally,' said Dr Rahman.

'He gave a good account of himself and described everything in great detail. He appeared to be an honest and truthful man. I came to a conclusion about his mental condition and felt he was suffering from a reactive depression following certain incidents in his life. He expressed suicidal thoughts and that life was not worth living and had no meaning for him.

'Depression started with his eldest daughter and he became disturbed and unsettled and kept himself to himself. He thought that doing away with himself would be a great sin. He was not actually responsible for himself. You can say his judgment was substantially impaired. I have no doubt about my opinion.'

Dr Rahman made no comment on the fact that Jagjinder Singh thought it would have been a 'great sin' to do away with himself but was prepared to commit a greater sin and kill his daughter to save face within the Sikh community

Another doctor called by the defence to support Dr Rahman was a consultant psychiatrist at Birmingham's All Saints' Hospital. Dr Mohinder Singh Dayal said he examined Jagjinder Singh and came to the conclusion that at the time the defendant killed his daughter his mental capabilities were substantially impaired. 'He was suffering from an abnormality of mind at the time,' said Dr Mohinder Singh. 'He lost control at the material time and did not know what he was doing. It was a depressive illness and was sufficient to impair his mental responsibility at that time.'

Dr Mohinder Singh was cross-examined by Mr Griffiths for the prosecution and in reply to a question said Jagjinder Singh's illness 'was depressive and more than mere unhappiness.' He said there were 'cultural reasons' and he lost control because of the anxiety to which he had been exposed.

An expert witness in any criminal trial is obviously of prime importance to the eventual outcome. In this trial, an expert on cultural affairs within the Sikh religion was called to explain what was, to many people, the mystique which surrounded something bordering on the unknown.

Surgit Singh Kalra, as schoolteacher in the Small Heath area of Birmingham, was called as an expert on the Sikh religion to help jurors understand the many details of a belief of which many knew little. Surgit Singh explained that Sikhism was founded 500 years ago when the first, Guru Nanak, declared the equality of men and women and the need for a Sikh to retain his pride no matter what the consequences. He told Mr Justice Cusack: 'It is unthinkable for a Sikh girl to be married without her parents' consent. The parents will arrange a marriage keeping in view, in most cases, the wishes of the girl and giving regard to caste, family background and suitability, etcetera.

'Should a girl refuse to consider her parents' wishes and marry without consent, associate with men, run away with a man, it would be very disgraceful for that family and adversely reflect on all members of that family. Disgrace of this nature could seriously affect the matrimonial chances of other daughters of that family.

A friend of the family, but not an Asian, seemed to support this view and said privately after the trial: 'The situation was, if he allowed her to live or did not take instant action, the other three unmarried daughters would not make good brides.'

The situation with Charrangjit followed so closely on from her eldest sister's break from the family's deeply ingrained sense of family culture and tradition, that Jagjinder Singh had reached a stage where he could no longer ignore or condone dishonour and to uphold his image as pious man, he had to kill her. This, in spite of his belief that to take his own life when he considered suicide, was nothing sinful.

Charrangjit had dishonoured and displeased her parents once by associating with a young Sikh of a lower caste. But against all their beliefs they were, however, prepared to accept him and allow their daughter to go out with him. But the girl deceived them and while they thought she was going out with the Sikh she was, in fact, keeping company with and going out with the young Jamaican.

Surgit Singh, the Birmingham schoolteacher and a learned man wise in the way and traditions of Sikhism, touched on this aspect of the subsequent crime and made this telling comment from the witness box: 'In my opinion a daughter of a Sikh could be in personal danger ... if she was keeping company with a Jamaican boy against her parents' wishes.

'The degree of danger would depend on the parents' attitude and inflexibility. Most certainly main warnings would have been given and many things tried to prevent the relationship before a Sikh could be forced in the position of having to kill her.'

Charrangjit Kaur Gill tried hard to shake off the Asian customs upon which her family life had been built. But she was brought up in an environment of conflicting views and customs where the English way of life was something more exciting, pleasing and acceptable than the centuries-old customs and beliefs her parents had tried to instill in her. She lived in a demanding twilight zone of conflict and confusion and unknowingly, death at the hands of her father was the only way out.

The Sikh environment meant stringent and strict conformity to conditions she was not prepared to accept. But the enforced acceptance of rules and family regulations was something that did not appeal to a young woman torn between two cultures while growing up in the turmoil of adolescence where the Western way of life held the greatest attraction and appeal. She had above average intelligence and shared her English girlfriends' passions for pop music, dancing, clothes, make-up – and boys.

The children of Asian parents understandably adapt more readily to the appeal of a newly found-way of life. But the older generation, equally understandably, found the new way of life a threat to the foundation and of their religion and culture. It was alien and difficult to accept, despite the fact that they had chosen to make their home in a country where the unbending attitudes and lack of toleration could, in some cases, create for them many problems.

At the end of the prosecution's case Mr Griffiths made his closing speech to the jury and went over some of the evidence briefly and outlined the major facts for jurors. He told them: 'From the evidence and facts it is quite clear that on the night in question the accused did, in fact, kill his daughter by strangulation and she did in fact die at her home. The sole issue for you is the state of mind of the defendant at the time of the killing.

'In the case of Jagjinder Singh at the time of the killing it was claimed he was suffering from an abnormality of mind caused by disease which resulted in substantial impairment of his judgment and mental responsibility. This is a special defence provided by the law and the law also says, and this is the exception to the ordinary rule, it is for the accused to satisfy you of the existence of that state of mind.'

Jagjinder Singh was not called to give evidence. It was his right to stay silent. The prosecution brought the case against him and it was for the Crown to prove beyond reasonable doubt that he was guilty. Jagjinder Singh only spoke two words during the whole of the two-day trial. He said 'Not guilty' when the clerk to the court read the indictment which gave details of the charge, the name of the victim and the date when the killing happened.

His counsel, Mr Michael Dillon QC, decided that expert medical evidence was his client's only salvation and a plea to the jury. He said: 'It has never been disputed from the beginning of the trial, tragically you may think, for all concerned, that Jagjinder Singh killed his daughter. The questions you have to answer fall into a narrow compass. You have to ask: "are we satisfied on the balance of probability," and it is more possible than not, that at the time at the time he killed his daughter he was suffering from an abnormality of mind brought about by mental disease.

'If you look at the evidence on the whole I suggest that, at the end of the day, you will be satisfied that it is more probable than not that at the time he was suffering from what I shall call diminished responsibility.'

Mr Justice Cusack, who had sat quietly throughout the trial only taking notes on import points to remind the jury. But he made it quite clear that the twelve jurors were judges of the facts and he the judge of the law. If he impressed upon them specific points he thought might be important he told them they could ignore them because the facts were their responsibility. But he reminded them, if he ignored particular evidence which they thought was important it again was in their domain to take on board or ignore certain evidence. The judge said if he made any errors then judges in the Court of Appeal Criminal Division at the Royal Courts of Justice in London, would put him right.

He went over the main points put forward by the prosecution and defence and considered carefully evidence of witnesses with expert knowledge. But he warned them not to assume that the defendant was guilty because he did not give evidence. He said Jagjinder Singh need not give evidence or say anything in his defence. The prosecution brought the case and had to prove he committed the murder. It was not for him to prove he did not. He then told the jury to retire to consider its verdict.

The twelve jurors filed out of the jury box to follow a jury bailiff to a room set aside for them at the rear of the court building. They made themselves comfortable, appointed a foreman to speak on their behalf when the verdict was ready to be returned, and then settled down to discuss the evidence for and against Jagjinder Singh Gill.

The jury bailiff waited outside their room being the only person allowed to talk to them and ask if they had reached a verdict. For many of the twelve it was their first time on a jury and the burden of a man's future weighed heavily on their shoulders. They talked and looked around and took notice of a printed warning

which reminded them it was an offence to tell anyone outside the jury room about their discussions – even after the trial.

Two-and-a-half hours later at the end of a two-day trial the jury bailiff was made aware that they had a verdict. Defence and prosecution counsel, junior barristers, solicitors, and members of the press were made aware on a tannoy system that a verdict had been reached.

They filed back into court to take their original places in the jury box and as they made themselves comfortable the judge's clerk brought Mr Justice Cusack into court, assisted the judge into his chair while the court clerk asked the jury foreman to stand.

'Mr Foreman,' he said, 'have you reached a verdict on which you are all agreed?' The foreman replied quietly: 'Yes.'

'Do you find the prisoner Jagjinder Singh Gill guilty or not guilty of the murder of Charrangjit Kaur Gill?' The foreman replied: 'Guilty. And the clerk asked: 'Is that the verdict of you all?' Replied the foreman: 'Yes.'

In his summing up Mr Justice Cusack said to the jury: 'People are not allowed to kill other people and in particular they are not allowed to kill their daughters because they disapprove of the young men with whom their daughters are associating. There are many English parents who disapprove of the friends their daughters make and if they were permitted to kill their daughters on that ground we would have, perhaps, a most disastrous slaughter.

'This case has revealed more than one tragedy. A young woman has lost her life and the father who was there to protect the family has brought disgrace upon himself and upon them.

'The unfortunate girl who died had displeased her father and for some reasons he had assumed on himself, the autocrat of the family, the power of life and death and he killed her. It must be understood by every community that however disobedient their daughters are, however much they break away from their own particular faith and surroundings, their lives are still sacred and that I believe to be the teachings of every civilised religion.'

The judge then sentenced Jagjinder Singh Gill to life in prison. His wife and son, who had appeared with him in the dock at the start of the trial, had both pleaded guilty to assisting in the removal of the girl's body. Amrit Kaur Gill, the wife, who spent six months in custody awaiting trial, was given a conditional discharge, and her son Baljit Singh a six months prison sentence suspended for twelve months.

This case must show quite clearly how a man-made religion, which promotes equality between men and women, can so wrongly create an interpretation which makes a man choose between the love for his daughter and the love for his religion. To be more concerned about what others may think, and make a father feel shame if his daughter steeped more in a western culture and went astray, is a sad indictment.

It shows beyond any doubt that the teachings of the Guru Nanak were ignored. The Guru did not say a daughter should be killed. Instead he made it clear that men and women were equal in the eyes of all practising Sikhs. There is nothing in Sikhism which orders the killing of a man if he breaches the religious code. Why should a woman be any different? Is it because she is subservient?

As Mr Justice Cusack so rightly said: 'However much they make a break away from their particular faith and surroundings, their lives are sacred, and that I believe to be the teachings of every civilised religion.'

Charrangjit Kaur Gill was sacrificed as an offering on purely religious grounds. She had no say in her future as a woman. Her life had no value and she was destroyed so that her father's standing within the Sikh community would remain sacred. It was an honour killing to maintain respect for a religion which preached the undeniable: that men and women were equal.

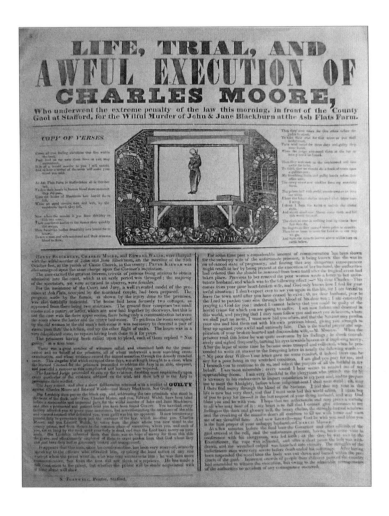

THE DEVIL'S DISCIPLE

The voice of Satan haunted the tormented mind of Wesley Kenneth Churchman. In his paranoid and unbalanced state he became increasingly disturbed and deluded. For years he was the devil's willing disciple as he listened quietly in his unstable world to whispers of evil, as they channelled their way into his thoughts and along a mind-bending path of destruction.

Wesley Churchman had to kill. He was one of society's dangerous misfits primed and programmed by a faulty gene to destroy life on impulse in a cruel and savage frenzy of hate. He was diagnosed by psychiatrists as a psychopath whose emotional instability and behavioural disorder would not allow him to form personal relationships. He became more indifferent and ignorant of all his obligations to society as the functional disorder of his mind manifested itself into a scheming wish to destroy life.

The pleasure of inflicting such grievous violence started in 1958 when, in an outburst of loathing, he mercilessly attacked and murdered his brother in a domestic argument.

In his uncontrolled rage and fury he repeatedly slashed and stabbed his younger sibling 124 times with a knife, then walked round to the local police station to give himself up, claiming he had acted in self-defence. He was arrested, interviewed by detectives and charged with murder. When he appeared at Staffordshire Assizes in 1958 he was jailed for life, after some caustic words of reproach from the judge.

But amazingly, after six years behind bars, doctors, psychiatrists and the Parole Board studied his case, medical records and behaviour during his short time in jail and decided it was safe to release him from Yorkshire's Wakefield Prison back into society, free to be controlled by his unstable mind, primed and ready to kill again. It was a strange decision after such a short time in prison and one that officialdom was likely to rue for many years to come.

Nineteen-year-old Leonard Churchman died because he did not like a fire being lit in a particular room at the house he shared with his mother, Minnie and his twenty-three-year-old brother, Wesley, at Thurlston, Commonside, Pensnett in the West Midlands Black Country town of Dudley.

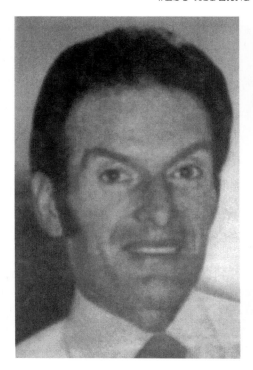

Wesley Churchman, left, jailed for life after admitting manslaughter and, right, the victim, Mr Alfred Martin, who died a savage death.

The trial at the 200-year-old Shire Hall in the county town of Stafford started on 3 July before Mr Justice Pearson in the austere, dark panelled walls of court number one. Mr George Baker QC, one of England's leading Queen's Counsels, who later became President of the Family Division at the High at the Royal Courts of Justice in London, prosecuted, and briefly outlined the case to the jury.

Behind him was Churchman sitting in the large dock with the jury members in their jury box on his right hand side. The judge sat opposite him and other barristers at a large table in the well of the court. It would be many years later that Churchman would find himself in the same dock on another murder charge. But more of that case later.

Churchman pleaded not guilty to murder. Mr Baker told jurors that nineteen-year-old Leonard Churchman was a 'mentally peculiar brother and was a cross to bear' for the family but it did not justify him being killed. He said the jury would have no doubt that the dead man had been a 'sore trial' to the family for many years.

'He had on occasions threatened his mother and assaulted her and had also assaulted his brother,' he said. 'On 17 May Mrs Churchman lit a fire in the living room. Leonard was in the habit of having a fire in the front room and he did not apparently like a fire in the other room.

Knife used to kill Mr Martin.

'Leonard took some coal and put it on his own fire and his mother put some pieces of wood. But he took the wood and threw it out of the window. Mrs Churchman went out and got it back and once again Leonard on his fire threw the wood away.

'From that stage, members of the jury, you will probably find that in the evidence there is some conflict of detail between what the mother tells you and what the accused man has said in his statement. Leonard went into the front room with a chopper and bolted the door. He shouted: "I will give him this if he comes in here".

'The accused did not immediately try to get into the room but went upstairs to his own bedroom and fetched his knife. The case I am putting before you, members of the jury, is that the door was broken down by the accused and he went into the front room.

'He was in there for some time and when he came out he was bloodstained. He said to his mother: "He won't worry you no more because he is dead". He had been stabbed 124 times. It is perfectly clear, in the submission of the prosecution that the stabbing had been by the accused man who had stabbed his brother to death.'

Mr Baker said Churchman then went to the local police to give himself up and told a policeman: 'I did it in self defence.'

Mr Baker went on: 'Of the 120 wounds on the deceased a large number were on the back and a large number on the hands indicating, you may think, that the deceased was trying to save himself with his bare hands from the frenzy of the knife attack.'

The first witness was Mrs Churchman and she said Leonard had been an in-patient at a Stafford mental hospital on several occasions over four years. She was a little woman and stood in the witness box on the right had side of the jury. The jurors watched her closely as she gave her evidence in a quiet voice and was told several times to speak up because it was necessary for the judge and jury to hear what she was saying.

'He had been at home for the past three years. He did not work and was always violent at home. He was always knocking me about and hitting me. On several occasions he beat me up and he was always very spiteful towards Wesley,' she said.

She went on to talk about lighting the fire and said Leonard went outside and returned with the chopper. 'He raised it and said: "Wesley, come near me and I will give you one with this." With that he ran into the front room and fastened the door.'

She was questioned by Mr E. Ryder Richardson QC, defending, and said that on many occasions Leonard attacked Wesley 'without provocation.' She said he also attacked her 'and seemed to have double strength.' She agreed with Mr Richardson that, on the day of his death, the only reason he could have had with the chopper was to use it as a weapon.

The prosecution completed its case with evidence from detectives and pathologist Dr Frederick Griffiths, who told the jury he carried out an autopsy on Leonard Churchman, and decided he died from shock and haemorrhage.

He said there were twenty-three stab wounds on the man's back, sixteen on the back of his neck, three on his right shoulder, two on his right upper arm, one on the front of his right shoulder, thirty-eight on the front and side of the chest, twenty-five on the chin and neck, nine on the right hand, six on the left and one on the back of the left wrist.

Dr Griffiths said the wounds varied from point marks to the largest on the right upper chest which measured almost three inches by one-and-half inches. Most of the wounds were about one inch.

Mrs Churchman, a widow, told the inquest coroner, Mr D. F. Cave, that her son's last job was as a night watchman 'but he didn't work at half the time. Years back he went in for brickmaking. That was the start of his trouble – studying a lot. He was in and out of hospital for years.'

Wesley Churchman was escorted from the dock by two prison officers to take his turn in the witness box to give evidence. He took the oath 'I swear by Almighty God that the evidence I give shall be the truth, the whole truth and nothing but the truth.'

His counsel Mr Ryder Richardson told him to keep his voice up and speak clearly so that everyone, in particular the jurors, could hear what he had to say as his evidence was just as important as that given by prosecution witnesses. He confirmed what his mother had said about the way his brother treated her. He said his brother made several attacks on him with a chopper, a chair and a knife.

Churchman said that on the day of his death Leonard had the chopper and threatened to kill him. He said he went upstairs to his bedroom to fetch a knife – a souvenir he brought back from overseas when he was in the army. 'I did it to defend myself in case I was attacked. It was unsheathed in my trouser pocket,' he said.

'I went to the room where Leonard was and pushed the door to get in but he was standing behind it. I wanted to get my portable radio and went over to take it and I heard a movement behind me. I turned round and Leonard attacked me with the chopper. Three times I tried to take it away from him. I thought he was going to kill me. I did not succeed in getting it away from him.

'I was very scared at the time and took the knife from my pocket and stabbed him in the arm that was holding the chopper. He did not let go of the chopper. We both struggled and we fell to the floor. I stabbed him again. I think it went into his chest. I have no recollection of delivering any further blows.'

It must have been like a bloodbath in that small room as the two brothers fought with each in a life and death struggle. The frenzied stabbing with knife blows being rained on the upper part of Leonard's body left little to anyone's imagination. Asked to account for the 120 wounds Kenneth Churchman told Mr Baker in cross-examination: 'I must have lost my head.'

Mr Baker said: 'You intended to kill your brother when you went into that room.' Churchman replied: 'No, sir.'

The prosecution and defence counsels then made their closing speeches, outlining the particular points of the trial with which jurors should concern themselves.

Then Mr Justice Pearson started his summing up and urged upon the jury that a man who relied upon self-defence as the reason for killing someone must also show he did not use excessive force. He said that when a man was in a fight and did not pause to weigh and estimate the amount of force then the jury had to 'consider very carefully' whether excessive force was used.

To consider provocation, said Mr Justice Pearson, the jury would have take into account two conditions – that Churchman was provoked to such an extent that he was deprived of his self-control, and was put into such 'a blind rage of fury and such a transport of passion that he was not for the moment acting rationally.'

Mr Justice Pearson went on: 'When you are considering whether he was acting under extreme provocation or self-defence you are entitled to see the events of May 17 (the day Leonard died) in the light of past history.

'It may be you think all these factors which militate against a suggestion of self-defence to support a suggestion he was deprived of self-control. That is not what the accused says.'

Once the judge completed his summing up the jury was taken to its room to consider a verdict. A decision was reached ten minutes before lunch-time. The judge took a guilty verdict and sentenced Churchman to life imprisonment.

It would be six years later, in 1964, after such a horrific killing, that officialdom decided it was safe for Wesley Kenneth Churchman to be released into the community. The amount of violence used in a short space of time to kill his younger brother could only mean that Churchman was the type of person to lose his self-control and put someone else in danger.

On Friday evening, 9 February, 1973, those voices Churchman heard, and had talked about to psychiatrists, urged him to kill again. From deep inside his brain the seeds of destruction which had lain dormant for nine years exploded and sent him on another path of havoc and devastation in which another victim was unaware that he would soon meet his Maker. Once more Churchman used a knife and this time a seventy-eight-year-old widower who lived alone was left in a pool of blood on his kitchen floor, stabbed at least fifty times in the face and chest.

Alfred John Martin, whose wife died year earlier, was a great-grandfather and a former lightweight boxing champion, last seen by a neighbour at noon on the day he died. His body was found five hours later by family friend Mrs Flossie Cole, who lived not too far away in Unett Street. He was described by neighbours as a friendly old man who lived in a bungalow at Will's Road on Smethwick's Cape Estate in the Black Country area of the West Midlands, between Wolverhampton and Birmingham. He and his late wife ran a greengrocery shop in the area for thirty years until they retired.

There was no sign of a forced entry and detectives believed the killer was someone Mr Martin knew. Detective Chief Superintendent Reginald Scragg, head of West Midland Police CID, said: 'This is a very nasty and vicious murder.' Detectives from New Scotland Yard in London were called in to help. A large-scale murder inquiry was launched and a search was made for the murder weapon.

Seventy thousand residents of the estate were asked to help the police and search their gardens and dustbins for a knife believed to have a blade at least four inches long. Door to door inquiries were carried out and 8,000 employees at the nearby GKN factory in the Grove Lane works were questioned.

Detectives stepped up the hunt for a clean-shaven man, aged about twenty-eight, who was seen running near Mr Martin's bungalow by a neighbour. They were convinced that his killer was a local man. Over 120 witnesses had come forward and Scotland Yard's Detective Chief Superintendent Richard Brooker, who was leading the investigation, said an early arrest was expected.

On 27 February, eighteen days after the killing, thirty-eight-year-old welder, Wesley Kenneth Churchman, from Kentish Road, Handsworth, Birmingham, was arrested and charged with Mr Martin's murder.

The fatal paths of Churchman and Mr Martin crossed casually in November 1972 while they were patients in adjoining beds in Dudley Road Hospital, Birmingham. Like all patients they soon started to chat then became friendly, mainly because of their common and shared interest in sport. To a lonely pensioner still coming to terms with being a widower the friendship of a stranger was a welcome relief since the death of his wife.

The friendship developed during the short stay and shortly before their discharge Mr Martin made it clear he welcomed Churchman's friendship and gave him his address and told him he would be gladly received at any time to his bungalow for a cup of tea.

This was the beginning of the end for the friendly old pensioner as Churchman heeded the voices in his head and subconsciously filed in his memory the invitation to tea and bade his friend farewell and their ways parted.

But Churchman's schizophrenic deep seated voices had taken control, and from the depths of his innermost being they taunted him, and for five months led him on a search of the Black Country for victims. He bought a knife and drove around, looking for houses for sale, hoping there might a target inside one who could satisfy his degraded eagerness and depraved desires to take a life.

Then Churchman remembered the former lightweight boxer but now a frail old man he had befriended in hospital. He recalled a book that Mr Martin had lent him – *The Godfather*. His search had ended. The victim in his murderous pursuit had been chosen. His damaged mind had satisfied his urge and a death sentence was put in place.

On a pleasant, late spring morning on 6 June, 1973, Churchman faced his second indictment for murder, this time in front of Mr Justice Phillips at Stafford Crown Court. He sat in the same dock as he did when tried for the murder of his brother, Leonard, at old Staffordshire Assizes in July 1958. This time he pleaded not guilty to murder but admitted manslaughter on the grounds of diminished responsibility.

Mr Edward Jowitt QC, prosecuting, who was some years later appointed to the High Court bench, accepted Churchman's plea and began to outline the story of a man he said 'was eaten up with a compelling urge to take the life of a human being.' Churchman sat impassively in the centre of the dock in court number one.

Mr Jowitt quietly related the story of a man who found it necessary to kill and satisfy the desire to take a human life. 'Medical reports give a detailed account of the man's history and doctors say he is a dangerous psychopath but they would not recommend that there is any treatment for him.'

Churchman, a medium-built man with a thick head of hair, cleanly shaven and smartly dressed, was behind Mr Jowitt and stared ahead as details of the gruesome and horrific taking of life were disclosed clearly and simply and left little for the imagination as he outlined the attack and the subsequent murder.

Mr Jowitt continued: 'The accused man is thirty-eight and has a previous conviction. In 1958 he murdered his brother.' All eyes turned for a brief moment towards Churchman and then back to Mr Jowitt. 'It was a vicious stabbing with again many stab wounds,' he said.

Churchman remained unmoved and outwardly unaffected by what Mr Jowitt had just said. What does a psychopath think? What thoughts go through his troubled mind as he is reminded of dreadful events many years ago? 'There appears to have been some evidence of provocation on that occasion,' said Mr Jowitt. 'He was sentenced to life imprisonment but was released on licence in 1964. (Although Churchman was released he could be recalled to prison for any offence committed at any time and continue to serve his sentence).

'At the time of the present killing he was living with his wife and baby and in a statement to the police referred to a continual urge to kill,' said Mr Jowitt. Churchman still stared ahead. Nothing betrayed what may have been going through his diseased mind.

Mr Jowitt told how Churchman had met old Mr Martin at a hospital where they were both vulnerable as patients being treated for their ailments. But a bizarre friendship sprung up, and the two men came to know each other only as well as people do when they meet in the caring atmosphere of a hospital. Mr Martin loaned

Churchman a book called *The Godfather* – the story of an American Mafia family and how Don Corleone held the power of life and death when people crossed the line and angered him.

Wesley Churchman held the power of life and death and, as Mr Jowitt told the court, how he had a 'lust to kill.' As the desire to take a life began to manifest itself, Churchman knew it would not be long before he had to find a victim and in his deranged mind he remembered Mr Martin and the old man's encouragement to visit him.

The pensioner, who had lived almost four score years of a trouble-free existence, moved around his house unaware that the minutes and seconds of his long life were ticking away and he was doomed by fate to a grave earlier than he expected.

Churchman had worked out where Mr Martin lived and how he would get to his victim's home from his house in Handsworth. Quickly, he made his way by car to Mr Martin's bungalow in Wills Way, Cape Hill, Dudley. Mr Jowitt said it was the pensioner's usual habit to change into his pyjamas ready for an afternoon nap. Churchman knocked at the front door and although Mr Martin was not too happy to be disturbed he was pleased to see the man who posed as his friend and so invited him in for a cup of tea.

They chatted for a few moments before Mr Martin went into the kitchen to make a drink, totally unaware that time for him was rapidly running out. Without warning, Churchman crept silently up behind Mr Martin and plunged a long knife deep into his back. In his crazed fury and rage of passionate madness Churchman lost control. Time and time again he stabbed and stabbed Mr Martin and as the old man fell dying he cried out to Churchman and pleaded with his killer: 'Oh, no, don't kill me. I am an old man.' But nothing could stop the lust to kill, until Mr lay dead on his kitchen floor with his old, frail body lying in an ever-growing pool of blood.

Mr Jowitt continued his story: 'After the man fell to the floor there followed what can only be described as a merciless and brutal use of the knife on the man. That attack continued after Mr Martin was dead. When a pathologist carried out a post-mortem examination, he found fifty stab wounds to Mr Martin's back, chest, abdomen, arms, thighs and neck.

'Churchman, by now possibly realising what he had done, then ransacked the house with the object of making it appear as though the killing had taken place during the course of a robbery.

'Mrs Flossie Cole, a neighbour who regularly did Mr Martin's shopping, called the police when she could not get an answer to her knocks on his door. Neither could she open the door and when she looked through a window she saw the old pensioner lying on the floor in a massive pool of blood. Later when the police started their investigations they found secure in the house about £600 in cash. When Churchman left the house, the only thing he took with him was the book *The Godfather* he had loaned to Mr Martin. As he later told detectives, he thought the police might find his fingerprints on it and connect him to the killing.

'He drove from the house and about a half-a-mile away threw the heavily bloodstained knife into a canal and dumped the book in a litter bin in a park. He took his raincoat to a drycleaner and explained that the bloodstains on it were

caused by a heavy nosebleed. He then returned to his home in Kentish Road, Handsworth, where he lived with his wife whom he married in 1966, and their baby son, Christopher.

'He looked for a notebook and tore from it a page on which he had written the address of Mr Martin. He also destroyed a notebook in which he had traced a route from his home to the old man's bungalow.'

The following morning Churchman got up early, left his wife and baby asleep and carefully checked his clothes for bloodstains. There were some on his shoes and trousers and so he went to a chemist's shop and asked for something that would remove the marks.

Churchman tried to cover up all his tracks and anything that could lead to him being identified as the killer. He returned home, and without disturbing his sleeping wife or son, took £150 then left. Detectives found he had travelled to Manchester where he spent a night, then moved on to Huddersfield. But the police were not far behind him as he tried to lose himself in the heartland of the industrial north. He was eventually tracked down to Bradford where had obtained a job and found lodgings. He was arrested without any struggle and taken back to Smethwick to be interviewed.

Other detectives went to the drycleaners at Smethwick, after an employee urgently called the police when Churchman's raincoat, with a blood covered sleeve, was found in a pile of clothing. It was then that detectives decided to try a million to one shot in the dark to find out whose blood was on the raincoat. They called in experts from New Scotland Yard, whose skill at classifying blood groups had earned them a worldwide reputation among other police forces.

Churchman and Mr Martin had the same blood group, but with painstaking care the experts checked and re-checked a sample of blood from the raincoat. Eventually they came up with what they were seeking. A speck of blood from the raincoat matched, in every respect, a sample taken from the dead man. The net had closed. Churchman was trapped. He could not argue with the proof that the blood on his raincoat was from the man he had slaughtered several days earlier.

While scientists were checking the tell-tale blood samples, detectives were stepping up their hunt for Churchman, when a second break led them a step nearer to the man they were seeking. From Bradford, the distraught Mrs Churchman received a letter from her husband. He told her he had left home because he was worried that the police might connect him with the pensioner's death.

Now the police knew where Churchman was hiding, having driven from his home. Several days later, as police fanned out and expanded their search in the grim northern town, a young policeman spotted Churchman in his car and the hunt for a sadistic killer was over. By the time detectives caught up with him they had taken nearly 2,000 statements from witnesses in a manhunt which had lasted seventeen days.

When Churchman was arrested and admitted to killing Mr Martin, he made a confession which highlighted the mental anguish and confusion that existed in his disturbed mind. Watching him in the dock of that ancient courtroom which, over the centuries, had seen hundreds of killers take their turn in front of a judge before being convicted and sentenced to death, it was hard to imagine any of them more mentally disturbed that Churchman.

Just to listen to the eight page confession he made, gave some insight into his demented and seriously disturbed way of thinking. It rambled on, and as it was gradually read out by Mr Jowitt, the more bizarre and unreal it became. After he was charged with Mr Martin's murder he volunteered to make a confession. These chilling words were the most significant part of his statement:

'I killed him, you know. My God I have got to tell somebody. I don't know why I did it. I have got a wife and baby. I just had to kill. For a long time I had an urge inside me to kill someone. I don't know why. I didn't know who it would be. I thought about my former fiancee's husband because he took her away from me while I was in hospital the last time. There was murder in me even at this time to kill.

'From time to time the urge kept coming and going. I wanted to rob a bank or commit murder. I had read a lot about the Boston Strangler and saw the film. It fascinated me. I thought about the same thing putting on overalls as a plumber. All that week before the murder there were voices inside me. There was something in my brain that kept telling me I had to kill. I knew I must do it soon.'

Churchman's confession continued and newspaper reporters in the press bench battled hard with their shorthand note to keep up with Mr Jowitt, as he told how Churchman thought about Mr Martin and 'how he hoped to God he was not at home because the urge to kill was very strong inside me.' His confession continued:

'As he came into the room I pulled the knife out. It was hard to say how I felt. The motivation inside me would not let me stop. Like something inside me was evil. Satan or something. Not just my body movements but my way of thinking.'

Then Mr Jowitt called his first and only witness – Dr Ernest Jacoby, a consultant psychiatrist. He described Churchman as a dangerous psychopath and said the voices that told him to kill were not known to anybody else. 'He kept it to himself and eventually it was considered safe to release him from his previous conviction,' said the doctor.

When Churchman left prison it was six years later, after being given the statutory life sentence for the murder of his brother. Within three years, the demon voices which had twisted his unstable mind, returned and took control, urging him to take another life.

Investigators had several big breaks during their short investigation, but the most telling and important one came by chance when a detective suddenly recalled Churchman's name and his trial for killing his nineteen-year-old brother, Leonard.

The hearing came to an end with comments and sentence by Mr Justice Phillips who told Churchman: 'The only sentence I can pass is one of life imprisonment. You will be detained in prison until such time as those in charge think it is safe – if it ever is – for you to be released.'

Churchman turned, to be escorted down a narrow set of stairs at the back of the dock which led to the cells beneath the court, with the words of Dr Jacoby ringing in his ears. 'In view of his history one had to be guarded in being optimistic about the future,' he said.

He is now in his seventies. If he is ever entitled to parole, doctors, psychiatrists and the Parole Board will have to consider, with great caution and care, whether it will ever be safe to once again grant Churchman his freedom.

Once the work of the court had finished for the day, Churchman and other prisoners were transferred by van to Shrewsbury Jail. He would be processed through a system he remembered well from his previous life sentence. After about four or five weeks he would be transferred to another prison which would be his home for weeks or months. And so, the situation would be repeated regularly every six months to a year for the rest of his life behind bars.

By 2009 he had served almost thirty-six years in prison for the manslaughter of Mr Martin – a long time by any standards, and he was now seventy-three years old. But he did not stay out of the news and made an application to move to a bail hostel in Walsall but the West Midlands Probation Board decided he must stay in an open prison because of the risk he posed to the public. It was considered that the chances of Churchman re-offending were high.

In December 2006 and February 2007 he made an application to the High Court in London, in a bid to overturn the Probation Board's decision but he failed on both occasions.

In 2005 he was transferred to Kirkham Open Prison near Preston. Here, despite the risk of re-offending being high, he was allowed out regularly on unsupervised day trips and also worked five days a week as a gardener and maintenance man at a local church. The prison opened in 1962 on part of the 220 acre site of RAF Kirkham which closed in 1957.

He then made another application to the High Court to be moved to the bail hostel in Walsall. In a ruling turning down the request, Mr Justice Pearson said: 'The decision to keep Mr Churchman in prison was lawful and rational and it was up to the Probation Board to decide whether he was suitable for release on temporary licence.

'The Probation Board has a duty to assess whether Churchman poses a risk to the public and it does not automatically follow that because the Parole Board and the Home Secretary backed a decision to send him to an open prison he should be granted a move to the hostel.'

That was the last time Churchman made any application to be transferred to the hostel but, in October 2009, he was moved from Kirkham to a closed prison. There was no reason given publicly, but normally prisoners are returned to a closed jail from an open prison for some form of breach of rules and regulations. The decision by the Home Office for him to be moved gave loud support to the possibility that he may stay in prison for the rest of his days.

You may recall that Dr Jacoby described Churchman as a dangerous psychopath and one had 'to be guarded in being optimistic for the future.'

Churchman killed twice following extremely violent attacks with a knife and claimed he did so because of voices he heard in his head. Voices he kept to himself

and away from doctors and psychiatrists. That was one reason he was allowed out after serving only six years for the murder of his brother.

He has served a long sentence, only right for the cruel, senseless killing of Mr Martin. One can only hope that the next voices to be heard are of those of cold, hard reason which will keep him in prison until the day he dies.

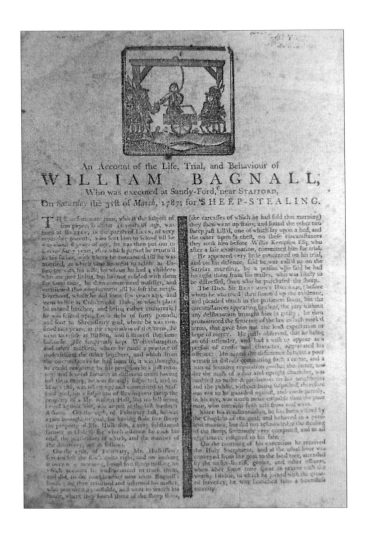

POISON IN A TEAPOT

Being poisoned is a cruel, agonising way to die. The victim becomes aware of a searing, tormenting, spreading pain caused by the venom that has invaded and ravaged his body. He grows increasingly sick and his organs begin to break down as the infectious contamination takes hold and he fights for his life which hangs by a thread as the coldness of death begins to take over.

The pain caused by shooting, stabbing or strangulation must be short but at least it ends reasonably quickly and cannot possibly compare with the slow, dreadful, lingering death inflicted upon someone by a killer who has decided to put poison in his victim's food or drink. It cannot be seen as it lies in wait for an unsuspecting person to drink or eat.

Such was the case of John Parker of Swindon in the parish of Wombourne, Staffordshire, who lived in a large country house, south of Wolverhampton. He died because his killer decided to play a trick on someone else, but made a mistake and picked the wrong victim.

William Hawkeswood pleaded not guilty to murder. He was only twenty years old and worked as a servant at Mr Parker's home and was highly thought of. He was described as a stout, muscular young man with very high cheekbones and a dark complexion. He told people that Mr Parker could offer him no more than the love and care shown by his own father. He was also appointed bailiff at a nearby farm, which his master had turned over to his nephew, John Parker Wilson, and had been working there in farm management for six weeks from late September or early October 1808.

Another member of Mr Parker's staff was housekeeper Sarah Sheldon, an older woman, whom young Hawkeswood claimed had been cross with him on a number of occasions and he could not understand her attitude or behaviour. Such was Hawkeswood's unsupported imagination that he decided to teach her a lesson. Not just to play a childish prank upon her or a joke that would last for a few seconds, or even something that would be forgotten by the end of the day.

He decided instead it must be a trick with such serious and forever lasting consequences, hatched in a young mind, that she would learn a lesson and behave towards him in the future with more thought and courtesy.

He decided he would poison her. Not with something that would just make her sick and enable her to recover before the end of the day, but instead it would be with such a caustic preparation that it would be a lesson she would never forget.

He decided to use white mercury. There was no problem obtaining the innocent looking white powder because it was used on his father's farm to treat sheep scab. He was also aware he would not raise any alarm or concern because a local chemist supplied his father with the preparation, and he had been to buy some on previous occasions.

A Mr Coltman, who ran a drug store at Stourbridge, not too far from Hawkeswood's farm, told the judge, Baron Graham, during the young servant's murder trial at Stafford Assizes in December 1808, that on Monday, 23 November he came to his shop and asked for two ounces of mercury.

He said that Hawskeswood offered him two shillings and sixpence (25p) which was all he had. Mr Coltman said he was annoyed but because he had known the young man for many years he allowed him to go home for the extra money. Hawkeswood returned within a quarter of an hour, but in the meantime Mr Coltman mistakenly entered in his poisons' book that the mercury had been bought by Hawkewsood's father.

He described Mr Hawkeswood senior as a 'beast leech' who had bought mercury for a number of years. He used it to cure vermin in beasts, and for the 'quitter', a disease in horses.

And so, with half of his plan complete, Hawkeswood now had the highly potent and perilous drug which had the most terrifying and unbelievable effects on a human being. Pharmacists say it is no secret that mercury is a dangerous toxin, and when it accumulates in the human body can produce some of the most disastrous problems when it invades multiple organs.

All that is needed is half a gram of mercury – a self-contained package of destruction. Within a short space of time, the body is wracked with pain as the drug targets the liver, the immune system, the pituitary gland, vision, hearing and speech. It creates disturbed sensations, lack of co-ordination, feelings of itching and burning, swelling, the peeling off of dead skin in layers and hyper salivation.

The skin turns pink on the cheeks, fingertips and toes. Profuse sweating is induced, followed by high blood pressure and a faster than normal heartbeat. The kidneys are damaged and the mouth, gums and teeth are affected.

As the effects of the drug rapidly start to take over, the whole body and the immune system begins to lose control and collapses, and death soon follows – but in the case of Mr Parker, it tormented him for five agonising days in miserable, merciless pain before death eventually took over.

The allegations against Mrs Sheldon were a figment of an over-active imagination on the part of Hawkeswood. It was a habit of Mrs Sheldon to prepare regularly, and on a daily basis, a pot of camomile tea for Mr Parker. Hawkeswood had seen her carry out this daily ritual and place a white teapot on a ledge in the kitchen. Then she would go off for a short while. While she was away, he tipped a small amount of mercury into the tea, totally unaware that it would not be drunk by Mrs Sheldon. On the Wednesday morning after he was given his camomile tea, Mr Parker complained of feeling unwell and was sick.

He asked her what tea she had given him and he said he had been poisoned. Mrs Sheldon told the jury: 'I drank some of the tea which had no taste of camomile, and was very hot and brackish in my mouth and not like anything I had ever tasted before. It made me sick and I was not well for the rest of the day.'

By then Mr Parker became very ill and decided to take to his bed in the hope that he would soon recover. Hawkeswood arrived in the kitchen where the staff were talking about Mr Parker's condition, when he disclosed that he had drunk some of the camomile because he had a cold, and someone told him it would help ease his problems and make him feel better.

He told Mrs Sheldon he did not like the taste, so he went out and drank some water and threw it up. Mrs Sheldon said Hawkeswood never told her he had a cold. Mr Parker's condition worsened over the next two days and by the Friday, Hawkeswood had disappeared and was nowhere to be found. She said that Mr Parker and Hawkeswood never argued 'and he was received and treated like a friend.'

Sarah Dale said she was a neighbour to Hawkeswood, and when he came to her for some washing to be done she told him that Mr Parker was very ill. 'There had been some very ugly talk in the brew house and the women were saying that someone had put poison in the camomile tea,' she said.

'The prisoner said "yes" and that it put him in all of a tremble to think they should say so. He went again but came again and said that old Doctor Wainwright had called him into the parlour about the stuff in the tea and asked him if he knew brown hellebore. He said "no". He asked him if he knew white mercury and he said "yes" and that his father used it to dress sheep with.' (Hellebore is from the buttercup family and a drug is produced from its roots.)

Edward Higgins, a waggoner, who slept in the Parker house, said that on November 24, he was up at four in the morning to take some foul linen for the washerwoman who lived in the village. He put the linen down by the fireside and there was nothing else there. He left and returned about an hour later, and saw Hawkeswood by himself.

Hawkeswood must have hidden the teapot in Higgins' laundry and pushed it behind him, so that Mr Higgins could not see it and, as he did so, the pot rattled. What happened after that was not forthcoming in Higgins' evidence. But he did say that while he was out in the fields ploughing, Hawkeswood turned up and told him that Mr Parker was very ill after drinking some camomile tea. Higgins said he had seen the teapot 'many-a-time' but had never heard of any mercury being kept in the house.

The prosecution called a continuous stream of witnesses and eventually came to Dr Thomas Wainwright, a surgeon at Dudley several miles from the Parker household. The doctor told the jury he had been called to visit Mr Parker and arrived between mid-day and one o'clock. 'I went up to Mr Parker's bedroom and found him very ill. He had a weak, trembling pulse, cold extremities and his countenance very much bloated and he was evidently much exhausted,' he said.

'Mr Parker said he was well the day before and had had a good night. He said he had drunk some camomile tea and finding it uncommonly nauseous did not drink as much as usual. He said he had been taken with a violent pain in his stomach and

vomited, afterwards purging. I administered medicine to Mr Parker. He was sick and threw up blood which left him weak, but his sickness was less and he was better. I asked him what he had the day before and said he was poisoned and attributed it to the tea.'

Dr Wainwright said he tasted some of the tea and realised it contained a corrosive sublimate 'which was like that of copper but more pungent.' He said he went home and carried out an experiment with some of the liquid in a cup. The result was that half the camomile tea contained six to eight grams of mercury.

Dr Wainwright said: 'I considered that two grammes was enough to destroy life in an old man and four would be sufficient for the stoutest. A dose half a gramme was the usual quantity but it was now, as a medicine, little used. I had given two tablespoons of the mixture to a dog which quickly became sick and was in violent pain and convulsed. It was then I destroyed the dog but I had no doubt had I not killed it the dog would have died.'

Dr Wainwright said he opened up the dog's body and found the stomach and intestines 'dreadfully inflamed.'

He said he was called again to Mr Parker's house the following Saturday 'and found him in a dying state. I did not believe he would last the night out. He was in a state of extreme debility, his stomach was swelling and there was a decided symptom of death in the cases of poison and fluttering pulse. These are such effects as I should expect from the operation of the corrosive sublimate.

'I left Mr Parker in such a state as might be expected from the operation of the poison. His constitutional powers were yielding fast to its effects. I did not see him again until after his death.'

Mr Parker died the following morning, Sunday, November 29, 1808.

Dr Joseph Wainwright, a surgeon, and father of the previous witness, said he tasted the tea drunk by Mr Parker and 'I could pronounce instantly and absolutely on it being impregnated with corrosive sublimate.' He said he later spoke to Hawkeswood, who denied knowing there was any poison in the house but admitted he knew about mercury because it was used in cattle by his father, but not as corrosive sublimate.

Dr Wainwright told the jury that Hawkeswood admitted he had drunk half a spoonful of the camomile tea but found it very it very bitter. 'He told me the tea had made him sick and he vomited over a fold wall and that two threshers saw him. I immediately asked who the men were and he instantly denied that they had seen him. I was astonished that he should tell such a direct untruth because my son heard him likewise,' he said.

'He persevered in his denial of the words and when he was asked to show the place where he vomited but said it could not be seen because cattle had trampled upon it.' Mr Wainwright said the sublimate would cover the bitter taste of the tea. 'I tasted it but it had a nasty, brackish taste and left a great heat in my throat.'

Mr John Parker Wilson, who had received some land from his uncle and employed Hawkeswood, said he went to the accused man in the fold and found him 'all of a tremble' and asked him what 'fluttered' him. 'He said the doctors were more against him than any other members of the family. I told him not to doubt them for if he was innocent all the world would not hurt him,' he said.

'He asked if I thought the doctors would enquire at Stourbridge whether he bought any poison or not but I told him I could not help him. He said he thought the doctors could not tell whether it was poison or not in the tea pot and he would fetch another doctor to see but I advised him not and he agreed.'

Hawkeswood must have felt his guilt somewhat overwhelming because he disappeared from the area, and was found many days later near Bristol about 120 miles away in the southwest part of the country. It was here that ships, loaded with cargo, were leaving one of the busiest ports in Britain for all parts of the world, and it offered him a chance to get work, put his crime behind him, and try to make a new life for himself in another city where he was not known.

He had never been remanded in custody while the investigation into the death of Mr Parker was underway so he was free to leave, which he did, but how long he was away was never disclosed. His only way to get to the port was by coach and horses – a journey that must have taken at least a week.

This was corroborated by the last prosecution witness, Mark Guir, the sheriff's officer for Worcestershire. He did not tell the jury how he came to be on the trail of the runaway fugitive, but catch him he did, in the strangest of circumstances. But to go directly to Pill suggests Mr Guir must have received a tip-off.

He told the court that he had travelled to the port of Pill about eight or nine miles further southwest of the bustling city of Bristol and found Hawkeswood on a tender. 'He was dressed as a sailor but had his own shirt on. He came to the call of John Gilbert. We went to the mate's room and he was searched. He cried and confessed that his name was William Hawkeswood,' said the sheriff's officer. That was the extent of Guir's evidence.

He was the last of the major prosecution witnesses. Its evidence was completed and it was now the turn of the defence to present its case. Hawkeswood was not allowed to give evidence on his own behalf or on oath, because the legal system of the day argued he would be guilty of perjury if he was convicted. It was not until 1893 that the law was changed so that defendants could tell their own story on oath from the witness box without fear of committing an offence.

Instead, Hawkeswood handed over to his counsel some paper on which there was writing but the defendant said he was 'too much affected' to read it and it was accordingly read to the judge and jury. It turned out to be a confession. Considering he was only twenty and a servant and bailiff, Hawkeswood's skill at writing and its clarity was way above his station. He said:

'I will tell your lordship the whole truth. Mr Parker was a most kind and good friend to me. I understood that he had been my friend in having me employed by his nephew of taking care of the management of the farm for him, and scarcely a day passed that he did not show me some mark of his kindness or attention.

'I respected him most sincerely and nothing should have induced me to have done him any injury. My own, the best of fathers, was hardly more kind or affectionate to me than Mr Parker was.

'Mrs Sheldon, who had lived as housekeeper with Mr Parker for many years, had repeatedly been cross to me for what I thought little or no cause, and having seen her pour out something from the teapot, which was placed on a shelf over the dresser of drawers in the kitchen, and taste or drink some part of it and believing that the

tea or liquor was what she used to drink; and, having so bought the mercury for the cure of the scab in the sheep and having heard that a little could make anybody sick, I thought that I could play her a trick by putting a little of it into the pot expecting that it would make her vomit, which I declare most solemnly was the only object and motive I had for doing what I did; and as I solemnly declare that I had not the most distant idea of it doing her any serious or other injury.

'I have been informed it has been reported that Mr Wilson, the prosecutor, and others, were concerned with me an intent to kill Mr Parker. But I most solemnly declare that I never had intention to do any injury to Mr Parker and neither Mr Wilson nor any other persons whomsoever were engaged with me in anything that has been done; and I declare again most solemnly that what was done was done by myself alone and I had no other objects whatever in doing what I did, further than to plague the old woman a bit.'

Hawkeswood had access to mercury on his father's farm for use in animals and must have known that improper use of this dangerous medication could have had serious consequences particularly in a human being where death from an overdose was inevitable. To decide to 'play a trick', a prank or a practical joke so that Hawkeswood could get his own back on a member of staff, with such a perilous chemical, is difficult to comprehend.

However, the claims made by Hawkeswood in his handwritten confession statement did nothing to induce his barrister to call Mrs Sheldon and cross-examine her to find out what trouble or misunderstanding there may have been between them. But, several witnesses were called on his behalf, and they spoke of his 'good character, honesty, sobriety and humanity.'

In the days of the Hawkeswood trial, and for many decades after, evidence was introduced at a pace and hearings lasted hours rather than days or even weeks as is evident in many of today's high profile cases. It was a totally unfair system, loaded against the defendant, made even worse by the dazzling speed with which jurors discussed, or ignored, most of the evidence to reach a verdict.

A decision was normally reached in minutes, which was the clearest indication that they did not take even a respectable amount of time to consider the smallest part of the evidence and were seriously and improperly impeded by the judge, whose bias in favour of the prosecution and a conviction was blindingly obvious.

But it did not seem to matter and there was never any objection by defence counsel. I have covered trials where jurors took what may have appeared to be a rudely short amount of time to consider a verdict, and they managed twenty minutes, which included appointing a foreman or forewoman to take charge of their discussion.

Court documents from cases, as far back as Hawkeswood in 1808, have disappeared and the only record of the trial and what went on is that reported in the *Staffordshire Advertiser, Political, Agricultural and Commercial Gazette*.

At the start of his summing up Baron Graham wasted little time in telling the jury: 'I have the difficulty of conceiving the prisoner to be ignorant of the qualities of the drug from his having been so long accustomed to see it used. What could be his business with the drug? Had it been for the design of playing the housekeeper a trick the quantity used was too great to suppose him ignorant of its power.

'Would he not in that case have employed other means or have taken other opportunities to have put it in the housekeeper's tea? But there was nothing in their quarrel that could warrant such a revenge. If he were ignorant that the camomile was for the deceased so he must be ignorant that it was for the housekeeper.

'He pretended that he had drunk the tea and that it made him sick with a view to giving a certain colour to his ignorance of it. He said that two men saw him sick, and when he was asked what men, he denied he said that anybody did see him. On the contrary, the apparent case of any adequate motive to affect the death of the deceased threw a doubt of a malignity so desperate.

'The motives of human conduct are frequently difficult to conceive. He could not say what may have been lurking in his mind in respect of the death of the old man.'

The judge leaned forward from his high-backed seat on the bench above the well of the court, and told the jurors to consider their verdict. They went through the motion of discussing the evidence and quickly arrived at a guilty verdict with a caveat of mercy.

The barristers, court officials and people in the public gallery became silent as the black cap was put on the judge's head by his clerk in the large, high-ceilinged, grim-looking room with its dark wood panels. He passed the sentence of death and set in motion a clock that ticked off the last few days of young Hawkeswood's life.

The judge spoke of Hawkeswood's youth and the indulgence and kindness shown to him by the man he murdered. 'What could be the wicked impulse of your heart might remain a secret to everybody but himself,' said Baron Graham.

The judge said it was his 'severe and painful duty' to pronounce the sentence of the law namely that he be taken to a place from whence he came and being hanged. Within three days, Hawkeswood was hung in public outside Stafford Prison in front of a crowd of many hundreds, who gathered in the fields opposite to watch someone being despatched to eternity.

Observers said that Hawkeswood made no further confession. They said he had spoken with his father but refused to say anymore.

(Murder is a common law offence which derives from judges' decisions and is not an offence created in Parliament by statute. Common law has its basis in precedent which means that judges follow decisions made in similar cases down the years to create a consistent, just and fair system. To be guilty of murder, a defendant has to intend to kill or at least cause the victim grievous or serious bodily harm.)

Apart from Hawkeswood there were two other people in the county executed for poisoning, the most prominent being Dr William Palmer, of Rugeley near Stafford. He was convicted after a murder trial at the Old Bailey in London and was returned to Staffordshire to be hung outside Stafford Prison on 14 June, 1856, at the age of only thirty-one.

He led an extravagant lifestyle. His medical studies were constantly interrupted by allegations of theft, gambling and horses which led him into extreme debt problems. Several people connected to Dr Palmer died in his presence, including his mother-in-law and at least two other people to whom he owed money. In 1854, his wife, Ann, apparently died of cholera, after Palmer had taken out a £13,000 insurance policy on her life.

He also insured his brother Walter's life, but when he died shortly after the insurance company refused to pay out, Palmer was now heavily in debt and was being blackmailed by one of his lovers, the daughter of a Staffordshire policeman.

One of his horse racing friends, John Parsons Cook, won a large amount of money at Shrewsbury and he and Palmer held a celebration party before returning to Rugeley. The following day, Palmer invited Cook to dinner after which Cook became violently ill and died two days later. Palmer tried to bribe several people involved in the coroner's inquest. Later, it became known that Palmer bought some strychnine shortly before Cook's death. Four of five children born to Palmer's wife all died as babies, along with an illegitimate child following a relationship with his housemaid.

Palmer was arrested for Cook's murder and a special law was passed in Parliament for his trial to be held at the Old Bailey, because it was felt that it would not be possible to select a fair jury in Staffordshire.

When he was returned to Staffordshire, 30,000 people waited outside Stafford Prison to watch Palmer's execution. As he stepped on the gallows he is said to have looked at the trapdoor and asked: 'Are you sure it's safe?' After he was hanged his mother is supposed to have remarked: 'They have hanged my saintly Billy.'

Over the years, numerous books have been written about William Palmer, who became known as the Rugeley poisoner.

The only other person to be hanged in the county for poisoning her victim was forty-two-year-old Sarah Westwood. She used arsenic, and was executed on 13 January 1844.

DEATH OF BETTY SMITH

The ghost of Betty Selina Smith haunts the stillness. Its presence reaches out from the unknown and intrudes into the thoughts of those who wish to disturb events which happened long ago. The copse where silence hangs like a spectre has a chilling eeriness which is now and again disturbed by a few rabbits and pheasants as they scurry through the undergrowth.

Trees and bushes stand like silent witnesses and hide in their leaves and branches the secret of a warm summer night in 1953 when a young girl, happily playing with friends, was lured from their safety and savagely murdered.

The leaves whisper of the darkness that closed around her and of a killer who slowly strangled her with his tie and then threw her still alive, but barely conscious, down a deep airshaft into the quiet, damp secret darkness of a tunnelled section of the Shropshire Union Canal at Atcham on the edge of the medieval county town of Shropshire.

The shaft opening was made of bricks almost three feet high and topped off with large shaped blocks. The opening was one of several, around four feet in diameter, at regular intervals along a gently rounded roof which covered the canal with several layers of soil to complete the topping off.

Slowly, the killer dragged her body up a gently sloping embankment to the top of the tunnel and, struggling with her weight, managed to manhandle the dying girl to the top of the air shaft and pushed her down where she landed 20 feet below in the water.

Even today there is a strange sense of foreboding as one retraces the steps of twelve-year-old Betty Smith to the spot where she met her death. Deep in the heart of the copse, along well-trodden paths covered by years of a decaying undergrowth of leaves, one's senses take on a far greater awareness of an evil past.

It is not easy to try to imagine the terrifying fear and panic of a young child taken away from her parents and playmates as the shadow of death began to overpower her in its final embrace. Betty Smith lay unconscious in a narrow stream of running dirty water with rats scurrying nearby. Above her, light from the late evening summer sun shone down the darkened air shaft as she slowly died a lonely death.

Above left: Betty and her little sister Beryl.

Above right: Mrs Smith and Betty.

Betty Smith was the eldest of five children; her siblings were her brother Richard, aged eleven; ten-year-old Beryl; Jennifer, three and Patricia, just over a year old. They lived with their mother in an old squatters' hut once occupied by soldiers at the former Atcham army camp on the fringe of the 3,000 acre Attingham Park Estate, now owned by the National Trust.

Little Betty, an independent and apparently self-sufficient child of her time, was remembered vividly and with great sadness by one of her sisters as a mother figure and someone quite grown up in spite of her tender years. Even on the night she disappeared and was only hours from her death, she demonstrated her forceful independence and made it clear to another of her sisters that she wanted to be on her own as she decided to spend some time away from the family's poor, crowded home.

It was about 8.30 in the evening, towards the bright end of the day on 31 July, 1953, when Betty left the hutted encampment, originally built several years earlier for a large contingent of American servicemen who spent the wartime in the camp, not too many miles from Shrewsbury.

She skipped off down the road watched by her sister, Beryl, and disappeared in the distance. She was never seen alive again. It was expected that she would return home within a couple of hours, but as darkness began to fall and evening turned into late night there was no sign of the 'little mother' and the family began to worry.

With the hazards of the busy main A5 on the line of the Roman-built Watling Street leading to Shropshire's ancient county town of Shrewsbury, the fast-flowing River Tern and the Shropshire Union Canal all so near the camp, her mother, Dorothy, became frantic when her daughter did not return to home so late at night.

With a neighbour they searched as best they could in the darkness and throughout the night, but by the morning light when Betty had not reappeared, Mrs Smith decided it was time to seek help and she turned to the police with an emergency 999 call. What developed after the police arrived was the start of what was to become the biggest and most intensive search for a missing child ever investigated with such limited resources in the long history of Shropshire.

As the 999 call alerted the police that a child was missing, the county constabulary was hampered by the lack of personnel and communication abilities to launch a major search. In those days there were no local radio or television stations that would be able, within minutes, to rush out news bulletins to alert the local population that a little girl had disappeared.

Publicity, on a national or county-wide scale compared to the facilities available today, was virtually impossible and it was left to the local newspapers that appeared once a week or the evening *Express* and *Star* to seek the help of the public. The BBC radio and television authorities, for reasons that never became clear, refused to allow its facilities to be used so that the news could rapidly and regularly be transmitted into the homes of those limited number of people who owned TV sets.

However hampered the county constabulary was, there were still dozens of policemen, many of them giving up their time off, who were called to the area and inquiries were started by a team of senior policemen which included the county's deputy chief constable, Superintendent J. W. KcKiernan; Detective Superintendent L. S. Evans, head of the county Criminal Investigation Department and Detective Inspector G. F. Woolam.

As the investigation got underway the police followed the normal, laid down procedures for this type of case. They issued a full description of little Betty and details of the youngster were carried in the local *Wellington Journal* newspaper and displayed on special posters throughout the Midlands as the help of people was sought.

They were urged to be on the look out for a child between four feet seven and four feet eight inches tall, of good build with brown hair and eyes, a small nose and a fresh complexion. When last seen she was wearing a distinguishable red, lemon and black check dress that would have made her hard to Miss Her shoulder length, mousey-coloured hair was parted on the left side and in it she wore a blue slide. Her teeth were described as good but she bit her fingernails.

The police felt that with such a vivid description someone was sure to have seen her and would soon let them know. But by 23 July, police concern grew as their attempts to find the little girl failed and they now suspected that something frightening must have happened to the youngster. The hunt for Betty was stepped up.

New inquiries were made at Shrewsbury and Wellington and other larger towns around the former army base at Atcham. But still there was nothing from a rural public whose imagination had been stirred by the disappearance. Betty had never strayed before and detectives knew that she was a careful child, aware of strangers and the dangers they might pose. She was to some extent what nowadays would be called street-wise.

Three Shropshire police Alsatians and their handlers were called in to search among difficult places, and a Doberman pinscher from the neighbouring Cheshire police was brought in to reinforce the number of growing policemen on the ground. The skilled, highly trained dogs searched thick, tangled undergrowth and moved rapidly, easily and quietly through the thick summer vegetation in fields, local woods, the covered section of the Shropshire Union Canal and other places where a child might be hiding or trapped.

But policemen and other helpers were finding the going difficult as they used sticks to search the undergrowth. To make matters worse, deer in the park had broken down grass and shrubs which confused the dogs.

Detective Superintendent McKiernan used his years of experience to lead the search from a radio equipped police van – all that was available to him. He was still limited by the lack of equipment. In today's world search teams would be helped from the air by a force helicopter with heat-seeking equipment among its highly sophisticated on-board electronic state of the art computers.

For eight hours, during a warm July day, the search for little Betty was intensive as well as extensive and only ended for the day when the evening closed in and night took over. In the meantime, other policemen made a concentrated sweep of the hutted encampment knocking on countless doors speaking to parents and children. But no one was able to shed any light on Betty's disappearance.

Numerous old, damp, brick-built air-raid shelters provided for the safety of local people should a German bomber stray into the Shropshire sky, were carefully searched in the days that followed. Many disused buildings were systematically and repeatedly examined. Humus tanks, which contained a mass of black or brown partially decomposed plant or animal matter from local farms, were drained and carefully searched but Betty Smith had vanished without trace.

The banks of the nearby River Tern were minutely examined inch by inch and as the police hit a blank wall, without any clues coming to light, they eventually turned for help to Mr Harry Rogers, recognised at the time as one of the most skilled river boatmen in England. He was an expert at handling a coracle but to help the police he decided to use a punt to make his own search of the water between the Tern Bridge at Atcham and the Tern Weir. It was a thorough and demanding search but in spite of his skill it was fruitless and provided nothing that would help find the little girl.

As the search went into its third day it was extended to take in a much wider area of the 3,000 acre park and surrounding parkland. It was a decision that paid off. At 8.30 that evening and almost to the minute when she left home and was last seen by her sister three days earlier, saddened police officers found Betty Smith's body.

It was seen in a twisted, crumpled heap at the bottom of a 40-foot air shaft leading to a long, disused underground section of the Shropshire Union Canal

Mrs Dorothy Smith, Betty's mother.

between Berwick Wharf and Uffington, a little more than two miles from the home Betty shared with her family.

Again lacking facilities and equipment to bring her body to the surface, Detective Superintendent McKiernan sought the assistance of the Shropshire Fire Brigade. One of the firemen, who later became a senior officer, recalled taking part in the search for the child during the recovery operation in which dozens of pools, ponds, and streams were searched.

He asked to remain anonymous as a condition of disclosing the part he played in bringing little Betty's body back to the surface. 'I can remember the day we found the body as though it was yesterday,' he solemnly recalled. 'It was a warm day around the middle of July. Adjoining the shaft was a hayfield and the hay was about two or three feet high and in the immediate area of the shaft there were signs that a struggle had taken place.

'There was also a trail where somebody had walked. The top of the shaft was totally overgrown with brambles and grass. The only reason anybody went in that area that day was because we had pumped out a number of pools for the police. That's all we were doing when we found her – just looking for pools to pump dry.

'One of the lads helping found a coat folded by a few posts and strands of barbed wire fencing, around the top of the shaft. (The coat was later to play a vital part in the trial of the man subsequently charged and convicted of Betty's murder.)

'The fencing was partly broken down. The shaft was a typical brick air shaft and there was little or no water at the bottom, only piles of rubble. She could clearly be seen about 40 feet down. Everything was left as we found it and the police were called. People in the immediate area who been watching were ordered away.

'When the police came one of our lads went down the shaft wearing breathing equipment to make sure he was not affected by any gas that might have been down there. Then another fireman followed him down. Ropes were put round the girl's body and she was carefully hauled up. She was then wrapped in a canvas sheet. When she was brought up we looked at her but she was not really in a bad way. We did hear people say that an attempt had been made to strangle her although there was blood on her face. It was by pure chance that she was found.'

Once Betty's body had been brought to the surface she was laid to one side and the area was cordoned off so that any clues which may have been left would not be disturbed. The district coroner, Major R. W. B. Crawford Clarke, was hurriedly informed and he ordered a post-mortem.

A policewoman was called and burdened with the sad task of breaking the news to Betty's mother that her daughter had been found dead. In a state of shock, Mrs Smith was taken to a nearby mortuary where she tearfully identified her daughter's body.

Later that day, Desmond Donald Hooper, a twenty-seven-year-old gardener of Brown Ditch, Atcham, was charged with the murder of twelve-year-old Betty Smith, who lived only a few hundred yards from him on old army camp site.

When I started my lengthy research into the murder of Betty Smith I could only go so far with the help of newspaper cuttings, letters, interviews and a confidential police report. Court documents were no longer available and like many records into the case of the little girl – including those of the investigation by West Mercia Police – they were eventually destroyed because of the acute shortage of space into which they could be stored. Now police forces usually send their case records of investigation for destruction after twenty years.

I was left, therefore, with only one other important and unique source of help and information – people. They were people close to Betty; people who grew up with her; family and friends. Who better than a sister to disclose something about a youngster whose life was cut short and taken under such dreadful and violent circumstances.

I received letters from many people. The majority were kind and helpful and went out of their way to provide what they believed would be private and personal thoughts and memories and details of interest that would add important, missing parts in the life and death story of a tragic child.

Sadly, it is one of life's miserable facts that there are some among us who are opportunists and think they are able to help. But to impart that information so badly needed, they decide to impose a condition. They have something someone else needs and to disclose that sought after information there is a price. They are only prepared to give it in exchange for money. Two such people came forward. One was the wife of the man who was eventually hanged for the murder of Betty Smith. The other, most surprisingly was Betty's mother. They both offered to meet me and give

Above left: Betty with her father, Richard, who died in a motorcycle accident a year before Betty was kiled.

Above right: Mrs Smith with Betty standing, brother Richard and sister Beryl.

all the help I wanted but only if I was prepared to pay them for their information. Rightly or wrongly, I turned down their offers of help and that was the last I ever heard of them.

However, there were others who were freely prepared to give the help that was sought without the demand for blood money, but only if they were allowed to remain anonymous and their names kept out of the public domain.

There was one old lady pensioner from the Telford area, now long dead, who well remembered the shocking tragedy. In a poignant letter written with obvious sincerity and genuine sadness, she wrote: 'I am not at this moment prepared to say a lot as it is a thing that people at Atcham Camp will never forget. 'We were all questioned about this from morning to night until they found her murdered. It could tell you a lot more but it take (*sic*) too long and what do I gain from all this?

'I am only a pensioner living on my own and don't want to get involved with any trouble although I know living there I was in the middle of it all. Betty knew too much and that was the only way out. (A bizarre comment to make but the old lady never took it any further.) Sweet girl who had no life of her own – just a little

stay-at-home mother's help. There is a very long story to this but it is best to let this be enough now.' Whatever she was prepared not to give has long since gone with her to her grave.

Again the letter writer was not prepared to provide any further details on what may have only been titbits of gossip in such an enclosed community but she went on to say: 'My family and I lived at Atcham Camp for nine years and there are many families scattered around that could tell you the story re little Betty Smith. But guess like me don't want to say anything. You have to be very careful today. All I can say was life was very happy at the camp till this tragedy struck. Then that put the gloom on the whole village population every place around.'

Mrs Beryl Foreman, who, many years later remarried and became Mrs Beryl Williams, lived in a neatly furnished, end of terrace council house in Shropshire not too far away from the main A5 road leading to Shrewsbury. A few miles down the road are Atcham and the Attingham Park Estate which hold so many dreadful memories for this lady. A little further on and across one of the nearby fields is where her sister, Betty Smith, was murdered. It is a long time since 1953 when little Betty died and time has helped ease the sorrow that shattered the lives of a fatherless family.

But is spite of the passing years, Mrs Williams is able to recall clearly across the many decades to that summer night when she last saw her sister alive. She holds in her hand a tattered, fading photograph and with some sadness the memories flood back in a torrent to make the many years since her sister died seem only a moment ago in time. 'I can remember when she went missing and the night mother came into my bedroom and woke me up and asked if Betty had said she was going anywhere that evening. I wanted to go to Hooper's with Betty but she said: "You are not coming. You are not following me." I can just remember swinging on the gate outside where we were living and that was the last time I saw her. Hooper's house was only five minutes away. At the back was Attingham Park. She could have gone across a field to get to Hooper's house but she might have gone by road.

'Earlier that evening my mother came back with Hooper and asked whether Betty had come home. I did not realise how serious the situation was. My mother came back on her own about four in the morning but I could not swear to it. She said she could not find Betty and asked me if Betty said she was going somewhere else. The police were called about an hour later at 5 a.m. or 6 a.m.

'It was late the next day when a policewoman called and she asked me if I could tell them anything about Betty's friends but I can't remember what I said to her. There was a police search going on at the time and I think they found Betty on her birthday. I can remember a policeman coming for mother on the Thursday afternoon and she went to the Royal Shropshire Infirmary.

'Mother asked the policeman if Betty was dead and I can remember him saying he did not know anything. That's all I can remember. I was playing in the garden at the time. Then mother came home from the hospital and told me Betty was dead. They had found her and that was it. They kept shutting the children away all the time from hearing things and I was put with a neighbour. The police had been visiting the house and saying things they did not want us to hear. Then we went to Liverpool a couple of weeks after that.

'Betty was buried in St Lawrence Church, Ludlow. I can remember the funeral when they brought her. I try to go the cemetery once in a while. I have to dig my way through the overgrown grass and weeds to her grave. It's heartbreaking to see it. They buried her on top of dad. My dad was killed a year earlier at Atcham Bridge in a motorcycle accident. He didn't have a crash helmet on.

'There isn't a marker on the grave where Betty and dad are buried. It grieves me to go up to the church. There is not stone at all. All there is, is a hump. It's heartbreaking to see it. None of the family will rally round. It seems so wrong that she was put there. It's just overgrown with weeds. I wish she was buried nearer so I could look after her grave. When it's her birthday I try to get up there but it's difficult without a car.

'The day I went to the churchyard for the first time, the grave upset me. I still do remember her. I kept crying and wanted to go to the funeral but they would not let me but they let me make a posy of flowers. Betty was born in Ludlow and is buried in the churchyard overlooked by the house in which she was born.'

Mrs Williams described Desmond Hooper as a sulky looking person who was quiet and would not make conversation. 'He was a very shifty looking character and when he was arrested and sent for trial we were not allowed to know anything about it. My mother used to shove us to bed and not tell nobody about the trial. We never found out anything until the last day and we were told that he had been found guilty.

'Pat, that's my younger sister who lives in London, and I don't believe Hooper did it. She would like to drag it all up again. I have my suspicions it could have been him and someone else. I can't remember much about Betty but from what I can remember she was quite grown up for her years. She was like a little mother to us. When she went everything fell on me. Everything about the death of Betty and the trial was kept from me – by my mother in particular. I don't know why. I could not understand it. Everything she did tell me was lies. She had got something to hide.'

As the years have rolled by and the tragic, untimely and cruel death of little Betty Smith have become somewhat dimmer in the minds of those who knew her, Mrs Williams will be able to rapidly recall the trial at least – because she has kept newspaper reports of the hearing carefully looked after and protected inside a cardboard tube.

The public appetite and interest for information surrounding the murder of Betty Smith went on unabated for months as no-one could recall a child disappearing in Shropshire in recent history and being found murdered in such terrible circumstances. There were those who still wanted to know more and by the time the trial started and came to an end they would know all there was to know.

It gripped the attention of thousands around the Midlands and many other parts of the country, not only because of its sheer brutality, but for the fact that such a horrific thing could happen in an agricultural county renowned for its rural peace and quiet.

By the time the man accused of killing her was ready to stand his trial, most of the details surrounding the child's disappearance, the massive police search and the subsequent appearances of the defendant in the dock at the local magistrates' court and the lengthy preliminary hearing to decide whether there was a case to go before a jury, were reported at great length in the weekly *Shrewsbury Chronicle*.

THE TRIAL

It was the day before her thirteenth birthday that Betty Smith disappeared late on the night of 21 July, 1953. Four months later almost to the day on Monday, 23 November, Desmond Hooper took his place in the dock at the Shropshire Assizes in Shrewsbury, where the most serious cases on the criminal calendar were tried in front of a High Court judge.

The clerk of the court, looking imposing in his black gown and white wig, told Hooper to stand, and as the accused man rose from his chair two prison officers moved like shadows, one on either side of him, to ensure he did not make any sudden movement to try to escape from the dock.

The common law charge of murder was read out to Hooper which said that between July 21 and 22 1953 'you murdered Betty Selina Smith. How do you plead?' asked the clerk.

The small public gallery was crowded mostly with women who had waited for hours for the ancient court to open its doors so that they could get a seat to watch the proceedings. As Hooper stood in the dock they leaned forward and strained to see what this man accused of killing a child looked like.

In a quiet voice Hooper replied to the clerk's question: 'Not guilty, sir.'

Murder is a common law offence. That is a law which has come into being over hundreds of years through a set of rules and principles built up by judges and based on general custom. But the penalty for murder is statutory – that is a law passed by Parliament and the sentence at the time of Hooper's trial was death by hanging. The death sentence was abolished in 1965 by the Murder (Abolition of the Death Penalty) Act and life in prison became the sentence. Judges were allowed, in a letter to the Home Secretary, to privately state how long a person had to serve before being considered for parole and that meant the public had no idea of the final sentence in years. Nowadays a judge is allowed to disclose in open court a minimum sentence to be served before parole could be considered.

A panel of prospective jurors stood at the side of the court and from their number, by random choice, twelve would be selected to try Desmond Hooper. The clerk drew cards one by one from a box and, as each person selected answered to his or her name, they were directed to take their places in the jury box.

As the panel was completed the clerk asked each juror to rise and take the oath which was: 'I swear by Almighty God that I shall faithfully try the defendant and give a true verdict according to the evidence.'

Those who did not wish to take the oath on religious grounds were allowed to affirm and say: 'I do solemnly, sincerely declare and affirm that I shall faithfully try the defendant and give a true verdict according to the evidence.'

The jurors made themselves comfortable and the clerk told them Hooper had denied murder and it was up to them, having heard the evidence, whether he was guilty or not. And so they were ready – twelve people, complete strangers, brought together by chance to decide whether a man they knew only by name, was guilty or not guilty of the charge he faced.

The imposing figure of Mr Justice Cassels in his fine, red robes trimmed at the cuffs and down the front with white ermine, sat in his leather backed chair to survey

his domain and look down at those who were to play their respective roles in a legal system respected around the world. He acknowledged the jury and the array of prominent counsel before him and gave his consent for the trial to get underway.

The prosecution was led by Mr Edward Ryder Richardson, a King's Counsel and later Recorder of Walsall in the West Midlands not far from Britain's second city of Birmingham. He was assisted by Mr Peter Northcote, a prominent barrister who many years later became a judge to sit regularly at the Crown Courts in Shrewsbury and Stafford.

For the defence was Mr George Baker, also a King's Counsel. Many years later he gave up criminal law practice to become Sir George Baker, president of the Family Division of the High Court at the Royal Courts of Justice in The Strand, London. For the trial about to start he was assisted by junior counsel, Mr Paul Wrightson, who was later appointed King's Counsel.

To the judge's left sat the official court shorthand writer who would take a verbatim note of all the evidence. In clear, almost perfect shorthand, it would become a permanent, lasting record of the proceedings written in numerous notebooks. Millions of words – a total documentation of hours of evidence from witnesses, statements read, agreed evidence, speeches by prosecution and defence counsel, the judge's summing up, anything said in court that might be needed in case either side required a transcript of some part of the proceedings.

Mr Richardson stood up, adjusted his gown comfortably over his shoulders, moved his papers into their correct positions on the table in front of him for quick and easy access and introduced prosecution and defence counsel to the jury so they would know who represented who and then proceeded to outline the case for the Crown.

He made it clear that what he was telling them was not evidence; it was purely and simply a way of putting the prosecution story of what happened to Betty Selina Smith. Just to call witnesses at the start of the trial without telling them what had gone on would confuse them. As each witness was called, their evidence would fit into the jigsaw and so to help jurors follow the Crown's allegations.

Evidence was called in two other ways – statements which were read and were as important as evidence given from the witness box, and then agreed facts between the defence and prosecution which made it unnecessary to call witnesses.

Mr Richardson reminded the jury that Betty Smith had died on the night of July 21-22 and from the evidence it would be seen that her assailant held her down by some means then tightly tied a tie around her neck. That nearly killed her, he said, but her still-alive body was then thrown down an air shaft which led to a tunnel in disused part of the Shropshire Union Canal.

'It was right that the prosecution should say that there was no evidence of motive but it was necessary to prove a motive as there were many cases when the motive was known only to the person committing the offence,' he said, looking at jurors one by to make them feel he was talking particularly to them and creating that special rapport of relationship of understanding.

The case for the prosecution was that Betty was a friend of Hooper and went to his home about 9 p.m. on the night she died. 'Later she left the house with him wearing a jacket, sometime before midnight and went for a two mile walk with him

to the shaft and there, or near there he killed her,' continued Mr Ryder Richardson who, by now, had the jurors hanging on to his every word. 'On the lip of that air shaft was found a man's jacket.'

He said the jury might think it was an important piece of evidence as the prosecution believed Betty Smith was wearing it just before she was killed. But it was a decision for the jury. The prosecution planned to call forty witnesses whose combined evidence would help prove the case of murder against Desmond Hooper beyond any reasonable doubt and enable a conviction and send him to the gallows.

Then Mr Richardson set out prove how important the coat was to the case of Rex v. Hooper. Described throughout as exhibit seven, the history of the coat was outlined by several witnesses – the first of whom was Hooper's brother, Bernard. He told the court that the coat and a pair of trousers he had been to look at were similar to those which belonged to his father and which his father gave him when he came out of the army.

He spoke quietly and carefully and recalled an incident when he had an accident while riding his motorcycle. He said at the time he had been wearing what he described as a suit and it was damaged and so he sent it to the cleaner's to be cleaned and repaired.

Another of Hooper's brothers, Horace, followed Bernard into the witness box and he, too, identified the jacket and remembered it being damaged after his brother had the motorcycle accident. He recalled he took it to a tailor to be repaired then later sold it to Desmond, the defendant. However, in an earlier statement to the police, Horace Hooper became confused and said he could not swear that the coat was the actual coat he had taken to the tailor to be repaired.

In a further, more confusing, remark he said he could not say it was not the coat but he would rather say it was.

The next witness to give his evidence was George Herbert Lee, a tailor, who was shown the jacket, told the jurors that he was convinced the repair work to the coat was his. 'I definitely know that repair work is mine,' he told the jury.

One by one, other people took their places in the witness box to give their evidence and shed some light on what they saw or knew of the period over which young Betty met her tragic death. They added little or nothing to the jigsaw puzzle as they answered questions put by prosecution and defence counsel.

But by mid-day on the second day of the trial, a witness most people had been waiting to see was Mrs Dorothy Webb, Betty's mother, who re-married following the motorcycle death of her husband about eighteen months earlier.

People craned forward from the public gallery and others turned to look at a woman whose life had twice been hit by tragedy in such a short space of time. She walked slowly into the dark, drab courtroom and took her place in the witness box. An usher handed her a copy of the New Testament. 'Repeat after me,' said the usher and following his words Mrs Webb repeated in a quiet, hushed voice: 'I swear by Almighty God that the evidence I give shall be the truth, the whole truth and nothing but the truth.'

She handed the bible back to the usher and at the encouragement of Mr Richardson made herself comfortable for the ordeal about to confront her. She

tried not to look at Desmond Hooper in the dock near her but occasionally turned to glance in his direction. Mr Richardson encouraged her to keep her voice up and answer his questions clearly and direct her replies at the jurors, particularly those at the back of the jury box so they could all clearly hear her answers.

Mrs Webb told the court she had known Hooper for about two years and that Betty visited the home he shared with his wife not too far away, on two or three occasions, to find out whether he had repaired a bicycle she owned.

On the night she disappeared Mrs Webb said Betty had spent part of the evening visiting a 'social' being held nearby and returned home by about 8.30 p.m. She explained that shortly afterwards Betty went out again and she expected her to return within an hour but she fell asleep. Sometime later she woke up, but could not remember the time and realised her daughter had not returned.

Mrs Webb said she recalled that Betty told her she was going to visit Hooper. She went to Hooper's home but neither Betty nor Hooper was there. She stayed in the house talking to Mrs Hooper when about 1.40 a.m. she heard footsteps and a man's voice. Hooper came into the room. Mrs Webb said he was not wearing a tie and his shoes and trousers were very wet with what looked like grass seeds on them up to his knees.

'He was pale and his forehead was heavy with perspiration,' she told the jury. 'He seemed surprised to see me. His hands were trembling and he said he had no container in which to put pigeons.' This last comment took the jury by surprise but it was explained that throughout the police investigation after Hooper had been arrested and charged then committed for trial, he continually maintained that he had been to a friend's farm to collect pigeons.

Mrs Webb continued: 'He told me he did not know where Betty was and said the last time he saw her was about 10.30 that night when she went home after he had given her some books. The three of us then went out to search for Betty but after a while I said the police should be called. Hooper said he would call them but said he did not think it would be a good idea to say what time she had come home.

'I told him that if Betty had not returned home by eight that morning I would tell the police what time he returned and tell them the condition in which I had seen him. He said it would not make any difference as he had not seen her and her disappearance had nothing to do with him.' Mrs Webb completed her evidence and left the witness box.

Witness after witness was called to give evidence as the prosecution continued to build up its case and each one told the jury what they knew as, piece by piece, the jigsaw puzzle was being completed in the case against Desmond Hooper.

One of the main witnesses was Detective Superintendent L. S. Evans, one of the senior officers with Shropshire Police Criminal Investigation department. He told the jury he took a statement from Hooper after his arrest and again the defendant referred to his pigeons and how he decided to go to collect them on the night Betty disappeared. He said Hooper told him he had been thinking the whole day about collecting the birds.

Superintendent Evans said Hooper told him the twelve-year-old girl called at his home and told him she planned to go out that night to the local social event. After she collected some magazines he told her to go home. 'He said the last thing he

could remember was seeing her running towards the direction of her own home,' said the detective.

Slowly, the prosecution entered the final phase of its case and called one of its last witnesses – pathologist Professor J. M. Webster of the West Midlands Forensic Science Laboratory in Birmingham, who carried out a post-mortem examination of Betty.

He was taken through his highly scientific medical evidence carefully and was encouraged by Mr Richardson to explain in a language that could be easily understood by jurors what he did as he carried out his highly detailed external and internal examination of her body to scientifically decide how she died.

Professor Webster finally arrived at the cause of death and said a tie had been tied tightly around Betty's neck. There were slight bruises and grazing injuries to her face consistent with an assailant having used a hand to stifle her screams. He decided that death was due to strangulation and drowning, together with shock from multiple injuries, after being dropped head first from a great height.

Professor Webster told the jury there were many injuries to Betty including injuries to the region of her mouth and chin consistent with an assailant stifling the child's screams. He said there was also a mark on her arm 'consistent with a grasp of some strength. There was gross injuries made before death caused by the child dropping down the air shaft.

Death was caused by asphyxia due to strangulation and drowning together with shock due to multiple injuries from being dropped head first down the air shaft. She was alive when she hit the bottom and she was sufficiently alive long enough to inhale water. She had been dropped down this hole practically immediately after she had been partially asphyxiated due to strangulation.

'In my opinion there was a struggle close to the hole and I am quite certain she was unconscious when she was dropped down. In my opinion the child died later on the night of July 21 between 11 p.m. and midnight. There was also a bruise on her kidney due to a kick.'

You may recall it was estimated that Betty had fallen about 40 feet after she was thrown still alive into the airshaft above the covered section of the Shropshire Union Canal. Professor Webster said she had been partially strangled when she was put down the shaft and was probably unconscious but lived long enough to inhale water and die a terrible death in such a lonely place.

By Wednesday afternoon, two and a half days after the trial started, the prosecution ended its evidence and brought its case to a close.

It was now the turn of the defence to present its case and Mr George Baker, having spent weeks with his junior, Paul Wrightson, preparing a sound defence for Desmond Hooper, stood up and as Mr Justice Cassels nodded his approval the defendant was invited to go into the witness box.

Hooper was accompanied from the dock by one of the prison officers and made his way to the witness box to stand in a place where not too long before others had taken their turn to give evidence against him. It was now his turn to give his side of the story and convince jurors that he was not guilty of the murder of Betty Smith.

Again the clerk of the court stood up and told Hooper to take the New Testament in his hand and repeat after him: 'I swear by Almighty God that the evidence I give shall be the truth the whole truth and nothing but the truth.'

DEATH OF BETTY SMITH

George Baker carefully and skilfully took Hooper through his evidence, urging him to speak slowly and clearly and to ask for a question to be repeated if he did not understand. Hooper said that the day Betty disappeared he want to a public house at about 6.15 in the evening. He said he was not wearing a tie. After about two hours with friends he returned home then went to see a friend to borrow a pigeon basket.

By about 8.45 he said he saw Betty's mother and told her there were some books at his home for the little girl if she wanted to collect them. Betty arrived at his door a short while later and went into the house with his son, Keith. He said the three of them played dominoes for while and he put his son to bed by about 10.40 p.m and told Betty to go home.

14 May 1987

Dear Mrs Williams

I was so pleased to hear from you and I now have pleasure in forwarding the book.

Although it has been many years ago now I shall never forget the murder of Betty Selina Smith, your sister. We were all very upset when it happened and worked very hard to ensure that justice was done. I did virtually nothing else from July 1953 to January 1954.

Time is a great healer but you never forget the passing of a loved one.

I hope you will read all the book, but the special pages relating to Betty are 105-108.

Is you mother still alive? I met her of course during the investigation. If she is, please give her my regards.

I hope you enjoy the book.

Yours sincerely

Alan Morgan

He said he watched her as she made her way to her own home, then shortly afterwards left his wife a note telling her he had gone to collect some pigeons from a nearby farm. He said he crossed a road outside the squatters' camp, once owned by the army, and arrived at his destination farm around 11.40. He said he spent some time looking for his pigeons and when he could not find them after about one-and-a-half hours decided there was no point staying any longer.

Hooper said he left the farm and headed towards his home taking a short cut through a field in which tall grass was growing. He insisted he did not go anywhere near Berwick Wharf or the shaft. He admitted he owned a blue coat but not a pinstriped jacket like the prosecution exhibit seven, which had been found at the top of the shaft and shown to the jury earlier in the trial.

Hooper had little more to say. There weren't any witnesses for the defence and when its case had been completed Mr Baker sat down. Mr Richardson took his place to cross-examine Hooper for the prosecution. One after the other questions were put to the man accused of murder.

In an alien and unfamiliar place, like a court room where people in the public gallery come to listen in silence totally unaware of what to expect, they seem to have a fear of the unknown. Witnesses feel uncomfortable until they are put at ease and even those on the jury take their time to adjust to a job most of them have never done and will probably not do again.

So how do defendants feel when they face the might of the law, accused of the most serious offence on the criminal calendar? Most are quiet, a few do not seem

to bother about the situation in which they find themselves, while others try to brazen their way out. But they face the unknown. What type of questions will they be asked? How will they answer them? Will they feel tricked into a situation which they cannot handle?

Questions were asked that Hooper felt were putting him at ease. He was asked one or two questions about the pigeons he owned, then suddenly the questioning took a different turn.

'Were you fond of Betty?' – 'As children go, yes sir.'
'Were you anxious to see her that night?' – 'No sir.'
'Did you find Betty a kind girl?' – 'She was kind to children.'
'Kind to you?' 'Yes.'
'A modest girl.' – 'Yes.'
'An obedient girl.' – 'Yes.'

But he added he had, on occasions, seen her with other girls and men when she was not behaving modestly.

The questioning continued:

'Are you saying that you asked a girl of 12 who was not modest to look after your two children?' – 'Yes, she was modest as far as children went.'
'You know what I mean by a sexy girl?' – 'Yes.'
'A girl who would go off spooning in the dark and so on.' – 'Yes.'
'She was the type of girl to go off with men for the purpose of love making.' – 'That was the attitude I took.'
'A very dangerous type of girl to have in your house when your children were in bed and your wife was away.' – 'Not to me.'
'Why not?' – 'She always behaved herself in our house.'
'Why, when your children went to bed, did you not send her about her business?' – 'Well, I did not like to tell her to go.'
'You killed that girl that night after she rejected your advances, didn't you?' – 'No, sir, I didn't.'

There was little more telling questioning of Hooper by Mr Richardson. He completed his cross-examination and the judge gave permission for Hooper to return to the dock.

The last witness was Hooper's wife. She did not stay long to give her evidence. She told Mr Baker that she denied asking her husband about a missing jacket and told the court that the pinstripe jacket found at the top of the shaft did not belong to him.

The trial began to enter its final stages with Mr Richardson for the prosecution giving his closing speech and addressing the jury to emphasise the most important parts of his case. He leaned on his lectern, used during the trial to hold papers as he examined and cross-examined witnesses who took their turn to give evidence, to make himself comfortable for what could have been a lengthy closing address to the twelve jurors.

DEATH OF BETTY SMITH

He pointed out facts he thought were particularly important as he guided them carefully through the evidence they heard. This was his last chance to seek a conviction. Some points he said were more important than others but it was up to them to assess what they thought were the most salient, striking pieces of evidence. It was what they believed or accepted from the witnesses who gave their stories that counted at the end.

He said they had to look for someone who knew the girl and was, above all, liked and trusted by her; someone with whom Betty would have gone for a walk knowing that she was safe in the company of a family friend. But above all the jury would have to look carefully for someone with an alibi that was unsupported, uncorroborated and someone who knew the position of the air shaft above the canal.

He argued that if they discovered those traits in one man they would find it virtually impossible to come to any other conclusion that Desmond Hooper was guilty of the murder of Betty Smith.

Mr George Baker, Hooper's eminent King's Counsel, slowly rose from his seat to face the jury to present his final plea for a verdict that would save his client from the gallows and the hangman's noose. He said they had to be convinced that Desmond Hooper was the man; absolutely certain that he killed Betty Hooper; anything less than that and they must acquit. That, he said, was the law.

He insisted that the Crown's case had broken down and because of the lack of convincing evidence the jurors could not be satisfied beyond a reasonable doubt 'that this man is a brutal and callous murderer as was the man who murdered that girl that night. This is murder or nothing. The girl had been murdered with horrible brutality.'

It was then the turn of Mr Justice Cassels to review the evidence given by forty-nine witnesses during the five day trial and sum up the case and refresh the minds of the jurors. One by one over three and a half hours he reminded them what each witness had said on behalf of the prosecution and defence. He turned the pages of his large red notebook in which he had taken copious notes to pick out the evidence he thought was important. He impressed upon the jurors that they were the judges of the facts but he alone was the judge of the law.

If, during his summing up they did not agree with what he said, they were perfectly entitled to reject his observations. A decision had to be made on their impressions of the evidence presented. If they felt something the judge had missed out was important then they must consider it when they retired to the privacy of their jury room. Each juror might feel the strength of one piece of evidence was greater than another but by discussion and taking into account each others opinions they would eventually reach common ground and a verdict.

'How at the time of night, did Betty come to be at that air shaft unless she was taken there? She could not have got there by herself. A man's tie strangled her; a man's foot kicked her; a man's hands threw her down that shaft; a man's jacket was found there. Was it the defendant's?' asked the judge.

Mr Justice Cassels concluded his summing up and his clerk called two jury bailiffs forward to take their oath, promising that no-one would approach the jurors behind closed doors or talk to them unless it was to ask them whether they had reached their verdict.

81

By late afternoon of Friday, 27 November, the jury let it be known that they had come to a decision. The public gallery began to fill and prosecution and defence teams made their way into court from the barristers' robing room. Word was sent to the judge. Desmond Hooper was brought from the cells and when everyone was organised and seated there was a knock on the door leading to the judge's private room at the side of his bench.

'Court rise,' said the judge's clerk and Mr Justice Cassels hurriedly walked into court and seated himself in his large, dark brown leather chair. Everyone sat down and the court clerk turned to the jury and asked if the foreman would stand. One of the twelve rose.

'Mr Foreman,' said the clerk. 'Have you reached a verdict?' 'Yes,' replied the juror selected by his colleagues to speak for them. 'Do you find the defendant Desmond Hooper guilty or not guilty of the murder of Betty Hooper?'

In a firm, but quiet voice, the foreman replied: 'Guilty.' That damning word echoed around the courtroom. Hooper turned white and lowered his head. His counsel, George Baker, just looked at the jury and turned to his junior, Paul Wrightson, and said nothing. Edward Richardson and his junior, Peter Northcote, looked at each other and kept their delight to themselves.

The jury of ten men and two women had taken a little less than three hours to reach their verdict at the end of a five day trial.

There was only one sentence: death.

When asked by the judge if he had anything to say Hooper told him: 'I am not guilty of murder.'

Mr Justice Cassels sat impassively as his clerk placed a square black material – the black cap – on the judge's head. There was silence, and then Mr Justice Cassels pronounced the words that would soon end the life of Desmond Hooper. 'A jury has found you guilty of the crime of murder. Upon that night you committed a callous and brutal crime. For that the law provides but one punishment. It remains for me to pass upon you the awful sentence of the law which is that you be taken from this place to a prison and thence to a place of execution and there suffer death by hanging and that your body be buried in the precincts of the prison. And may the Lord have mercy on your soul.'

Hooper turned and smiled; he was held by the arms and taken from the dock to the cells beneath the court, before being driven in a van back to Shrewsbury Prison and placed in the condemned cell. Hooper was on his own to think of how and why he killed Betty Smith; to look forward to his last day on earth, a day yet to be decided.

Within hours of his conviction and the death sentence, Hooper's defence team of barristers and solicitors got together to draft an appeal notice to try to save Hooper from the gallows. His solicitor, Mr David Harris, said 'certain information' he described as important had come to light and would be presented to the Home Secretary.

On Monday, July 11, 1954, six weeks after he was sentenced to death, Hooper's appeal was heard in the Royal Courts of Justice in London, by the Lord Goddard, the Lord Chief Justice assisted by Mr Justice Park and Mr Justice Byrne.

Mr George Baker KC stood in front of this impressive tribunal of legal brains to present Hooper's appeal, with his main point being that the jury at his trial had not been properly directed by Mr Justice Cassels. The three judges listened intently

So convinced were the juror's of Hooper's guilt that they took just over an hour to find him guilty. Picture from the *Wellington Journal.*

but after a lengthy argument by Mr Baker they quickly rejected all that he had put before them. The last lifeline that could have saved Hooper from a one-way trip to meet his Maker was rejected unanimously.

Lord Goddard, renowned as a hard, no-nonsense member of the judiciary, described Mr Justice Cassels' summing up of the trial as 'impeccable and entirely satisfactory.'

He went on further to announce the appeal court's judgement and told Mr Baker: 'There is no ground upon which this court could interfere and any attempt to do so in such a case as this would be merely to usurp the functions of the jury and to substitute any opinion of this court would be to do that.'

But days later the case was to take a bizarre and unusual twist. A man, who became known only as Mr X, turned up out of the blue and disclosed to a surprised defence team that he had fresh evidence or at least a new lead which might provide a last straw to save Hooper's life.

Mr X claimed he was a distant relative of the condemned man and Mrs Hooper and had travelled from his home in Scotland in a last gasp attempt to have the case re-opened. A petition was organised by Hooper's wife with the execution date only days away and more than 900 people signed the plea to urge the Home Secretary of the day to step in and mercifully at least grant a reprieve to a sentence of life in jail.

Desmond Hooper could see that his chance of escaping the gallows was rapidly fading. He wrote to his wife from the condemned cell declaring his innocence. But by the time January came his last, desperate bid to be saved was rejected by the Home Secretary.

As the inevitable gradually became imminent Mr Harris approached the Home Secretary on 23 January, 1954, only three days before the execution, with his 'important' new evidence. Hooper's wife and friends clung desperately and hopefully to the possibility of a last-minute reprieve. Their 900-name petition was thrown out by the Home Secretary and the time moved relentlessly on for Hooper's appointment with the hangman.

Hooper was a doomed man in a hopeless situation and condemned to the gallows, but he still hoped for Divine intervention which was supported by a last letter written to his wife from the condemned cell. It said: 'Well, dearest, every day now is one step nearer my appeal and I am looking forward to it and by the grace of God I shall be back with you all again for God knows that I'm innocent. I've not long come back from the chapel.'

It was a cold day with snow falling heavily and the ancient, historic town took on a mantle of gloom and foreboding in anticipation of that final act of the law which would take a life for a life. It was time for Hooper to pay the penalty for his motiveless murder.

The previous day the official hangman, Albert Pierrepoint, a civil servant by any other name arrived at the Dana which housed Shrewsbury Prison and looked down on Pride Hill, the main street of the town. Pierrepoint wrote years later in his biography that he was sure he was sent into the world to become the hangman. He was a short man, neatly dressed with his trade mark trilby fitting carefully on his head.

Pierrepoint was precise and careful in his movements and absolutely meticulous in what he did to prepare his contraption of death. While Hooper waited his last hours in the condemned cell, Pierrepoint was busy constructing the gallows which had been a method of execution in the United Kingdom for centuries. He made ready the trapdoor that would open in a split second to launch Hooper into eternity. He tested it with weights so that nothing could go wrong to carry out the orders of the trial judge which rang and echoed in Hooper's ears: 'You will be taken to a place of execution and there on an appointed day you will be hanged by the neck until you are dead and may God have mercy on your soul.'

By 8.15 that morning Hooper was prepared for his last day on earth. He was escorted from the condemned cell by prison officers and the jail's chaplain. Slowly they walked towards the gallows and slowly climbed the steps where the noose was waiting.

The small procession waited for Pierrepoint to take over and Hooper was released into his care on a platform below the noose. He was placed on the trapdoor. The hangman carefully fitted the black hood over Hooper's head to shut out the light forever. The noose followed with its knot carefully fitting under Hooper's ear so that his neck would break that much quicker. His hands were tied behind his back and his ankles restrained by a rope.

Satisfied that everything was in order Pierrepoint moved quietly away. Silently he positioned himself to pull a lever that sprung the trapdoor in a movement perfected over the years.

Within seconds Hooper dropped silently into space, as the trapdoor at Pierrepoint's touch opened. Hooper was unable to cry out because death followed

so quickly. The doomed man's neck cracked quietly as it took the full weight of his body which jerked, twisted and writhed. Within seconds Desmond Hooper was dead. The due process of law was ritually carried out and little Betty Smith had been avenged.

Later, two notices were pinned to the green gates of the prison. One confirmed that the sentence had been carried out and the other was the certificate of a surgeon who confirmed that Hooper had died.

A formal inquest was held later that morning and on the instructions of the coroner, Major R. W. B. Crawford Clarke, a jury returned a verdict that Hooper had 'died by hanging and that his death had been justified.'

Two hours after his execution an inquest was opened by Major R. W. B. Crawford Clarke, the Shrewsbury and District coroner, in the prison governor's office. A jury of nine men was told they were entitled to see Hooper's body but they declined.

Detective Supt L. S. Evans, head of Shropshire CID, told the jurors that the death sentence was carried out and 'everything went smoothly.' Dr A. V. McKenzie, the prison doctor, said that Hooper was executed 'and this was expeditiously and efficiently carried out.' He said he examined the body immediately afterwards and found death was instantaneous due to dislocation of the cervical vertebrae as a result of 'judicial hanging.'

Death cast its shadow twice in a short space of time over the Smith family and laid claim to two lives, tragically depriving, in catastrophic circumstances, a father to four young children in a motorcycle accident; and in the space of a year, the family had to cope with the death of Betty Smith in an even more grotesque, unnatural turn of events at the hands of a close neighbour.

Wounds were reopened after they came to terms with the death of a husband and father. His death could, to some extent, be explained by a mistake he made as he was riding his motorcycle, or there may have been something on the road he tried to avoid or possibly a problem with the surface.

But the death of Betty Smith has remained a deep mystery for many, many decades and will bring no answers to those left behind as they advance slowly towards their graves.

There was no motive. Detectives, with their limited resources and expertise in interviewing and questioning a suspect, can in no way be compared to the scientific and medical availabilities which help accomplish so much in today's investigations of crimes.

There was no suggestion that Desmond Hooper was a paedophile with an unhealthy sexual desire for a child of Betty's age. She had never complained to her mother that the father of two had ever 'tried anything on' and when the pathologist carried out a full autopsy he made it unequivocally clear from his findings that Betty had not been the victim of any sexual attack. However, her mother decided for reasons never made clear, that her daughter had been raped.

Whether Hooper made sexual advances towards Betty was pure speculation and open to conjecture, theories and nothing more than uninformed guesswork. It was never considered by experts at the time. Betty died a slow, lonely death in a place with only rats as companions. But why she was murdered will always remain an unanswered mystery.

HANGED FOR YOUNG GIRL'S MURDER

APART from police officers and newspaper reporters and photographers, only one man stood outside Shrewsbury prison at 8 a.m. on Tuesday, the time when Desmond Donald Hooper, 28-year-old gardener, of Atcham Camp, near Shrewsbury, was being executed for the murder of 12-year-old Betty Selina Smith, also of Atcham Camp. It was still snowing heavily and there was a heavy fall of snow on the ground.

At nearly 8.15 a.m., when prison officials came out to hang on the outside of the prison doors two notices, only 12 people—six men and six women—were gathered outside the prison, and these were people on their way to work.

The one notice, stating that execution of the death sentence had been duly carried out, was signed by the Under Sheriff (Mr. M. Peele), the prison governor (Commander S. W. Lushington, R.N. (ret.) and the prison chaplain (Preb. A. H. Bird). The other notice, certifying death, was signed by the prison doctor, Dr. A. V. Mackenzie.

Two hours after the execution an inquest was conducted by the Shrewsbury and district coroner, Major R. W. B. Crawford Clarke, in the governor's office. The coroner sat with a jury of nine men of whom Mr. George Davies was foreman. When the coroner explained that he must see the body and told them that they were entitled to see it if they so wished, the jury said they did not wish to see the body.

Det.-Supt. L. S. Evans, chief of the Shropshire C.I.D., gave evidence of identification and the prison governor said that sentence was duly carried out that morning and "everything went smoothly."

[left column fragments]
were by the hon.
nes, who was, how-
present.
luded with a general

LS COURT
BEHAVE
SELF

D girl appeared at juvenile court on being a young per- and protection. the girl in a state- associating with

irl said she would ature and would not

[right column fragments]
THE wedding took plac
Church, Shrewsbury,
of Miss Barbara Jane W
daughter of Mr. and
Wycherley, 2. Longmynd
hall Street, Shrewsbury,
Bradbury, youngest son o
A. S. Bradbury, Woodbou
The vicar, Rev. L. A.
ciated.
Given away by her fa
wore a white gown of la

Hooper's death reported in the *Wellington Journal*.

A SISTER REMEMBERS

Time has moved inexorably, stopping for nothing and heading into the unknown across more than half a century, from the hot summer days of July 1953 to a day in February 2009 where memories are recalled in a split second, fresh and clear as the day they were laid down.

Beryl Williams is a slender lady with neatly combed short hair and rimless glasses on a face that defies time. She remembers everything that happened to her family with a revealing clarity and keeps photographs and newspaper cuttings, not only as a sad reminder but as a fading, permanent record which devastated and destroyed a family already mourning the death of a father in a road accident a year earlier. But her life is full of deep scars from two deaths, and a mother who could not or did not want to care.

There's a certain amount of tiredness in Beryl Williams' voice as she recalls events which played a major part in shaping and forming her early life. Tragedy for Beryl

manifested itself quickly and suddenly, with one misfortune following rapidly and shockingly on another. For one so young to have to cope with the catastrophic death of a father was one thing, but in a state of shallow mourning, a dreadful life-changing disaster made its second appearance when her mother-figure sister died in circumstances so appalling it is a wonder she managed to cope; and this at a time when her family life was beginning slowly to recover from her father's death.

As she sits upright in her chair in her comfortable home in Wellington, with a specially restored picture of Betty, her mother and herself, almost in pride of place on the right hand side of a mantle-shelf, Beryl recalls with amazing clarity those early, tragic years of her life. 'From what I can remember she was a good child. I don't think she was any trouble to mother other than going to Hooper's house. I can't remember her being a cheeky girl. She was a little mother especially after dad died.

'I can remember her when they came to tell me that dad had died on that Sunday afternoon on the A5 stone bridge. A neighbour came to the door about three o'clock in the afternoon and mum was out with my other sister Pat, who lives in London. Betty came home and the neighbour said: "Your dad's dead, Bet". And she literally run up that camp screaming and crying, she did. We had to go and fetch her back. She was absolutely hysterical. I can remember that. She was so close to dad because she was the first born. My other sisters don't talk about it because they don't remember Betty. My mother was never close to any of them not just me.'

Betty's bruised and battered body was recovered from the shallow, cold water in the damp darkness of the Shropshire Union Canal on the Thursday, only a couple of days after she disappeared. But the first time Beryl knew that anything had happened to her older sister was the following Sunday, in one of the most unlikely of places imaginable. 'I first found out she died when I was at a Catholic church on the Sunday,' recalled Beryl, still saddened by what happened all those years ago.

'When Betty died we were all put with other people. We were all shipped out and looked after by other people. My mum could not look after us because she was in such a state after them finding Betty dead, see, and I suppose people rallied round to look after all the children and took them off all round the place.

'When I was in church and heard Betty had died it upset me terrible. It was only when the priest said he wanted to say a prayer for the little girl who died that I realised he was talking about Betty. I was shocked and broke down crying and they took me out and I can remember they took me out into this little room at the back, they did. Yes, I can remember that. It was an awful shock to me. To this day you think why didn't they tell me? I mean they tell children now when these things happen. I think it was wrong of them not to tell me.

'I can remember after Betty was killed and he (Hooper) was charged the children had to stay with teachers. That is the only thing I can remember happening. I remember we had to stay with an auntie in Liverpool while the trial was going on. I didn't even go to her funeral but I can remember sitting and making posies. Why did he do it? Why do any of them do it, I ask myself these days.

'My mum was never the same and we had lost dad a year earlier. Well, I don't think the family was ever the same again, actually. You know, when I hear people talk about Sarah Payne it wrecks the family. It is something you never get out of your system for the rest of your life. You never forget it. I think about it very often.

Betty's sister, Mrs Beryl Williams.

'Mum should have been a rock to us children after Betty died but she wasn't. She wasn't there for us. After dad died and Betty went it fell on me then and she locked me in the house at night looking after the children so that she could go out. She said to me: "Don't open the door" and she wouldn't come home until two or three o'clock in the morning. I can remember the morning she walked out on us. Never heard from her again for seven years. I never had a Christmas card or a birthday card. She should have been a rock to us and kept us together.

'Her father was a doctor and he washed his hands of her at the court case because he thought she was pregnant again. He never spoke to her again after that. It was years after when I had come back to her she wrote to Liverpool to her father. A neighbour wrote back to her and said her dad had been dead eighteen months. She said he caught a germ or something at the hospital and it killed him.

'I think to myself if dad hadn't died and if Betty hadn't died things might have been different but 'if' is the biggest word in the world. Would my life have been any better? Because it has not been easy, my life. The easiest part of my life I've had is since I have been with him.' (Mrs Williams' husband, Peter, of twenty-five years, who sits in an armchair nearby, listening to his wife.)

'My mum hated Hooper. Hated him. She said he was a shifty character and all this, you know. She used to say: "I don't like you going up there playing. I don't like him. I don't like her either (Hooper's wife)". She was a horrible woman, she was. Awful woman, she was. Awful woman. My mum might have told some lies in her time but I think one thing she did not lie about was him. She did not like that man. She loathed him. I don't think I ever remember him coming into the house. He used to come to the gate and shout: "Betty".

'What was his interest in Betty? Just to play with his children. She used to go up there (to Hooper's house) playing cards and games and things like that. My mum did not think there was anything wrong with that. You have to understand that in those days there was nothing wrong like that. I can remember my mum grumbling at her. She was always grumbling for Betty going up there.'

Life for the 300 families, who lived in comfortable accommodation and rural surroundings at Atcham Camp, was based in a small, safe environment. It was built on the sprawling Attingham Park, specifically to house American forces during the Second World War. It was a place where parents and their children became friends with many others in the same situation. There was a village-like atmosphere with places for children to play in the nearby fields and among the houses. They were out of harm's way. Safe, protected and secure, without a care in the world, happy in the knowledge that they played as children, with no-one to frighten or scare them.

'What was my life like at Atcham?' asks Beryl. 'When we were living here at Wellington we lived in a two-up and two-down and a toilet up in the garden. There was no running water, not nothing in it and that's why mother said after the war when there was no houses to be had they started moving into those places at Atcham. The mod cons we had in them was wonderful. We had hot water and everything. They had wonderful linoleum floors. We had lovely hot baths and everything which we'd never had.

'We lived in about five places when we were on there, we did. There were loads of families there and they established a school, they did. In the end we were accused of being squatters but we were paying rent in the latter days because they were coming in and doing things and laying things on for us. It was a better life than we had in Wellington.

'My mum married again briefly to someone else she did and we had another brother but it did not last long. She upped and went then and went to live at Madeley. She took up with a miner there and had six other children from her marriages.

'She always said there was someone else involved in Betty's death. She didn't think Hooper did it on his own. Betty's death devastated the whole family. My brother is the worst really about it because he is brain damaged that one. It happened at birth. He is a year older than me. He really dwells on it. Even though he is backward he can still remember Betty.

'Mother did nothing for him really when dad died. She put him in a home. When dad was alive and he was backward they wanted to take him into a home and dad would not have it. I do remember that. He said: "No lad of mine of mine is going in no home. There's nothing wrong with him. He'll be brought up with the rest of us". But as soon as dad died she put him in this home, she did. From that day on

she rejected him and he never lived with her again. If dad had not died in that road accident I think our lives would have been better than it has been.

'Now that fifty-six years have passed what do I think? There isn't a lot, really. I wish life would have been better, obviously I do. I am almost sure that things would not have been as sad as they have been. When I was growing up and before I left school I literally felt nobody wanted me. For years I did. My other sisters don't talk about Betty because they don't remember her. My mother was never close to any of them, not just me.

'I haven't been to Ludlow where my dad and Betty are buried. Not for years. I'd have a job to find it to be honest. The last time I went there was when granny was alive. I haven't been since to Betty's grave. I said to him (her husband, Peter) I ought to go but I'd have difficulty finding it after all these years. They are buried together, Betty and dad.

'I've heard of paedophiles and I am never going to rule out the fact that it was in his head, or even that night he did try something on with her and she resisted. Was he after children? I wouldn't rule it out. To this day, if there was any truth in it I'd be terribly shocked. This is it, yes. It's something you'll never know.'

In spite of being a kindly, gentle person Beryl Williams believes in the ultimate penalty for those convicted of killing – death. 'Nobody agrees with them more than me. When they ask for this hanging to come back there is nobody who agrees with them more than me. I would hate to think that man would come out free again today after what he did to our family.'

CHEATING THE HANGMAN

It was a rare event for someone sentenced to death in Staffordshire during the eighteenth and nineteenth centuries to fail to keep his appointment in public with the hangman. So rare, in fact, that over a period of almost 200 years between 17 August, 1793, and 10 March 1914, 128 criminals faced capital punishment and only one cheated the executioner – and he was just fifteen years old, a boy named Charles Shaw.

However, the youngest person ever to hang in the county was Charles Powys, aged nineteen, who died with his nineteen-year-old partner-in-crime on the gallows on 25 January, 1845, outside the prison in Stafford for the ultimate crime of murder. The oldest person who died at the end of a rope was sixty-six-year-old John Bowyer convicted of sheep stealing, but that did not compare with the sixty-year-old whose life was taken from him because he was convicted of bestiality.

At fifteen years of age, Charles Shaw killed because he wanted money. The desire to kill and the need to kill was not something he mulled over for days or weeks. It was simply a spur of the moment decision to take away someone's life and help himself to his wages. So he strangled his victim with a piece of cord and left him breathing his last breath on this earth in a ditch near the Macaroni Bridge at Etruria, a part of the potteries city of Stoke-on-Trent, during the early evening of 3 August, 1833.

Shaw and John Holdcroft worked together in a pottery factory at Burslem. They were paid late on the Saturday afternoon of 3 August, but Shaw only received 4p for his week's work because most of the money he earned was used to buy various articles he needed. Young Holdcroft was due to receive nine-and-half pence but because he was a 'good lad' his employer decided to pay him an extra one-and-half pence as a form of bonus. Shaw saw the transaction. He was hard up and decided the money had to be his and devised a plan to kill young Holdcroft. The victim was a skinny young boy, scruffy and not very tall but the outstanding thing about him was his age – he was only nine years old.

After they were paid the two of them walked along the banks of the Trent and Mersey Canal and were seen by a young swimmer who invited them to join him

in the murky water, but Shaw made excuses. For a short while, they engaged in youthful conversation with the young stranger, before Shaw and his young companion decided it was time to go and they walked off.

Then, in the quietness of the late, bright and warm summer evening and away from prying eyes, Shaw killed the lad. It was that simple. But the youngster was no match for the older boy; he tried to fight him off but he was overwhelmed by his greater strength. Shaw began to wear down Holdcroft and, as the boy's struggles grew weaker, he took a white cord from his trousers pocket. Quickly he double wound it around the boy's neck. He sat astride the youngsters and gradually tightened the cord and began to strangle and squeeze the life out of his struggling victim until it began to bite into his neck. Holdcroft tried to put his fingers under the cord as he weakly struggled to retain consciousness and fight for the life-giving oxygen. Slowly, as he gave up his struggle for life, he began to grow weaker and within moments he breathed a sigh and died.

As the long, warm day began to draw to a close and the chill of the early evening and the onset of darkness took over, the cold body of little John Holdcroft lay face down in the ditch where he was left by Shaw. His frantic parents, with whom he lived at nearby Burslem, searched with growing fear for their son. They made enquiries among the people where he worked but no-one had seen young John from the time he finished work at six o'clock that evening, ready to go home after he was paid. His friends could not help the anxious parents and Shaw, who was later charged with his murder, was twice spoken to but denied he had ever seen the boy.

The night came and went and dawn broke but still there was no sign of John Holdcroft until about ten or eleven o'clock the following day, a Sunday, when Thomas Davies of Shelton found John's body in a ditch while he was searching for wasps' nests. The following day he told the coroner during an inquest at the Etruria Inn: 'I was in search of a wasp's nest in a field adjoining the towing path of the canal, when I saw the body of a boy lying in a ditch. He was lying with his face downwards which was covered with water.'

Mr James Rankine, a surgeon who carried out a post-mortem, told the inquest that the boy had been dead for about forty-eight hours. He said a cord was tied twice, 'tightly and firmly' around his neck.

When the boy's body was discovered, the *Staffordshire Advertiser* newspaper reported: 'A very great sensation was produced in the Potteries on Sunday morning by a report that the dead body of a boy had been found in a ditch near Etruria with a cord tied tightly around with which it appeared he had been cruelly put to death.

'There is every reason to suppose that the poor fellow's life has been sacrificed for the trivial sum of 1s 6d, the amount paid to him as wages before he left the works, for on discovery of the body no money was found about it, and it is difficult to conceive any other cause than to gain possession of that trifling amount that could have led to the commission of the barbarous deed.'

Shaw was twice questioned about the disappearance and death of John Holdcroft while his parents searched for their son, but he remained silent. However, one workman colleague told inquest jurors that he saw Shaw with the boy shortly before he died as they walked towards the small township of Cobridge and the Trent and Mersey Canal.

He was a thief and a liar and consistently maintained he had nothing to do with the death of John Holdcroft. He blamed a man he had not long met for the killing and later told a policeman and his solicitor that the same man confessed to him that he had murdered another person in his home county of Yorkshire. He was obviously short of money after a week's work and Jason Turner, who employed Shaw and Holdcroft, told the coroner why.

Shaw was due to receive 3s and 10d (almost 40p in today's money) but from that he had to keep 2s 6d (about 15p) to pay for a hat and 1s (5p) to a person to whom he owed money. That left Shaw with only 4d (about 5p). Shaw saw that young Holdcroft was paid 1s 6d (15p). He also confirmed he saw Shaw with a piece of cord similar to that which had been tied around Holdcroft's neck.

Shaw continued to lie, particularly on the evening shortly after he had killed John Holdcroft, when he was seen buying bread, cheese tea and sugar. Asked where he got the money he claimed it was given to him by a relative who later told the police that he had never given Shaw any cash. Other statements made by Shaw also indicated that he was being untruthful.

The coroner's jury was so convinced that Shaw was continually lying that within moments of the evidence being completed a verdict of wilful murder was returned against the fifteen-year-old and he was committed to stand trial at the next session of the county assizes. The *Staffordshire Advertiser* noted: 'The prisoner both before and after his commitment manifested the greatest unconcern and was not in the least moved by the result of the investigation.'

A few months later at the spring assizes, Shaw was taken before Mr Justice Patteson to be arraigned. His demeanour clearly indicated he could not care less at his situation, something that is all too apparent in many of today's murder trials. In words which rarely or ever appear in modern-day reports of hearings, the *Advertiser* reporter wrote: 'The prisoner, whose expression of countenance was by no means sanguinary, appeared at the bar without manifesting either timidity or dread and pleaded not guilty to the charge.'

Mr G. Phillips QC, who presented to prosecution's case to the jury, spoke loudly and clearly so that those packed into the public gallery would hear everything he had to say, began to outline the evidence which he said would, without a doubt, lead to the conviction of Charles Shaw. He made it clear he wanted the jurors to give him the utmost attention and listen carefully and thoughtfully to the evidence he would call, which he believed would ultimately lead to a verdict that Holdcroft had 'come to his death by the hands of the prisoner.' He told how the two had been paid their weekly wages and how Shaw noticed the amount of money young Holdcroft was paid. 'The only assignable motive of the prisoner for the commission of the offence was the acquisition of 18 pence which the deceased possessed.'

He went on: 'In a few minutes after they were paid the deceased and the prisoner went away together towards Etruria racecourse. On their way they passed a boy named Robinson who was bathing in the canal (the Trent and Mersey). He saw the prisoner dangling a piece of cord and when afterwards the prisoner was reminded by Robinson that such was the case, he denied that he had any cord at all.

'The prisoner and deceased after some little rough play with Robinson, then went in the direction of the Macaroni Bridge and they were seen playing with some

copper money on a bank it then being half-past 8 o'clock in the evening. They were seen again at nine o'clock and the prisoner was going first at a good pace and the deceased, who was the smaller boy, trotting after to keep up with his taller companion.'

Mr Phillips said when Holdcroft's parents started to look for him they went to Shaw's house and he told them he had left their son, who you may recall was only nine-years-old, in the company of gamblers at the local racecourse. It was then that the man out looking for wasps' nests found, concealed under some willows, the body of the little boy with the white cord round his neck. Under the cord and next to his neck was some long grass from a nearby field in which a footmark was found that matched the sole pattern of a boot being worn by Shaw. Small spots of blood were found on Shaw's shirt which he claimed was caused by a nose bleed. The story that eventually followed was so far-fetched and totally fabricated that it knocked down the slightest defence Shaw might have had.

'Mr Phillips continued: 'At first he said he knew nothing of the deceased's death; but afterwards he said that a man overtook the deceased and himself on the canal side and said the man insisted on the deceased going with him and drove him (the prisoner) away with a stick; and, on being further pressed, he said the man's name was Baggaley, and that this man Baggaley, whom he had known in Yorkshire, had murdered his own child and buried it in the road; and the prisoner further stated that this was at seven o'clock and that in about twenty minutes after, Baggaley overtook him and said he was 18 pence the richer.

'The prisoner said that, observing blood on Baggaley's trousers, he asked him how it came there, and Baggaley said he had murdered the boy, but threatened to kill the prisoner if he said anything about it and besides that gave him half-a-crown (12-and-a-half new pence).'

Mr Phillips said he would show 'most satisfactorily' that Baggaley could not have been near the spot by the prisoner and that Shaw's 'tale was a wicked fabrication respecting Baggaley from beginning to end.'

Mr Rankine, the surgeon who carried out a post-mortem on John Holdcroft, was called to give his evidence to the jury, and said that the cord around the youngster's neck had been tightly knotted. He said the nine-year-old's face was bloated and swollen from immersion in the ditch water. 'The eyes enlarged and slightly prominent and bloodshot; the lips were a dark purple colour, approaching black. The tongue protruded through his teeth and was firmly held by them,' said Mr Rankine.

John Holdcroft's mother, Elizabeth, was the next to be called to give moving evidence and wept for a short time before becoming composed enough to answer Mr Phillips' questions. She said that about two in the morning of 4 August, several hours after her son's body was recovered, she went to Sneyd Green in another part of Stoke to the house of Shaw's grandfather where the accused man was staying. 'I did not see the prisoner, he was above stairs. I was answered by his voice from above and he told me he had last seen my boy between six and seven o'clock and that he went from Hanley to Burslem with a gambler,' she said.

Mrs Holdcroft said she left the house but returned several hours later to again try to confront Shaw about the death of her son. 'I asked him again where he had left my Jack

and he said with a man by the towing path,' she said. 'He told me my boy was tossing up a penny and a man came up and said: "Heads a penny, my boy." He said my son told him: "No, it's my wages. I must go home with them or my mother will be cross".

'I asked him if he knew the man's name and he said no. He described his dress saying that he had a blue coat, fustian trousers, a light striped waistcoat and white apron. He said he came from towards Stoke. My boy was not addicted to keeping company with gamblers. He was a good boy.'

Two other witnesses followed young Holdcroft's mother into the witness box and both told the jury that Shaw had confessed to them that he had killed the boy.

A young Irish lad, Thomas O'Neill, who had been committed to Stafford Prison as a vagrant, caused a great commotion of interest when called to give evidence in which the confession was made. The defence objected because of its hearsay value. But Mr Justice Patteson threw out the objection ruled in his judgment that O'Neill's evidence must be given and the 'jury would attach that weight to it which they judge it deserved.' Some prisoners believed that if they gave evidence for the prosecution after listening to what another prisoner told them about their crimes, then they might have reduced whatever sentence they were likely to receive.

O'Neill told the jury: 'I have had some conversation with Charles Shaw about this murder. I asked him if he would tell me anything about it. Shaw said if I would make an oath not to tell he would tell me all about it. I said I would and that "I hoped God would strike me dead if I ever told it again."' At this statement the *Staffordshire Advertiser* reporter who covered the trial said a 'shudder of horror appeared to run through the court on the witness making the statement.'

O'Neill continued: 'Shaw said the first thing it began about was a halfpenny. Little Holdcroft wanted to have it again but Shaw would not give it him. Shaw then laid on him and kicked over the temples. He then left him a bit and went to him again and laid on him again. I said they say there was a cord round his neck and Shaw said: "I put none round".'

Charles Adams, another boy who had been a prisoner in Stafford Gaol but acquitted after a trial, said he knew Shaw and spoke to him about the murder of John Holdcroft. 'I said: "Charles Shaw is that you that killed the little boy at Burslem?" and he said: "No." I asked him again and he said: "If you will go upon your oath I will tell you" so I went upon my oath and he told me.

'He said he won Holdcroft's wages off him and Holdcroft wanted him to give threepence back, and he gave it to him, and won it again. Holdcroft then asked for threepence more and he would not give it him; and little Holdcroft then began fighting at him.

'Shaw then knocked Holdcroft down with his head against a stump and kicked his head. Holdcroft then got up and Shaw knocked him down again then he tied a string round his neck and dragged him into the ditch. I asked him how he came to kill the lad for that little money and he said Holdcroft began fighting him first.'

When he was cross-examined by Shaw's Counsel O'Neill said: 'When I went upon my oath said I wish I may never stir out of this cell if I tell.'

It was at this stage that Mr Justice Patteson interrupted and rebuked O'Neill for making such a pledge and told him: 'Never take any more such oaths. It is dreadfully wicked to take them.'

The police had little detection work to do in this particular case or any other that led a suspect to be charged and committed for trial. Ninety-nine per cent of murders are committed by people who know their victims. The same applies to many murders committed nowadays. In such small communities at the time it did not call for skilled detective work to find the suspect. Word spread quickly from mouth to mouth and in no time the perpetrator would be arrested, charged and committed for trial all within a matter of days.

George Rhodes was the local constable who said that Shaw was brought to him the day after the killing with the only evidence against him being the cord around Holdcroft's neck, and the print of a sole from Shaw's boot found in a field near the where the body was discovered.

Rhodes said he compared one of the boots with the marks made near the ditch where Holdcroft's body had been placed. 'I compared one of the boots with the marks made in the ditch but it some distance from that part where the body was found. There were several different footmarks in the ditch. I did not feel any confidence about the marks or I should have kept the boots myself.' He said he had a cord which was taken from the dead boy's neck.

Thomas Jones, a solicitor from Hanley said he saw the body 'of this poor boy' on Sunday, 4 August, the day after it was found. 'I saw the prisoner on Monday and took something down from his lips. The following is the substance of it.' He read to the jury the alleged comments made by Shaw which said: 'I am not the man who did it. I know the man who did it. He gave me half a crown (25p) not to tell. That man is John Baggaley. He lives at Stoke. I knew him in Yorkshire. I know he did it because he had blood on his hands and trowsers (sic).

'I saw the little deceased boy on the canal side with Baggaley. Baggaley said he was going to Burslem and he enticed the little boy to go with him. In twenty minutes or half an hour after I left him, Baggaley overtook me in Cobridge. When we had gone a bit further I saw that his hands and his trowsers were bloody. He said he had struck him and killed him. I said that I should tell but he gave me half-a-crown not to.'

The prosecution's case then ended and the judge asked Shaw if he wished to say anything in his defence but he replied: 'No.'

Shaw was not allowed to give evidence on his own behalf because it was not allowed. The law of the day was such that if an accused gave evidence on oath and was then convicted he would be guilty of perjury. In 1893 the law was changed.

Mr Justice Patteson then summed up the evidence which had taken just hours to complete. He said if the if jurors were satisfied that Shaw had killed the boy there were two other questions which had to be taken into consideration. The first was whether he was insane at the time. This may have seemed a strange thing to say because many witnesses called on Shaw's behalf said there had never been any suggestion that he was insane at any time during his life. However, the judge had his reasons for suggesting why the jury might have considered insanity. His lordship said he felt there was absolutely no reason why the jury should entertain insanity and did not feel there was the 'slightest pretence for entertaining it.'

He said: 'It would be quite shocking if a plea of that kind were admitted on grounds so slight. It was often said of certain deeds that they were so horrible that no man in his senses would perpetrate them. Such kind of reasoning was not

conclusive and before the jury could acquit the prisoner on the ground of insanity they must be satisfied that at the time he committed the crime (if he did not commit it) he did not know right from wrong.'

(Since 1833 much has changed with regard to insanity that it takes much more than knowing right from wrong to be considered.)

The breathless speed, with which the jury considered its verdict after a trial lasting only nine hours, meant it could not have been safely reached. There was no possible way for the evidence to be properly, fairly and carefully studied before a decision was made. In those days juries did not have the benefit of a so called 'comfort break' or adjournments for meals as allowed in today's court hearings, so they wanted to finish their job as quickly as possible. In the case of Shaw it took them a 'few minutes' before they found him guilty of the murder of John Holdcroft on 3 August, 1833.

On the day that Shaw was due to be sentenced scenes in the crown court were described as 'truly awful.' Shaw was not the only one facing death. Two others, a man and a woman from different parts of the county, had earlier been convicted of murder. Hundreds of people tried to get into the court where space was limited and at a premium to see a child defendant in the dock waiting to be sentenced for the murder of a lad just six years younger.

Mr Justice Patteson donned the black cap reserved for those about to be sentenced to death and told Shaw: 'It is always distressing to a judge to pass the awful sentence of death on a criminal; but more especially so on one of such tender years as yourself. No person I should think, who has heard the evidence, can have doubt of your guilt. The circumstances are strong in every way against you. The real question is did you murder the deceased? It has been brought home to you so clearly that no person can entertain a doubt of that fact.

'It would appear that the desire to possess a little paltry money provoked you to commit an act of atrocity of the most barbarous character. I know not whether you have turned your thoughts to a future state, but I entreat you to consider the heinousness of your crime and to ask without delay the forgiveness of God; for in the crime of murder execution follows almost immediately after conviction.'

It was reported that Shaw, who 'stood unmoved during the progress of the trial scarcely showed the least indication of feeling when the dreadful sentence was passed upon him.'

Mr Justice Patteson was visited at the judges' house in Shrewsbury as a matter of urgency, by the governor of Stafford Jail and the chaplain and shortly after the judge called for a respite on Shaw's sentence which meant there would be a temporary suspension of his execution.

The day before he was due to hang, Shaw was visited by his mother and she urged her son to tell the truth about what happened near the tow path of the Trent and Mersey Canal when little John Holdcroft died. The *Staffordshire Advertiser*, again privy to private conversations, told its readers what went on between mother and son. 'He then declared most solemnly that having won the deceased's wages off him they quarrelled and exchanged blows and Shaw knocked Holdcroft down twice.

'A boat came along and Shaw retired for a while and when it passed returned to the spot and found the deceased heaving his last gasp. Finding Holdcroft was dead

he tied the cord around his neck and left him on the bank to induce an opinion that he had destroyed himself.'

Believing that there might be some truth in this statement and there could be a possibility that the conviction might be reduced to manslaughter, the governor and chaplain decided to rapidly make the thirty mile journey to Shrewsbury as quickly as possible.

The respite was granted on Monday, March 1834, so that further inquiries could be made. Some of Shaw's relatives made statements that he was in Hanley at the time the boy died around seven o'clock in the evening. Shaw's execution was delayed until 29 March; the suggestion being that the death of young Holdcroft was unintentional. But by 27 March, two days before he was due to be executed, Shaw was granted a reprieve. But what happened to Shaw after that day was never disclosed. He must have served a long prison sentence but nothing was heard of him again.

The *Advertiser* had to have the last words to impress upon its reader just how the newspaper felt that Shaw had escaped the hangman. 'For ourselves we must confess that after giving a very close attention to the circumstances of this melancholy case, our conviction is that the deed was deliberate and wilful on the part of Shaw,' it said in one of the last reports on the case.

'We must not deny, however, that there is a remote possibility that it might have been otherwise; and when the life of one so young is in jeopardy every humane mind must rejoice that a doubt exists however slight which justifies the extension of mercy to the juvenile criminal.'

And so ended another sad part of the social history of the Potteries; an event that became a regular part of the lives of many people from all walks of life, between 10 August, 1833, and until the reprieve, nearly seven months later. Two lives were destroyed – one that of a little boy who never had the chance to grow into a man and the other who killed because he was short of money.

A WALK ON A SUMMER'S EVENING

It was a warm, pleasant summer evening in June 1818 when William Wilson took his pregnant girlfriend out for a walk in the Staffordshire countryside and cut her throat.

He promised young Elizabeth Parker he would marry her, but love can turn sour and eventually the wretched, hapless girl had to make way for his new girlfriend who had a fortune of £200 and paid for it with her life. Mercifully, she died quickly and her body was thrown into a ditch and covered with brambles.

But the untimely death of Elizabeth created a mystery nearly 200 years later because there was no record of an inquest into her death. Wilson, a miller, was arrested and supposedly appeared in front of a coroner's jury which committed him for trial for the wilful murder of Elizabeth Parker but, again, there is nothing to indicate he ever appeared at Staffordshire Assizes and no evidence to show there was a hearing before a jury.

It was claimed he confessed to the barbaric way he was supposed to have killed the young woman but there is no indication that a man named William Wilson was ever hanged for murder. The summer assizes were held in Stafford and his name was not among those who appeared for various offences on the list of those to be tried.

It is difficult to understand what happened. There must have been something that attracted people's attention, because someone named Pilates of Birmingham wrote a poster as a 'dreadful warning to all thoughtless young women. Being a true, particular and affecting account of the villainous seduction and barbarous murder of Elizabeth Park by her own sweetheart.'

These notices of hanging were usually written after a killer had suffered the drop, but again there is nothing to show that William Wilson went to meet his Maker other than in the normal way after a long life.

Whoever wrote the notice must have gathered his information and knowledge from somewhere but there is no-one by the name of William Wilson among the 127 hangings outside Stafford Prison between 1793 and 1914. The story itself is interesting and throws as much light as possible on the alleged murder and why

it was committed. It is written in a language no longer seen or heard with turns of phrase that show the writer has the ability and skill to present his narrative as interestingly as possible. It tells how an unsuspecting woman was lured to her death. But where did the writer manage to get hold of the letter or a copy?

'The unfortunate woman, the subject of this narrative, was born in Darlington (this could have been Darlaston) in the county of Stafford (*sic*) where her parents, who are labouring people, now reside,' said the writer. 'She was courted by William Wilson and fondly believed him sincere and after the most solemn assurances of marriage yielded up her virtue.

'Her seducer, as too generally is the case, now forsook her and followed another girl who had £200 to her fortune, but Elizabeth Parker's proving with child, threw an obstacle in his way to his new connection which, to remove he formed the horrid resolution of murdering the poor deluded girl together with her unborn infant. The better to accomplish his wicked purpose he wrote her the following letter':

'Dear Betsey – I hope these lines will find you in good health as I am at present and to let you know I shall be very glad if you can contrive to meet me about 4 o'clock tomorrow afternoon and I will wait for you in the lane below Farmer Gough's field. I beg you will not fail coming, as I have something very particular to propose to you that may be of use to both of us. So no more at the present from your loving friend'.

The writer continued that on receipt of this 'seemingly affectionate' letter she returned the following 'really interesting answer':

'Dear William – Your letter has much revived my drooping spirits, and God knows I had need of some comfort under my afflictions which I have by my own indiscretion brought upon myself. I will not fail to meet you at the appointed and till then remain yours the afflicted, E PARKER'.

The writer of the notice must have obtained verbatim note of the letters, most probably at the corner's court, but there is nothing to say where the inquiry into Elizabeth Parker's death was held. However, he continued:

'Punctual to the time she met him at the appointed place when after walking together till they came to an unfrequented path, they sat down on a bank. Here putting his arm round her neck as if to salute her, he cut her throat and threw her into a ditch, covering the body with brambles. The atrocious deed lay concealed but a short time. The poor girl being from home all night, gave uneasy sensations to her friends, and after a diligent search, the poor father was the first to discover his murdered child.

Wilson was suspected – he confessed the inhuman deed and was immediately committed for trial at the next assizes.'

But the list of people charged with murder did not include Wilson when the calendar of names was published. It was normal that within a day or two after the arrest

of a suspect the coroner started his inquiry. The sheriff's bailiff may have carried out a limited investigation as he was the only form of the law. Within such small communities where people probably knew a lot about other folks' business, anyone suspected of a crime, however small, would soon have been arrested, questioned and charged.

A killing as horrific as this would soon have become public knowledge through the weekly newspaper, the *Staffordshire Advertiser*, but there was nothing in its news columns. It is a mystery how the newspaper missed this.

The situation begs the question: what happened to William Wilson? There may be some logic in the illogical; some cogent, well-reasoned argument. Something was not right. Down the centuries there has always been something that someone can do when they are in a difficult situation. A fixer might be that someone; a person who can do something when a friend needs help. It's not what you know, but who you know. Was Wilson spirited away out of the county or even the country to escape prosecution and possible death at the end of a hangman's rope?

Speculation is a luxury, but it's worth a thought.

THE LIVES TRIAL & EXECUTION.

OF PICKFORD'S TWO BOATMEN,

Who Suffered April the 11th, 1840 at Stafford, for the Wilful Murder of Christina Collins, near Rugeley, on the 17th of June 1839. Together with OWEN'S CONFESSION.

Life of Owen.

Owen, the captain of the boat, who is a married man is about forty years of age, was visited by his wife the day after his condemnation. The paper explains was destroyed during the interview, indeed, so strong did his fear and apprehension act as to be thrown into a fit. He was born at Brinklow, near Rugby, where his father and mother are now living, his wife resides with them. Owen has been a boatman all his life: his mother followed the same occupation.

Life of Ellis.

Ellis is a single man, twenty-eight years of age, and the man was born at Brinklow, and has always been a boatman.

Life of Thomas.

Thomas was a native of Wombourne, & is a single man, about 27 years of age.

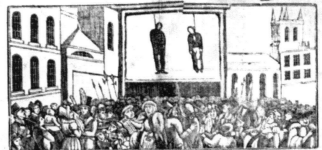

The Execution of Owen, and Thomas, in Front of the Goal.

Condemned Sermon.

The following Sermon were preached to the men the Sunday before they suffered, by the morning from Acts xv 18, and in the evening which were more particularly adapted to the criminals, from Mark ...

James Owen aged 39, George Thomas, alias Dobel aged 27, and william ellis, alias Lambert, were placed at the bar, charged with the wilful murder of Christina Collins, on the 17th day of June, at the parish of Rugeley. The prisoners were rather rough looking men and there also an apparent uneasiness completely indicated the state in which they belonged, they took their places at the bar with some degree of radiance, and manifested great composure during the trial.

From the evidence of more than forty witnesses the following summary is given:—

A respectably dressed female who gave her name Christina Collins, took her passage from Preston Brook, in Lancashire, to London by one of Messrs. Pickfords and Co's fly boats, which started from Preston Brook at seven o'clock. These men acted towards the unfortunate woman with great brutality, for at Stoke she complained to one of the porters, of the indecent language used by the men, and enquired if there was a coach to London, as she stated she was quite unsafe while travelling with them.

On the arrival of the boat at Stone, on the Sunday evening, she again enquired after a Londonwench, and renew all her complaints of them to Mr. H. Caldwell, the clerk, Clerk of the Trent and Mersey Canal Company, who advised her, if in afraid to report them to their employers. After leaving Stone the boy Musell went to bed, and was not (according to his own statement) called up until they arrived at Colwich Lock, and one mile from Rugely at 5 o'clock in the morning.

From the evidence of the lad, it seems that he was sent on with the boat after they left Colwich, and the horse went by itself; that the captain of the boat afterwards professed to miss the woman from the boat, and turned back with two other men to look for her.

At Hoo Mill the lock keeper and his wife were awoked by the loud cries of a female in distress, they got up to the window, and saw the boat in the lock, with three men, trying to force a female into the cabin, she exclaimed, "Don't attempt me, I'll not go in."

THE EXECUTION.

Copied from the Second Edition of the Stafford Paper.

These wretched men have this day explated their dreadful crime, by the forfeiture of their lives on the gallows. We have already mentioned that Thomas became greatly softened yesterday, and made a very important admission. He and likewise Ellis, confessed that their general habits had been of the most profligate and depraved character; though not differing much from those of the class of men to which they belonged. We understand it was most painful to hear their account of the scenes which are of daily occurrence amongst boatmen, Thieving, it appears, is reckoned an accomplishment, and those men are sought the most, by the captains of the boats, who ran pilfer the boats the most adroitly and to the greatest extent. They say there is no difficulty in disposing of the stolen goods receivers being at hand at all point of the canals. It is an unamiable practice to abstract ale, spirits, &c. from the casks, by means of syphon pumps, which are in common use in the boats. On the morning of their execution, they were visited by the Chaplin, deputed all knowledge of the murder, in which Mrs. Collins came

b. her death.

Although a respite had been received on behalf of Ellis in the course of the night, the Deputy Sheriff consulted it best not to disturb the arrangement respecting the time at execution, which had been fixed for one o'clock, after the arrival of the first London train

The drop was erected at an early hour in the morning in the front of the County Prison, and two allrs were suspended from the cross-beam. Great numbers of persons began to assemble by ten or eleven o'clock, and the multitude gone once as the hour of execution approached. About 11 o'clock the three culprits were summoned from their cells to the chapel of the prison in order to partake of the Sacrament. As soon as the service was concluded, it was made known that Ellis was to be respited, he burst into tears, and taking a sad of his comrades by the hand, kissed them most affectionately, exclaimed repeatedly "God bless you, dear boys." This conduct of Ellis appeared to overcome the feelings of both the men, particularly of Owen who wept bitterly. Thomas addressing all his, said " Bill, at any rate, old Ellis has a warning to take as long as you live. The scene was indescribably affecting. The procession moved towards the drop, the men walked with a firmstep. On arriving the ropes were placed round their necks, the bolt was drawn and they ceased to live. Their bodies were much convulsed. After hanging the usual hour their bodies were cut down, and buried within the liberties of the goal. It is supposed there were nearly ten thousand persons present. They suffered at one.

PICKFORD

WRIGHT, Printer, Birmingham.

THE GHOST OF RED STOCKINGS

The route of the old London to Chester road meanders through historic mid-Staffordshire into some of the prettiest and greenest parts of a county steeped in medieval history. There is the Bishop's Wood, a hunting playground for the Bishops of Lichfield, not far away from Eccleshall – a stopping post for stage coaches – where these powerful church leaders stayed to take a break from their religious labours.

Then there are the remains of Eccleshall Castle just outside the town centre. Most of it was destroyed by Cromwell's Roundheads in 1646 during the Civil War. All that is left of the ancient monument is a nine-sided tower, together with moat walls and a medieval bridge. The existing and privately owned house was built among the ruins in 1693, and until the 1870s was a country residence for the Bishops of Lichfield.

Leaving the town on the old Chester Road brought travellers to the magnificent Holy Trinity Church, with its distinctive Norman tower built by the invaders in 1189. Prior to that, there were several wooden churches erected on the site which were destroyed by the Vikings during the eighth Century, when they waged their onslaught and invasion on Britain.

But by far the most impressive of ancient buildings is about four miles northwest of Eccleshall, deep in the heart of ancient countryside where for centuries land has been farmed. Broughton Hall lies midway between the county town of Stafford and the Shropshire Border community of Market Drayton.

This majestic, magnificent black and white Elizabethan-style mansion was built in 1637 with the date clearly imprinted above a robust, built-to-last wooden door supported by two sturdy sword shaped hinges. The building stands proud in twenty-two acres of land in pastoral, idyllic countryside on the site of a manor house first recorded in the Domesday Book four centuries earlier. At one time it was a convent.

Broughton Hall has a ghost – well, that's the story handed down from generation to generation and family to family, over three and a half centuries, which tells of the county's longest, unsolved murder mystery. A distinctive, mysterious figure dressed

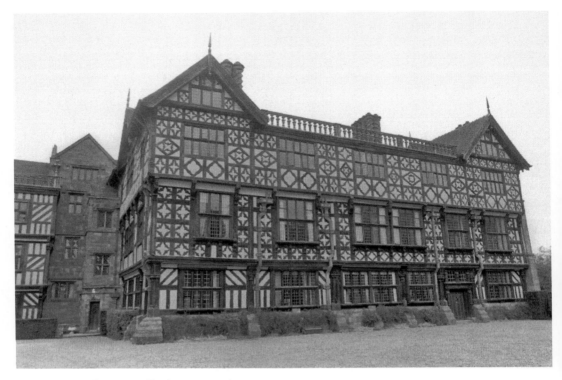

Broughton Hall near Stafford, as it is today.

in red, which has waited patiently, and watched and wandered in the twilight zone, between past and present.

The hall was carefully restored by Thomas Broughton, an extremely wealthy landowner whose ancestors first appeared at the time of the Norman Conquest, and it now stands as a silent, living memorial to ancient craftsmen who have long since departed. In the 1990s the Hall encompassed a more sedate and peaceful existence and provided a safe and secure mother home for a group of elderly nuns of the Franciscan Missionary of St Joseph. They travelled from around the world, where they worked helping others to live out the rest of their last days in the peace and tranquil surroundings of the green rolling countryside. When they died they were buried in a small cemetery at the back of the hall.

But in the 1990s, the high and rising costs of running the Hall for a small number of Nuns became a burden for the Franciscan Missionary, and so it was decided to put it on the market and it went into the hands of a private owner for £600,000. He now is the steward of this amazing Grade 1 listed building, and will protect it for his lifetime or for however long he remains at the hall.

Broughton Hall's rich tapestry of history is intertwined with episodes of violence, particularly during the days of the Civil War and the deliberate shooting of a young

Actual lower window to the left through which king's supporter shouted his support.

Inside the Long Hall. The window opened by the victim is to the left of the statue.

servant lad during an invasion by Parliamentary troops, which created the legend and mystery of the ghost who became known as Red Stockings, because of the colour of the hose he wore.

Since his death in May, 1643, this tormented young soul is supposed to have walked and wandered through the beautiful long gallery in search of eternal rest and peace. He has supposed to have been seen several times on the stairs and close to the window where he met his death. The hall also had what has been described as a 'curious hiding hole' in a wall between the dining room and the great hall.

Over its entrance used to hang a picture of a man in his antique costume, who went by the name of Red Stockings. Whether he was a man has never been made clear, but people who claimed they have seen him said he was a young boy. This seems upheld by two people who said they saw him clearly in the early twentieth century while at a party.

The shooting took place late at night and Thomas Broughton referred to the incident in a statement of apology to Cromwell's forces when he offered to pay a hefty fine of around £3,200 for the return of land seized as a punishment for the loyalty he showed to King Charles.

But he made no reference to a death cry said to have been screamed out by the young man as a metal ball fired from a Roundhead's gun ripped into him from the darkness. It has been claimed that moments before he received his fatal wound he opened a window of the Long Gallery and shouted down to a group of Cromwell's soldiers: 'I am for the king.' Needless to say such a remark would not have gone down well with the Roundheads, and one of them opened fire to cut down the offending Royalist.

So this was the ancient incident of violence which gave birth to the story of the ghost of Red Stocking; a tale which has travelled down tens of decades virtually unchanged. For a story to have remained whole and complete it must be accepted, even for the sake of argument, that such an incident took place. 'The very phrase "I am for the King" is too explicit to have been thought up on the spur of the moment by an observer.

So, let us turn back the clock to the mid-seventeenth century, and read through the local church records of the nearby parishes of Ashley and Eccleshall, to see if the lad's death was recorded. There is no entry to confirm that a burial even took place, but it must be made clear that because of the strife caused by the Civil War, people's minds were engaged with much more important problems of the day, and the keeping of burial records for future generations to read was forgotten, or at least erratically recorded.

The only hard fact evidence of such a shooting was that chronicled by Thomas Broughton in his letter of apology, seeking forgiveness for his loyalty, to King Charles. The Parliamentary forces had a job to do and there were, without doubt, some renegade, trigger-happy Roundheads fed up with the fighting and killing of war who might not have thought twice about taking a shot at an enemy, particularly when a shout of 'I am for the King' rang out in the darkness of night with the utmost provocation.

Before too long, word spread quickly throughout the local hamlets and villages that the person who had been killed was heir to the Broughton estate. This belief

persisted until very recently, when extensive and detailed research disclosed this was impossible. Brian Broughton was the older of Thomas Broughton's two sons and he lived, what was then, a very long life, and died in 1708 when he was ninety years old. Nearly half a century earlier he was created a baronet. His young brother, Peter, also lived a long life.

Further investigations revealed, with greater probability and certainty, that the person who shouted his allegiance and faithfulness to King Charles, and paid the supreme penalty for his folly and rashness, was one of two sons from the neighbouring village of Ashley, who worked with their father as servants at Broughton Hall.

Although this is the most likely outcome, Broughton family documents, burial records and historical documents have been carefully researched and rechecked, but the identity of this mysterious man who died because he spoke out of turn, has always eluded the investigator. However, the incident on a late spring night in May 1643, in the deep darkness of the Staffordshire countryside, left in its aftermath what was to become a baffling ghost mystery, which today still creates a lot of interest.

One important proposition to be carefully considered is that the story and appearances of Red Stockings was passed on with great care and accuracy by word of mouth, from one family to another, precisely and as authentically as possible.

The circumstances surrounding the death of Red Stockings, as he eventually became known, are quite clear, succinct and straight to the point, leaving nothing to a listener's imagination. He opened a window and, in a moment of irrational and spontaneous declaration of loyalty to his king, signed his own death warrant before an angry Roundhead, who despatched him to eternity with either a well-aimed shot from his gun or with more luck that judgement.

And, again, Red Stockings' movement moments after he was gravely wounded, also appear to have been well chronicled and put on record with an unusual accuracy. We learn that he fell to the wooden floor of the Long Gallery gravely wounded, and crawled from the window at the side of Broughton Hall to a doorway, about 15 feet away, which led to a landing above some stairs. He left a trail of blood as he slowly dragged himself to another doorway, almost as far into a room where his life slowly ebbed away, and he lay dying in a pool of blood. Some records claim he spent two days in the room which must have meant there was, without a doubt, some help, albeit not skilful enough to save his life, and so he faded away and passed on to meet his Maker.

Two-and-a-half years were to pass before any more was heard of the mysterious Red Stockings. It was the first time that any record of his death appeared, and it came to light in October 1645 after Thomas Broughton's estate was seized by the Parliamentarian forces. A document was recovered in which Broughton apologised for his loyalty to King Charles, and in it he sought a pardon by paying the fine of £3,200 to regain his land.

A transcript of his petition may be found in the 'Royalist Composition Papers at the time of King Charles I', copies of which were deposited at the William Salt Library in Stafford.

In the document Broughton said: 'In May 1643 some of the Parliamnts fforces comeing from Leeke and Newcastle to your petitioner's house at one of the clock at

night demanded the house as souldiers to the Lord Capell whereupon you petitioner kept them out and thereupon they did present and give fyre upon the howse, and shott into and thurrowe it in divers places.

'But afterwards the same night they demaunded the house for the use of Parliamt which you petitioner refused to deliver in respect of their pretences for the Lord Capel (sic). And thereupon and in respect the greater part of your petitioner's estate was under the power of the enymy and divers others of the King's garrisons neere him hee left his house and lived in the county of Salop where part of his estate lay.'

It was at this point that it seemed as though the shot which killed the young servant man was one of many fired into Broughton and was not intended to fatally injure anyone. It is thought that the group of Roundheads involved in the skirmish may have been a rough and ready troop with their own grudge to bear. They were known as the Moorland Dragoons founded in the Newcastle and Leek areas of the county and led by a desperado known only as the Grand Juryman.

John Sutton, an historian who specialised in the Civil War in Staffordshire, and was with the department of history at the Cambridge College of Art and Technology, explained and decoded some of the comments made by Thomas Broughton in his letter of apology. 'First, note, Lord Capel was the King's Commander-in-Chief in Shropshire and his headquarters were in Shrewsbury. When the Roundheads' task force first approached the house they tried to trick the owner to admit them pretending they were Royalists.

'Quite clearly some negotiations took place between the inmates of the hall and the hostile troops outside and it was doubtless that during verbal exchanges that someone in the large window facing the drive cried out: "I am for the King". When Broughton refused to admit the Roundheads then fired and their salvoes were returned. It was surely during this gunfire that a servant lad was mortally wounded and crawled away to die in one of the rooms of the Long Gallery. Through the centuries the story became embroidered and the lad was wrongly identified with Broughton's son and heir.'

It has been claimed that Broughton Hall was exorcised by a priest to drive away the spirit of Red Stockings, but this had been constantly denied by the Franciscan Missionary nuns. They confirmed, however, very diplomatically, that prayers were regularly being said for people who ever lived in the house.

Then, where did the tale of the ghost originate and come to life? It was towards the end of the nineteenth century that the first detailed and definite sightings of Red Stockings were committed to paper in a book called the *Bypaths of Staffordshire*, written by the Rev. Western E. Vernon Yonge, who lived in Charnes Hall near to Broughton Hall with his twelve brothers and sisters.

One of Rev. Yonge's sisters, Miss Frances, who died in 1952 aged eighty, recounted to him her first and only time she claimed she saw the ghost of Red Stockings, while with other children at a Christmas party at Broughton Hall. She was only eleven at the time, in 1880, but her recollection was forever vivid and remained with her until the day she died.

She told her brother that she hid behind a door in the Long Gallery during a game of hide and seek and said: 'After a few minutes I heard footsteps coming down the

staircase which leads to the attic and waited for what seemed a very long time for the seeker to find my hiding place.

'As nothing happened I ventured out into the Gallery and saw a young man in red stockings looking out the end window. I took him to be the son of the house who always wore knickerbockers and thick stockings. As he had his back to me I thought this was my chance to get 'home' without being seen so I crept quietly past him and rushed downstairs to the 'den' where everybody had started to have their tea.

'There to my astonishment was the very son of the house sitting at the table. So I went up to him and smacked his knee and said: "However did you get down here before me? I left you in the Long Gallery and you did not pass me on the stairs". The young man was bewildered and said: "You could not have seen me as I have not been in the Long Gallery this afternoon".

'I had such an argument with him that the rest of the party stopped their tea and Lady Broughton, thinking that my story was causing too much attention, took me by the hand and led me to the other end of the table where I soon forgot all about the figure I had seen.'

There is no record that she ever saw Red Stockings again and there is no indication that she confided in her brother, the Rev. Yonge.

But around the same time, another local woman from Fairoak, a hamlet off the London-Chester road and within the shadow of Bishops Wood, told the same story. She was a cleaning lady who claimed she saw Red Stockings while she was working on the Long Gallery attic stairs. According to people who knew her she told friends that she saw a young man in red stockings coming towards her.

She said she got up and moved the bucket so that he could pass 'but to her horror he walked through.' This was the first time that Red Stockings had ever done this, and where the story came from has never been clear, but local gossips passed on news which could have changed completely by the time it reached the last person. This ghostly experience never put her off her work, but every time she had to clean the Long Gallery stairs she always took a companion with her.

But Miss Frances Yonge was certain of what she had seen, and nothing anyone said, when they listened frequently to the story about what she claimed she had seen, could change her mind.

One of her close friends at the time was Aunty Bell Johnson, who lived in the Round House at Croxton, through which ran the London-Chester and was about a mile from Broughton Hall. She died in 1991, aged ninety-four. She was a sprightly old widow, whose house was full of antiques and she was always keen to talk to someone over a cup of tea and a few biscuits. She had a good memory, and loved nothing better than talking about things from years before, which were as fresh in her memory as though they had only happened the day before. She remembered well her friend, Frances Yonge.

She said Miss Frances was convinced until the day she died that what she had seen at that Christmas party at Broughton Hall was the ghost of Red Stockings. She told me one afternoon as she welcomed me into her comfortable country. 'Up to the time she died she stuck to it that she had always seen it. She told me it was true about the ghost and that it had red stockings.

'She was convinced she had seen something and nothing would ever turn her against that. She really believed it. She swore to it until the day she died. She said she was terrified. I suppose that is how it would affect anybody. She was a very strong character and self taught. She read and studied a lot and was interesting to talk to and listen to. She often talked about it and said she had seen something.'

Only two people claimed they ever saw the supernatural wanderings of a figure from the past. Their recollections were, no doubt, imprinted in their memories over many years and it would be unfair to suggest or accuse them, now that they have gone, that they had made it up; that what they might have seen was nothing more than fiction and fanciful imagination.

The investigation into the ghost of Broughton Hall and the mysterious and lonely figure of Red Stockings was a fascinating and backward excursion into a turbulent part of British history. The nuns of the Fransiscan Missionary have never been privy to the ghostly wanderings of Red Stockings, and like many people who have lived in the area for generations, they are only able to recount a story handed down by word of mouth over the centuries.

In 1926, nearly three centuries after the lad at Broughton Hall was fatally wounded, floorboards in the Long Gallery were removed for the first time since they were laid down, at a place where he bled to death. There for all to see was a large, indelible stain which was later identified as blood.

A dreadful Warning to all thoughtless Young Women. Being a true, particular, & affecting Account of the villanous Seduction and Barbarous MURDER of

Elizabeth Parker,

By her own Sweetheart, WM. WILSON, a young Miller at Darlington, in Staffordshire, on the 7th day of June last, 1818.

THE unfortunate young woman, the subject of this narrative was born at Darlington in the county of Stafford, where her parents, who are labouring people, now reside. She was courted by Wm. Wilson, and fondly believed him sincere, and after the most solemn assurances of marriage, yielded up her virtue. Her seducer, as too generally is the case, now forsook her, and followed another girl who had £200 to her fortune; but Elizabeth Parker's proving with child, threw an obstacle in the way to his new connection, which to remove he formed the horrid resolution of murdering the poor deluded girl, together with her unborn infant. The better to accomplish his wicked purpose he wrote her the following letter.

" Dear Betsey——I hope these lines will find you in good health, as I am at present, and to let you know, I shall be very glad if you can contrive to meet me about 4 o'clock to-morrow afternoon, and I will wait for you in the lane below farmer Gough's field. I beg you will not fail coming, as I have something very particular to propose to you, that may be of use to us both. So no more at present from your loving friend.

On the receipt of this seemingly affectionate letter, she returned the following really interesting answer.

" Dear William——Your letter has much revived my drooping spirits, and God knows I had need of some comfort under my afflictions which I have by my own indiscretion brought upon myself, I will not fail to meet you, at the place appointed, and till then remain yours the afflicted,

E. PARKER."

Punctual to the time she met him at the appointed place, when after walking together till they came to an unfrequented path, they sat down on a bank. Here, putting his arm round her neck as if to salute her, he cut her throat, and threw her into a ditch, covering the body with brambles. The atrocious deed lay concealed but a short time. The poor girl being from home all night, gave uneasy sensations to her friends, and after a diligent search, the poor father was the first to discover his murdered child.

Wilson was suspected——he confessed the inhuman deed, and was immediately committed for trial at the next assizes.

Verses addressed to the Fair Sex.

Young women all of each degree,
Of every rank and station,
Draw near and listen unto me,
I give a true relation ;
Of a young woman lost through love,
And Parker was her name,
She yielded to a false young man,
And lost both life and fame.
Near Darlington this maiden dwelt,
There led a happy life,
Until sly Cupid's dart she felt,
Which sorrow brought and strife.
Young Wilson was a handsome youth,
To court her he did come ;
And by his false deceitful arts,
He seal'd her final doom.
For she did yield her honour up,
And by him was beguil'd,

She drank of sorrow's bitter cup,
By proving next with chi'd.
He did desert and hate her then,
All for to end the strife,
The shocking resolution form'd
To take away her life.
He artfullo a letter penn'd
Fill'd with love's deceit,
And unto her the same did send,
Requesting she would meet
Him at a certain time and place,
Accordingly she came,
When he cut her throat O shocking case !
His wickedness to crown,
He hid her body, but 'twas found,
To jail he was convey'd,
And at the assizes must be tried,
For this most bloody deed.

Tomlinson, Printer, Birmingham---Re-printed by Martin, Leicester.

A FULL, TRUE, AND MELANCHOLY ACCOUNT OF

MISS SARAH MORTON;

Which happened on the 1st. of August 1815.

A rich Farmer's Daughter, near Stafford ; famous for her beauty and other accomplishments; who was decoyed from her parents by a Nobleman, who debauched, and then left her to poverty and ruin ; when being driven to the greatest distress she on Friday last swallowed some poison, and expired in the greatest agonies, at three o'clock on Saturday : Likewise copies of two Letters, which she wrote a short time

MURDER IN THE BLACK PLANTATION

The golden early morning midsummer sun began to break through the trees on the Black Plantation in North Staffordshire, and the leaves created a twinkling effect as they were gently moved by a cool breeze.

The plantation was part of the magnificent Churnet Valley, which even today sweeps graciously in a swathe of green across North Staffordshire, highlighting its recognition as an area of outstanding natural beauty, with hundreds of thousands of square acres laid down on beds of two geological periods spanning 350 million years.

The verdant softness looks as though a giant hand has cast a green blanket that nestles over the bare hills and rocky outcrops. Gentle running rivers, streams and brooks slowly carve their way through the lush green hills and valleys, as they peacefully roll northwestward towards Derbyshire to join with the Peak District National Park.

But, in the calm serenity of such a beautiful place strange, unexplained, mysterious things happen; evil things, curses and death, wicked and fiendish utterings and oaths from the mouth of an old crone to damn a family. And then murder: the deliberate taking of a life. A terrible, foul and violent deed committed at the start of a new day that would inflict tragic and grievous hurt on a family and its members for the rest of their lives.

THE CURSE

In the village of Alton, which nestles in the trees not far from the renowned theme park of Alton Towers, is the chained oak, a fanciful legend that has been part of local folklore since 1821.

The story goes that on an autumn night, Charles Thomas Talbot, 15th Earl of Shrewsbury, was returning by coach to his home of Alton Towers, along a byway known locally as the Barbary Gutter. It made its way over the River Churnet, through Dimmingsdale, to finish at the small town of Cheadle.

Suddenly, an old woman appeared from the side of the road in front of the carriage. The horses reared in fright and the coach stopped not far from an ancient oak to find out why she was there, and she begged for a coin.

Somewhat angered by the interruption to his journey, the earl shouted from his coach, telling the old woman to get out of his way and let him pass, and ordered his coachman to drive on. It was then, according to storytellers who recounted it over nearly 200 years, she placed a curse on the earl and said: 'For every branch of the old oak tree that falls a member of the earl's family will die.' He dismissed her rantings and ordered the coachman to continue his journey.

That night, during a violent storm, a single branch from the old oak tree snapped and fell off to the ground. Later that same night, a member of the earl's family suddenly and mysteriously died. The curse had claimed its first victim, and to prevent any further deaths the earl ordered his servants to chain every branch together to prevent them from falling.

Another story about the family death was a little closer to home for the earl. According to local legend his son was out riding the following day and, as he passed the old oak, under which the crone had been standing when the earl came upon her, a branch fell, knocking him to the ground from his horse, and killed him.

The earl decided that every branch of the tree should be chained to prevent any more family deaths. As recently as 9 December, 2009, most of the dead, rotten branches of the tree had crashed to the ground. The sadness of this once proud oak, a symbol of Britain for many centuries, lies splintered on the earth to which once gave it life. The chains did not look to be as old as folklore would have us believe. However, the family confirmed that no one else had succumbed to the curse of the old woman 186 years earlier. The steps leading up to the top of the old oak are still there, and the rusting chains have snapped in many places and hang forlornly from many branches lying on the ground.

A good story? Probably. Is there any truth to the tale that has spanned many decades? We will never know.

THE MURDER

It was dawn on Sunday, 8 July, 1866, as a bright early morning sun heralded what was likely to be a pleasant, warm midsummer's day. It was also the last day in the world of the living for a landowner's son, Thomas Smith, who had decided along with a manservant to seek out a local poacher who had been helping himself to his father's pheasants.

It was destiny and misfortune which brought to an untimely and brutal end the life of the twenty-four-year-old son of the lord of the manor, when fate decreed that his path and that of his killer should cross – one who would lose his life from a vicious beating with a rifle and the other at the end of a hangman's rope; an execution so bizarre and frightening that nothing like it was ever again seen in public in Stafford.

There were no witnesses to the murder but within twenty-one days the killer, a local farmer, thirty-five-year-old William Collier, had been arrested and was on trial

Today this is all that remains of the chained oak.

for his life at the Staffordshire Summer Assizes in Court Number 1 of the Shire Hall, an imposing building centred in Market Square, Stafford.

Before we go into the details of what exactly happened at the murder and trial, twenty-three men from all parts of the county were summoned by letter to form a grand jury from whom twelve would be chosen to hear the evidence against Collier and then decide whether he should be convicted or go free.

It does not happen now, thankfully, but it was a habit of High Court judges in those days to meet with the grand jury and talk to them about the cases. If such a thing happened today, barristers would be up in arms claiming that the judge had influenced prospective jurors. But what went on in those days was behind closed doors, away from prying eyes and ears, and barristers agreed to err on the side of caution to save themselves a lot of grief.

Mr Justice Shee had travelled for several days by coach from London, to hear his list of cases ranging from theft, robbery, horse stealing, rape and murder. Little has changed now, almost a century later, although horse-stealing very rarely happens. He greeted the grand jurymen and told them: 'Gentlemen of the grand jury, there are very few cases in the calendar which has been presented to me which requires any observation upon my part to you. It is a much less, generally speaking, serious

calendar than the one which was presented to me two years ago in this place. I am happy to congratulate you upon the change.

'There are very few cases of violence and wounding. There are very few unbridled, violent and un-natural offences. Unhappily there are two cases of rape upon the calendar – one upon a woman of seventy years of age – and there are four cases of wilful murder. Now, as to those cases of wilful murder, I have to make a few observations to you.'

Mr Justice Shee then took the grand jurymen through the list – the murder of a woman named Ellen Buckley was the first. He said it would 'probably turn out to be not so serious as respects its moral guilt, inasmuch as I think, there is upon the depositions much ground for hoping that the prisoner was not at the time he committed the murder, of sound mind. I mention this fact to you merely that I may remind you that in these cases you deal with them on the same ground as you would with cases in which the persons charged were of sound mind at the time the offence was committed.'

He then spoke of another murder which he described as 'exceedingly distressing' and dealt with the murder by Elizabeth Burford who was alleged to have drowned her baby of only a few months old. 'The case will cause you very little trouble,' he said. 'And with regard to your duties, though they may be distressing, it is not necessary for me to make any observations.'

The judge then told them of the murder of Ellen Davis who was alleged to have died in a 'brutal assault' committed by a man named George Smallwood. 'You may probably – but it is not for me to anticipate your decision – think it necessary to find a true bill against him. But I am in hopes that his guilt when it comes before you will not appear so great as the crime of murder though unquestionably, if you rely upon the depositions, he committed a savage assault,' he said.

Mr Justice Shee then drew their attention to the 'most serious – by far the most serious – case on the calendar is one which will no doubt occupy a great deal of your time and a great deal of the time of the petty jury, if you find a true bill; and I shall be happy if I shall be able to facilitate your inquiry into the murder by the few observations I shall make.'

 The judge then went on to outline to the grand jurymen what had occurred when Thomas Smith and the servant James Bamford met up to go looking for poachers stealing pheasants from the estate of his master. 'Shortly, the facts of the case are these. It appears that the deceased Thomas Smith, a man three and twenty years of age, who lived with his father at Whiston Eaves in this county, was in the habit of going out at night to watch poachers in his father's preserves. And on the night of the 4th of July he had arranged with one of his father's servants, a man named Bamford that they would both go out early on the following morning.

'They were to go out to a place about a mile distant from the covers of Whiston Eaves. Deceased got up at three o'clock in the morning and went out and shortly after that time some shots were heard in the neighbourhood of the preserves near where deceased was found by some of the neighbours or villagers about. Bamford continued to watch until six o'clock and then returned to Whiston Eaves where he expected to meet his young master but on arriving there found he had not returned.

'His father was there and said he was exceedingly anxious about him and the family commenced a search about the woods in the neighbourhood. They found in a quarry some of the clothes of the deceased and further on in some grounds near the woods or plantation in the lower part of the ground in some briars and ferns they found the body of the deceased, Thomas Smith.

'It was lying quite cold and had been dead some considerable time, and on lifting up the head the skull was found entirely beaten in, and where it rested was a pool of blood and there is no doubt, on the evidence of the surgeon who will be called before you, that death was caused by the wounds on the head. There were three or four wounds there of a most serious kind, and no doubts that wounds at the back, where the skull was fractured, had caused death.'

The judge said that a search was carried out and not far from the quarry villagers found the trigger of a gun and one of the locks of the gun. A little further on the stock of the gun was found. In an adjoining field, part of thirty acres farmed by William Collier, and close to the plantation where Thomas Smith's body was found, the double barrel of a gun was recovered.

Again, in this most unusual situation, Mr Justice Shee continued his narrative and disclosed to the grand jurymen: 'There seems very little doubt – the surgeon will tell you it was exceedingly probable – that the skull of the young man was beaten in by some such instrument as the stock of a gun or other blunt instrument and the surgeon is of the opinion that a man holding a gun by the barrel would be able to inflict very great violence and such wounds on the back of the head by means of it as we speak of.'

To say prospective jurors would be tainted by what the judge had told them would be an understatement. By today's court rules a jury panel from which twelve people would be selected, must not know anything about the case they are to try. Indeed, in some high profile cases jurors would be asked if they had read or heard anything about the case, the prosecution would outline. If any replied in the affirmative they would be discharged and so allow a totally impartial jury to be selected.

Mr Justice Shee made some further observations and said: 'Gentlemen, I refrain from saying more upon this case. Besides this most serious case there are others upon the calendar about which I do not, however, propose to make any further observations. It remains only for me to say that I am pleased to see so numerous an attendance of members of the grand jury.

'I am always glad to see gentlemen of the county taking a deep interest in the administration of justice, for it is always to be desired that the greatest respect should be shown for the law an the preservation of order. I have now merely to dismiss you to your chambers.'

THE TRIAL

The judge and jurors parted company. For the next stage in court the procedure would be the swearing in of a jury, followed by the prosecution's opening of what it claimed had happened to Thomas Smith on Sunday, 5 July 1866. The evidence would be presented shortly and by the end of the day the wretched William Collier,

the father of seven children, would know his fate. Jurors very rarely took long to reach a verdict and it was normal procedure for a case to be finished within a day.

Mr A. S. Hill, for the prosecution, waited for the jurors to get comfortable and once he had their undivided attention he opened the case for them so that they could become privy to all the information he had. He said he was sure he had their attention when they knew what they heard from the charge read out 'that the inquiry into which you are about to enter concerns the life of a man and probably the future and fate of the prisoner at the bar. I shall bring you the facts as concisely as possible.'

Mr Hill said that the young man he alleged was murdered 'was a young man of considerable promise, of good nature and kind disposition and was fond of field sports and other rural amusements. His father, as the owner of considerable property, also took great interest in game on his property. Mr Smith the elder, the father of the deceased, lived at Whiston Eaves near Alton in the beautiful valley of the Churnet, in the north of the county.

'His son also took great interest in game. He was living with his father on 4 July when he was in good health and spirits after which time he was seen alive by no human eyes but that of the murderer. The prisoner lived near a part of Mr Smith's estate called the Black Plantation. He farmed some 30 acres of land, the property of a gentleman name Fenton and bordering upon the land of Mr Smith on the north side.'

Mr Hill told the jury that the deceased went out early on the morning of his death to watch for the prisoner, who had been suspected of poaching on the estate. He described how the body of the younger Mr Smith was found and the numerous, violent injuries inflicted by his killer. He then called the first of 18 witnesses.

James Bamford, who worked as a servant in the household of Mr Smith senior, said it was part of his work to watch the game and had gone out with the younger man early in the morning of 4 July. Standing in the witness box with Mr Justice Shee on his right hand side and the jurors on his left, Mr Bamford explained: 'I and the deceased went out together according to custom. I watched at Cotton Bank about half a mile from the quarry on Monystone Common where the deceased always watched.

'We had arranged on the night of 4 July to go to these places to watch at three the next morning. We did not start off together. About half-past-six that morning I went from the place where I had been watching to Mr Smith's house. I did not find the deceased there. Between eight and nine that morning I and Mr Smith went out to look for the deceased. We went to quarry hole first and found a pair of leggings, a sack bag, a macintosh and a pair of straps which belonged to the deceased.

'From this quarry we have a view of the prisoner's house at Oldfield. After searching the hole we looked over Monystone Common going afterwards to the Black Plantation which consists of Scotch fir trees. There was little underwood but plenty of fir pins on the ground. There is a water course without much water running down the middle of the wood. It is a sort of narrow gutter.

'On the lower part of the plantation there is much briar, fern and grass, the upper part being more bare. The first thing we saw was the body of the deceased which lay in the lower part of the plantation near the gutter. He lay on his belly with one

hand under his head, his face being downwards. He was quite dead. His hands and face were cold. I saw two cuts, one on each side of his brow, and the back of his head was matted with blood as if it had been knocked about.

'This was about half-past nine-o-clock. I found the trigger of a gun underneath his body and a ramrod about six yards from the body on the plantation near the prisoner's house. I called Mr Smith, the deceased's father, who was in the plantation. I saw the prisoner in a turnip field two fields from the plantation.

'After the prisoner was apprehended, about three o'clock the next morning, I remained with him at the house of Moorcroft (Thomas Moorcroft gave evidence later that he helped carry home the body "of my young master.") He was handcuffed to me. He said: "Jim how should'st thee have felt if thee had'st been in Mr Smith's place?" I said I suppose I should have felt the same as he did if I had received the same blows. But it will never daunt me. I suppose I shall be as brave as ever.'

Rupert Mellor, a gunsmith, was the next witness and the told the jury: 'The prisoner bought a double barrelled gun from me about a month before Christmas (1865). The barrels and the gun lock produced are part of the gun I sold. I know it by the make and the length and I can swear to the ramrod. I know the barrels because they are shorter than are usually made.

'I was shown some shots which had been taken from the prisoner's house and some which had been found in a tree in the plantation where the body was found. It is my judgement these shots are all of the same kind. It must have been a very heavy blow which has broken the gun stock. P.S. (police sergeant) Perkins showed me the gun barrels produced after the murder. I found it had been recently used and both barrels were quite damp in the inside. I have been a gunsmith eight or 10 years. The dampness in the inside of the gun barrels was such as would be caused by a recent discharge.'

All this evidence was being given 143 years ago in a courtroom, which looks today almost as it did then. The words used then may be different to those expressed by witnesses in modern-day trials but the end result meant the same. William Brindley, a farm servant, was another prosecution witness who told the court he knew the prisoner, Collier, well and did not live too far away from him. 'I remember having a conversation with the prisoner 14 months ago,' he said.

'I asked him how he was going on with Bamford and Smith down at the Eaves and he replied: "I'll tell thee what I'll do; I'll either knock their necks out or blow their b-------- brains"'.

Cross-examined by Mr Mottram for the defence, he asked of Brindley: 'Why did you not go like an honest man and warn them of their danger?' Brindley did not reply but turned his gaze away and looked down. Mr Mottram said to him: 'I don't wonder you look as you do; tell me the day of the month when the threat was uttered.' Brindley was cowed and not keen to answer but under pressure from Mr Mottram eventually replied: 'I don't know the day of the month.'

Mr Mottram continued pushing the witness for an answer until Brindley told him: 'It was the beginning of summer – about June or July.' He was asked by Mr Mottram: 'Upon your solemn oath, did it ever take place at all? Name any person to whom you have said it before the present proceedings were taken?' Brindley, shaken by the strength of Mr Mottram's attitude, told him: 'I did not name it to anyone.'

The prosecution was rapidly getting through its list of witnesses and, probably one of the most important, was surgeon Thomas Webb, from the town of Cheadle. He said he knew Thomas Smith very well from the time he was an infant. He described him as an active, muscular young man for his size. 'I do not think there was a better disposed young man living,' he told the court.

He said he carried out a superficial examination of the body which clearly showed the degree of extreme, cold-blooded violence by someone out of control that was used to kill young Thomas Smith. 'His face was covered with blood, his hair was matted with blood and there were two wounds on the forehead varying in size from one-and-a-half inches to three inches down to the brow,' he said.

'There were four wounds on the top of the head – one a very large one. The left side and the back part of the head were completely beaten in. I could trace the line of the sound part of the bone that was not beaten. These injuries must have been inflicted by some heavy instrument struck with enormous force. The stock of a gun with a heel plate would have been the most probable instrument.

'My impression is that the deceased was either on the ground or just rising from the ground. I think the wounds on the forehead had been caused by the rim between the barrels of a gun. They were clean cut.'

Mr Webb and another surgeon carried out a post-mortem examination two days after Thomas Smith died, and from what they found, there was a clear indication that whoever killed him was totally out of control, and had slaughtered and overwhelmed his victim. 'We found two shots at the back of the head flattened against the bone. They had not passed through the skull. I found the brain was beaten to a pulp. The shots would have been sufficient to bring a man to the ground. From the position of the shots he must have been shot from behind.

'The heaviest blow, the one which caused the death was, in my opinion given from behind. The shots would not have caused death. I examined a slop (a loose garment, a cassock or a smock frock with wide, baggy trousers or breeches) an old cloak and a neckerchief, a shirt and a pair of boots. I found a spot of blood on the collar of the shirt. It was congealed blood and had been either spurted or splashed from the human body.'

Mr Webb told Mr Mottram, under cross-examination, that the shots found in Thomas Smith's head 'would not have caused his death.'

The prosecution, having completed its part, appealed to the jury 'to look at the whole broad aspect of the case' before reaching its verdict.

It was now the turn of Mr Mottram, in Collier's defence, to outline the most important and salient points which might help his client escape the gallows. There are no court papers available or verbatim record notes of a shorthand writer, because that was not how it worked in those days. The only reliable, dependable and trustworthy people with a skill at taking accurate notes, beyond question, were local journalists whose report of the trial appeared in the Staffordshire Sentinel on Saturday, 28 July, 1866.

Mr Mottram said he was sure he would have the sympathy of the jury in the position '... the deep, the anxious, I might almost say, the awful position' in which he stood before them, the advocate of a man who in a question of life and death had committed himself to his care. He said it became him that he 'should not shrink

from the performance of the duty which devolved upon him and he felt that already the jury had rendered him considerable assistance by the attention they had given to the case and he entreated upon them to give him a little more patience.'

Mr Mottram said if there was anything to complain of it was the way in which the prosecution 'had harrowed the feelings of the jury by the description of the dreadful injuries which had been inflicted upon the deceased.' He said the prisoner, Collier, was charged with the murder of young Smith, and the jury should bear in mind that the law in England held every man innocent until his guilt was proved.

He said it was to be 'deeply deplored that all this care to protect the subject of Her Majesty was lost because of the conduct of policemen of any grade, education or cunning. These men first sharply examined the prisoner, an ignorant man, then charged him with the crime and cautioned him. But was the guilt of the prisoner proved?' He said it was also to be deplored that the laws of England 'prevented magistrates on the bench or judges of the land' interrogating Collier.

Mr Mottram said that when young Smith went out with the servant it was clear that Bamford had placed himself in a position from which he could not see Collier's house. 'With respect to young Smith we knew nothing,' he said. 'It is clear he went to the quarry and put his leggings there, that is all. He was in what was termed the "Black Planting"'.

'Were there persons about? That was quite clear, for three shots were heard and this was also clear – the prisoner was never seen out of his house until long after the shot was fired. It was more probably than the suggestion of the prosecution, that the deceased had encountered poachers, an affray followed, and as was not uncommon, the keeper was slain.

'No feeling was shown, no enmity was alleged to have existed between the deceased and the prisoner.' Mr Mottram said he was sure the jury would 'look narrowly' on the suggestion of the prosecution before they convicted the prisoner of murder. He contended that the entire conduct of the prisoner 'was free from suspicion.'

Mr Mottram appealed to the jury 'not to rashly jump to a conclusion when that conclusion sent into eternity, a soul they did not give but might sin against.' He said he did not wish to deter them from their duty, but by far the safer verdict would be one of acquittal. He argued that it would be criminal for them to act upon suspicions 'for no eye but the eye of the Omniscient and the eye of the murderer, if living, had seen the deed done – the atrocious deed – which had disgraced the district in which it had occurred.'

Mr Justice Shee started his summing up and said there was no doubt that James Smith had been murdered. 'The evidence on which the prosecution relied for a conviction was purely and entirely circumstantial. This sort of evidence was no doubt often very reliable. Still, before a jury found a man guilty of so serious a crime as that imputed to the prisoner, they would examine narrowly and carefully every point of the evidence and unless it brought their minds to a conclusion without any reasonable doubt of his guilt, they ought not to find him guilty.'

Readers may notice that Collier did not give evidence on his own behalf. It was believed at the time that a defendant might commit perjury by giving evidence on oath and if he was later convicted. However, in 1898, the Criminal Evidence Act allowed a defendant to give evidence and defend himself on a scale previously unknown.

THE EXECUTION

The execution day came round just over a week after Collier was convicted. 7 August, 1866, was a Saturday. It dawned bright and clear and a warm, sunny day was expected. The crowds began to gather in their hundreds outside the gates of Stafford Prison shortly before 8 a.m., many of them looking forward to an execution so bizarre that it was to become the last public legal killing in the town.

Most of them had travelled more than a few miles from villages and hamlets in the countryside, either walking or coming in by cart along dusty roads and lanes. By the time the execution was due to take place an estimated 2,000 had taken their places outside the jail. The ghouls with their morbid curiosity, and the nineteenth century groupies, jostled for places to watch a man swing and twitch as the rope around his neck began to slowly strangle the life out of him.

The *Staffordshire Sentinel* reported the execution in its edition of Saturday, 11 August. There were two full columns in this broadsheet newspaper and the three-deck headline read: **EXECUTION OF WILLIAM COLLIER THE WHISTON EAVES MURDER.** The next lined declared **CONFESSION OF THE CULPRIT** and finally **DREADFUL SCENE ON THE SCAFFOLD.**

Collier was twice committed for trial – first, by the coroner at Oakamoor on 10 July, and then again two days later by magistrates at Cheadle. The newspaper reported the following after the two committals: "It was evident now that the prisoner's indifference was assumed. He sat with his eyes closed during a greater part of the proceedings, but he was observed when an important piece of evidence was being given, to peer cautiously from beneath his eyelids.

'He declined to question any of the witnesses drowsily remarking: "I suppose it's no use". At Oakamoor he had a parting interview with his wife who was in great distress and piteously asked him to confess the crime if he was guilty, for the sake of his soul and the Lord, she said, would forgive him. Still he maintained the dogged silence which he had manifested from the first, uttering not a word in his defence. This demeanour he continued to exhibit even at his trial.

'The chaplain, whose attentions to the criminal since his conviction had been very assiduous, became still more earnest in his ministrations on Monday night when he saw the prisoner several times in his cell. At eleven o'clock the doomed man retired to rest and slept soundly. He was awoken a little before five o'clock on Tuesday morning and ate a substantial breakfast, afterwards receiving the last sacrament of his church at the hands of the chaplain.'

Having made it quite clear that the only record of the trial, the execution and what went on before was in the Sentinel, it is only right that what was printed should be repeated accurately here. The written word makes interesting reading and the report continued: "The streets of Stafford were somewhat animated on Monday evening, a large crowd of people assembling in front of the gaol, the approaching, awful ceremony, with the incidents of former executions, being the subject of warm discussion.

'Shortly after midnight the unsightly machine called the scaffold was drawn in front of the entrance to the gaol. From five o'clock until about half-past-seven the population of the surrounding agricultural districts came straggling into the town towards the scene of the execution, a few in vehicles and some on foot.

'The majority of the pedestrians seemed to have walked some considerable distance, many of them carrying clumsy walking sticks and appearing much bespattered with mud. Some few came in rickety carts containing in several instances more women than men. The crowd behind the barriers across the three roads leading direct to the scaffold was about 2,000 in number consisting in the main of young men and a few young children.

'This is a much smaller number than usually attend on these occasions in Stafford –in fact it has been observed that at the last few executions the crowd has been steadily decreasing. But the very heavy rain which fell in the neighbourhood of Stafford late on Monday night and early on Tuesday morning may have had considerable influence in the present case.'

It goes to prove that a good hanging, even without the weather being taken into account, still had the power to attract those who wanted to watch a man die and at the same time meet up with friends they had not seen since the last execution.

It was eight o'clock in the morning on that dreaded day when a man came to finally accept there was nothing now that could save him, and he was on his last short journey that would take him into the sight of his Maker; that fearful, dreadful time when his future was measured in minutes with nothing beyond but the hereafter and timeless eternity.

A prison bell which normally tolled its funereal, mournful sound to warn the crowd that the condemned man was on his way lay silent that day, because a near relative of the governor whose job it was to ring the warning had been taken seriously ill.

The condemned man stood ready to leave his gaol cell shortly before 8 a.m. and was met by the Smith the hangman, a cowman from Dudley in the south of the county. Dressed in a respectable suit of black cloth instead of a white smock he wore on the last occasion, Smith pinioned the arms of Collier.

Everyone was ready to move and a sombre, mournful procession moved from the condemned cell through several court yards on its way to the scaffold outside the prison walls. Major Fulton, the prison governor, and Mr Hand, the under-sheriff, walked side-by-side at the head of the procession followed by Collier who was accompanied by Rev. Canon O'Sullivan, the Roman Catholic chaplain with the hangman behind him. Several warders and about half-a-dozen members of the press, keen to preserve the moment for posterity and future generations, took their place to commemorate the final public hanging in the county town.

According to the Staffordshire Sentinel reporter the 'dying man walked with a firm step, appeared somewhat pale, but quite calm and collected and devoutly repeated after the chaplain a number of ejaculatory prayers that Heaven would forgive him and that the Lord would have mercy upon his soul.' Because the bell did not toll its usual warning of the approaching condemned man, the crowd did not maintain its unbroken silence which they had solemnly shown at previous executions.

As the mournful cavalcade slowly approached the gallows, the quiet prayers recited by a nervous chaplain at his first execution were pushed into the background by the overture of mutterings and raucous shouts of those waiting for the show to begin. By the time they reached the foot of the first step that led to the waiting noose, the crowd began to quieten and a silence took over as the condemned man came closer to his unnatural end.

As the Staffordshire Sentinel reporter wrote: "At the foot of the scaffold there was a pause of a few seconds while the hangman laid bare the neck of the criminal. Dead silence prevailed as soon as the dying man as the chaplain, executioner and two turnkeys ascended the wooden steps and appeared in view of the excited multitude.

'The pinioned man was placed between two posts supporting a beam from which dangled a rope with a noose at the end of it. His lips moved in prayer. The chaplain who was performing his painful duty for the first time, and was visibly affected and seemed to pray most earnestly with the dying man.

'The hangman now produced from his pocket a small white bag which he placed over Collier's head, covering his face, then he fastened the rope round his neck and retired to the top of the scaffold steps and placed his hand on the iron lever which projected. In a few seconds there was a slight click and the trapdoor on which the murderer stood instantly dropped and fell upon its hinges with a heavy rush against the bags of straw which hung on the perpendicularly wooden side of the scaffold, as if the leaf of a table had suddenly given way.'

Then something happened which had never before been seen at a public execution in the town. The condemned man had not been hung. He had escaped the hangman. 'It would be impossible to describe the thrill of horror which went through the crowd beyond the barriers and the gaolers and others within the prison porch at the scene which followed. The closely packed throng of spectators expected to witness the head and shoulders of the murderer as he hung from the beam, his body hidden from their view by the wooden boundary of the scaffold; while the small knot of interested observers in the gaol who could see inside the dreadful machine reckoned upon seeing the whole body of the criminal dangling from the rope with his feet about thirty inches from the ground.

'But Collier and the rope entirely disappeared from the view of the outside public; the others saw him fall with great force upon his feet dragging the whole of the rope after him.'

Imagine for one moment Collier falling into what he would have believed was a black pit of darkness, convinced he had crossed to the other side; a rope biting into his neck tightening its coarseness into his skin and his face covered by a white hood shutting out any light and unaware of what had happened. Then the spectacle of a man supposedly to be half dead, emerging from a tomb like a zombie slowly rising to his feet and the panic of prison staff when they faced the terrifying realisation of what had happened.

'Some of the gaolers were frantic with horror,' wrote the Sentinel reporter, 'one springing from his feet and crying: "Good God, the rope has broken". The prison officials were for a moment overcome by the terrible mishap and were quite powerless.

'But they quickly apprehended what occurred. One of the warders called out: "Fetch another rope". Another ran for a piece of iron framework with which to raise the fallen "drop"; and the hangman, who at first stood in bewildered helplessness, ran down the steps to the miserable wretch, who, after a slight roll against the side of the scaffold, stood erect on his feet, with hands pinioned, the cap on his face and the rope round his neck.'

While many in the crowd shouted and screamed in fear as the whole ghastly situation became apparent, Chaplain O'Sullivan descended the wooden steps to

greet the murderer with repeated cries of 'Lord have mercy upon me', while the bedraggled Collier, the white hood and ropes around his pinioned arms removed by the executioner, Smith, looked bewildered, dazed and speechless at the position in which he found himself.

But those in authority acted quickly to make sure that a second attempt to carry out the death sentence should not be delayed by a second longer than necessary, while hundreds in the crowd chanted their anger and shouted out 'shame, shame' and 'liberty, liberty' as they demanded the immediate release of the hapless prisoner.

But the scaffold was hurriedly rebuilt and a new rope was brought and firmly secured to a beam by a warder, to make the gallows a satisfactory killing machine at the second attempt. Smith, the executioner, once again moved towards Collier to prepare him for the delayed journey to meet his Maker. He placed the white cap over Collier's head, tied his arms by his sides and carefully put the new rope around his neck and stood him precisely on the trapdoor and moved away.

He pulled the lever and Collier plunged downwards with a rush until his body jerked and his whole weight was borne by his neck. There was a sharp crack as bone parted from bone while Collier was suspended above the ground. His body jerked and wriggled once more until it stopped a few moments later and Collier was a dead man. Only five minutes elapsed between the first and second drop and the outpouring of public anger continued. After one hour, Collier's body was removed and he was buried within the walls of the prison; no one knows where. Much building has taken place over the many decades since that execution, and Collier's final resting place in the prison is not known.

As the Sentinel report acknowledged: 'Thus ended the life of one, who, a little over a month ago, was living happily with his wife and family and had every prospect and opportunity of spending the remainder of his days in comparatively easy circumstances.'

Calls were made for a public inquiry into the cause of the rope giving way, but the cause of the situation that provoked such an outbreak of criticism by 2,000 at the hanging was made public in later editions of the Staffordshire Sentinel. It appeared that Smith, the executioner, had nothing to do with fixing the rope to the beam from which Collier was suspended. The rope appeared to have been in two pieces, one of which was passed twice around the beam and spliced to the other which hung down.

This knot appeared to have been improperly tied, so near the end it slipped while taking the weight of Collier's body; no allowance had been for the rope tightening and the end slipping through a loop. An observer remarked that the wretched man had to face death twice over.

Collier was not allowed to give evidence on his own behalf, and neither were witnesses called for his defence. Mr Justice Shee told the grand jurymen a month earlier that all the evidence against Collier was circumstantial. There was nothing to prove that he had committed the murder and no evidence to say he was at the spot where James Smith was found dead. He never made any confession.

Maybe, in a different place at a different time, things may have been different for the man who was hung twice.

Staffordshire Summer Assizes, 5th August, 1843.

CALENDAR OF THE PRISONERS,

TRIED,

BEFORE

The Honorable Sir JOHN WILLIAMS, Knight,

One of the Justices of Her Majesty's Court of Queens' Bench, assigned to hold Pleas before
the Queen herself, at Westminster.

AND

The Honorable Sir William Henry MAULE, Knight,

One of the Justices of Her Majesty's Court of Common Pleas, at Westminster.

JOHN SHAWE MANLEY, ESQ. HIGH SHERIFF.

NO.	PRISONERS' NAMES.	AGE.	READ, WRITE, &c.	CRIME, &c.
1	Richard Nicholds Skerrutt (On bail.)			Assaulting Dinah Perkin on the 20th March, 1843, at Shelton, and ravishing and carnally knowing her against her will. Committed 22nd March, 1843, by T. B. Rose, Esq. *Not a true bill.*
2	James Lockett	36	N.	For a riot, and beginning to demolish the residence of the Rev. Benjamin Vale, on the 15th August, 1812, at the parish of Stoke-upon-Trent. 27th March—J. Harvey, Esq. *Not guilty.*
3	John Evans	42	R. W. Imp.	Assaulting Ann Worton, a child under the age of ten years, on the 10th March, 1843, at the parish of Rowley Regis, and ravishing and carnally knowing the said Ann Worton. 28th March—C. Cartwright, Esq. *To be transported for the term of his natural life.*
4	William Hodson	26	R. Imp.	Maliciously wounding Benjamin Cox with a poker, on the 29th March, 1843, with intent to kill and murder him, at the township of Willenhall. 1st April—J. Dehane, Esq. *Guilty of an Assault—To be imprisoned six calendar months and kept to hard labour.*
5	George Holding (On bail.)	54	N.	Killing and slaying William Tenant, George Richards, James Union, Henry Glover, and Thomas Priest, on the 1843, at the township of Bilston. 1st April—T. M. Phillips, Gent. Coroner. *Not guilty.*
6	William Morgan	41	N.	Breaking into an out house on the 8th November, 1842, at Bilston, and stealing the carcases of two slaughtered sheep, the property of Charlotte Sparrow and another. *Not guilty.*
	The same William Morgan			Breaking into the dwelling house of Christopher Cox, in the night of the 18th November, 1842, at Wolverhampton, and stealing therefrom one piece of flannel, a quantity of barracan, and other articles, his property. 1st April—W. Baldwin, & J. Foster, Esqrs. *To be transported for the term of fourteen years.*

SIX SHILLING MURDER

Sunday morning, on 2 April 1843, dawned chill and overcast. It was an exceptional and typical early spring day, with a damp fog hanging like a cloak over everything and the smell of rain hung in the air. The buds on hardwood trees clung tightly closed on their branches, waiting for the warm May spring days to open them and turn Bishop's Wood into a green oasis full of singing birds.

It was an exceptional day, and for Charles Higginson it was also a special day. It made his blood run cold when he thought of it because today was the day he decided it was time to kill his toddler son in the wood steeped in medieval history.

They had an early breakfast together in the kitchen of a friend's brick and sandstone cottage in the Shropshire farming community of Lipley, near Cheswardine, close to the edge of the thirteenth Century Bishop's Wood, a favourite hunting and holiday playground for successive Bishops of Lichfield, from their nearby country seat in the market town of Eccleshall, which was a regular stop for coaches and horses on their way from London to Chester.

A little after 10 a.m. Higginson, a widower, and his son, William, left the cottage to walk hand-in-hand about three hundred yards to the wood where the tall coniferous pine, spruce and fir, with their green needles, and the leaf shedding decidous trees climbed high towards the sky, their trunks blackened by moisture in the air.

Father and son walked along narrow Moss Lane, littered with rocks and stones and occasionally they stumbled in the deep ruts left by horse-drawn carts from the nearby Moss Lane farm. There was little cover from sudden gusts of wind as the lane meandered its way towards the protection of giant oaks that towered above both of them.

Its mysterious interior was privy to the many ghost stories and local legends that had been created by the local, scattered population and for 800 years the wood spread out across rolling green farmland to form a natural boundary between the agricultural quarters of Staffordshire and Shropshire.

Father and son chatted as they walked towards the wood, and now and then, the little boy left his father's side to run on and play. He laughed and shouted – his

BURIALS in the Parish of _Eccleshall_
in the County of _Stafford_ • in the Year 18_63_

Name.	Abode.	When buried.	Age.	By whom the Ceremony was performed.
Ellen Whittingham No. 2057.	Offley Marsh	May 4	.	Rev. G. J. Harding Offic. Min.
Mary Sims No. 2058.	Cotomen End	7th	42	C. J. Sale Curate
William Higginson No. 2059.	Found murdered in B__ Wood	12	4	Rev. C. J. Sale Curate
Matthew Ewing No. 2060.		24	53	R. H. D. Broughton
Christiana Sheffle bottom No. 2061.	.	24	In Inft	R. H. D. Broughton
Ellen Lightfoot No. 2062.	Croxton	June 5th	28	C. J. Sale Curate
Mary Emery No. 2063.	Fair Oak	12	31	C. J. Sale Curate
Phœbe Swift No. 2064.	Eccleshall	July 10	32	C. J. Sale Curate The Rev. J. Graham son

Six Shilling Murder. The name of little Williamson Higginson is the third name on a page of the burial register of All Saints' Church, Eccleshall.

No. 2057.				
Mary Sims	Coßman Ind	7th	42	C J Sale Curate.
No. 2058.				
William Higginson	Found murdered in Bkn Wood	12	4	Revd C J Sale Curate
No. 2059.				
Matthew Emery		24	53	Revd H D Brington
No. 2060.				
Christiana Kettle.			2.	" ? "

Record of William Higginson's death in the burial register at All Saints' Church, Eccleshall, Staffordshire.

Somewhere in this graveyard are the remains of William Higginson.

Imp. ⎱ on the 13th August, 1842. at the parish of Stoke-upon-Trent.
⎰ 17th May—T. B. Rose, Esq.

Not tried on this Indictment.

The same Richard Malony ⎱ Stealing two geese, the property of William Forrester, at Stoke-upon-
⎰ Trent, after a previous conviction for felony.

To be transported for the term of ten years.

15 *John Weston*........32..R. W. ⎱ Cutting and wounding James Tittensor, with intent to do him some
Well. ⎰ grievous bodily harm, on the 8th May, 1843, at Stoke-upon-Trent.
18th May—T. B. Rose. Esq

Guilty of an Assault—To be imprisoned one calendar month and kept to hard labour.

16 *Charles Higginson,* ⎱ ..26.. R. W. ⎱ Wilful murder of his son William Higginson, alias Higgins, on the
alias Higgins .. ⎰ Imp. ⎰ 2nd April, 1843, at the parish of Eccleshall.
20th May—R. Fowke, Gent. Coroner.

Death.—*To be executed on Saturday the 26th August.*

17 *Eliza Bott*22.. R. ⎱ Concealing the birth of her female illegitimate child, on the 9th April,
(On bail.) Imp. ⎰ 1843, at the parish of Colton. 15th April—J. O. Oldham. Esq.

To be imprisoned three calendar months in the Common Gaol

Charles Higginson's entry in the list of cases at Staffordshire Assizes and the outcome.

childish noises competing with the sound of the raucous screeching of high-flying rooks as they searched and battled for nesting places high in the topmost branches of the trees.

The pair moved further into the dense wood and disappeared from view at a bend of the narrow path, unaware that their progress had been carefully watched by one of the local women through a window of her kitchen in another house, not far from the one they had left.

The little boy's interest and natural curiosity in the newness of things to see excited him, and he regularly let go of his father's hand to run ahead, until he stopped and bent down to look closely at something that had moved in the grass and attracted his attention.

Silently his father came up behind him, and lifting the spade high above his head, smashed it on the little boy's skull splitting it in many places. It was a weapon he had hidden days earlier after he carefully dug his son's grave. The little boy gave a cry and fell to the ground in an unconscious heap. Carefully, Charles Higginson picked up the limp body then moved towards the grave and slowly lowered his son and laid him on the ground. He covered the child's eyes with a piece of bandage and used a second piece to tie under his jaw and back over his head to stop his mouth from opening.

Then, with tears streaming down his face, he lifted the youngster and slowly and gently lowered the unconscious body of his still-breathing son and put him into a deep, oblong hole and covered him with earth and clods of grass. Without looking

back, Higginson walked off to leave his son to suffocate and die a slow painful death.

Charles Higginson was only twenty-six-years-old. His wife had died a few weeks earlier and left him alone to bring up their son who was barely five-years-old. Higginson was not a skilful man and did not have a trade so he travelled the locality to find menial work on farms or helped as a builder's labourer in nearby villages.

He earned just enough money on which to eke out a frugal and meagre living, and had sufficient left to pay a local husband and wife one shilling and sixpence (seven-and-a-half-pence) a week, to look after and care for little William while he slept rough and put his head down where he worked.

But without children of their own, Sarah and William Breeze of Lipley Heath lacked parental skills and found life with a boisterous five-year-old a strain, and were unable to cope with a growing adventurous little boy. They lived in a small cottage where there was not only a shortage of space, but the weekly one shilling and sixpence was barely enough to feed William, let alone themselves.

With regular work difficult to find, Higginson ran into debt with the friendly, caring part-time parents. His son had lived with them for nearly three months, and for the last four weeks he had not earned enough to pay for the boy's keep, let alone feed himself. They proclaimed that he now owed them six shillings (thirty pence) and told him it was time for the boy to move on because they no longer wished to look after him and urged him to find somewhere else for his son to live.

The strain of providing for himself and a little boy of five began to manifest itself and Higginson realised he could resolve his predicament simply and easily by killing his son.

The Breezes had looked after the little boy for only a short time but Higginson thanked them for what they had done, saying that without their help he would have been unable to manage, but that he had found a new house for his son at his brother's cottage at nearby Knightly, less than five miles away, where he felt the child would have a happier life and be better off among people he knew.

But this lively, growing boy had become too much of an encumbrance and burden for the young widower, as well as a financial strain and something that impeded his freedom. Higginson looked upon his plan to murder the boy as the only way out. He became a haunted man, desperate to hide the crime he was eventually to commit. They enormity of what he had done preyed upon his emotions when he realised his son would pay the price for his failures.

It preyed upon his conscience so much that he confessed voluntarily, several days later, and he tried to cover up the killing, telling people that William had passed away naturally as they walked through Bishop's Wood.

But once a lie starts it is difficult to know where the truth begins and Higginson continued to weave a web of deceit as he made up one story after another to try to protect himself. He told one lie that the boy was taken ill at a relative's house at Wednesbury near Wolverhampton, some weeks earlier and was buried before a message could be sent out. On another occasion he said his son had died from an eye infection.

Workmates listened to his incredulous tales and they found it difficult to reconcile one far-fetched story with another. But on Wednesday, 10 May, 1843, a little more

than a month after the little boy was murdered, George Cooper, a shoemaker, and four friends, went to Bishop's Wood after one of Higginson's monstrous stories became too much for them to bear.

They went into the wood and searched among the grass and fallen branches and, after about fifteen minutes, one of them found the decomposing remains of the little boy buried in his shallow grave under the protection of an oak a few feet off a track.

Little William Higginson, whose life on this earth was only a short visit, had been dead about five weeks and his partially decomposed body was found under a small mound of earth covered by a layer of ferns. The news of the boy's death and the discovery of his remains, in such bizarre circumstances, spread rapidly to the populations of nearby villages.

The local constable was alerted and a hue and cry was raised for the man responsible for the 'terrible murder in Bishop's Wood.'

A hue and cry comes from the Latin 'hutesium et clamor', literally a horn and shouting. It was said that anyone, either a constable or a private citizen who witnessed a crime, shall make a hue and cry and that the hue and cry must be kept up against the fleeing criminal from town to town and county to county, until the felon is apprehended and delivered to the sheriff.

Hue and cry dates from the middle 1200s and it was made clear that all able-bodied men, upon hearing the shouts, were obliged to assist in the pursuit of the criminal. Residents of the manor were duty bound to 'raise and respond' in order to assist in the apprehension of criminals.

Higginson's description was sent as quickly as possible to other police forces in Staffordshire's neighbouring counties of Shropshire and Derbyshire, and the biggest manhunt ever seen in the region was organised. In the meantime, as the search for his father intensified, the body of little William Higginson was carefully and reverently removed from his tiny grave and, for convenience, taken to the nearby home of George Adams, a farm worker, who lived in a cottage at Fairoak on the opposite side of Bishop's Wood, where Higginson and his son were last seen.

An inquest was opened for the formal identification of William Higginson, and the inquiry was then transferred to Eccleshall, five miles away, where it was planned to hold a full inquiry into the little boy's horrific death. It was there, that for two days, Mr Robert Fowke, the local coroner, resumed the inquest in front of a jury of eight local residents, who listened to a mass of information from witnesses and heard gruesome testimony from a local surgeon who gave the cause of death.

Locals from surrounding areas crowded into the small room where the inquest was held, unable to believe that someone within their community had committed such a heinous crime.

Nowadays detailed statements are taken from witnesses for inquests and, when the hearing is completed and a verdict returned by a jury or recorded by a coroner is declared, papers in the case are, by law, kept for a minimum of fifteen years in a local records office. It was unlikely in 1843 that records were kept and the only evidence available to twenty-first century researchers and historians are local newspapers of the time.

Journalists in the mid nineteenth century were renowned for their skill and verbatim accuracy, and it is safe to say without any fear of contradiction that an

unnamed journalist with the prestigious weekly *Staffordshire Advertiser* broadsheet faithfully reported details of the lengthy hearing.

On 13 May, at the start of the resumed inquest, he reported: 'A serious investigation has occupied the attention of Robert Fowkes Esq, a coroner and jury in Eccleshall, two entire days which terminated last night, Friday, with a verdict of wilful murder against Charles Higginson, a labourer. Higginson, who is a widower, is supposed to have murdered his child, a boy of about five years of age, in Bishop's Wood and to have buried him there.

'Higginson, who had been working in Shropshire, made some extraordinary statements to his fellow workmen and master respecting his child being taken ill and died in his arms and he buried him in Bishop's Wood. He proposed to go and point out the spot where the child was buried on the following days but instead of keeping his word he absconded and has not been heard of since.'

On Saturday of the following week, in the latest edition of the Advertiser, the evidence was reported of Sarah Breeze who, with her husband William, had agreed to look after the young Higginson child when his mother died. The couple's home was about three hundred yards from the edge of Bishop's Wood, in a straight line with an unimpeded view.

The timid, childless Mrs Breeze 'having seen the body of the unfortunate boy she had cared for and looked after for three months, confirmed his identification to the coroner "because I know it by its clothes, features and size".'

Charles Higginson worked for farmer James James at nearby Park Heath Farm, when he sought to employ a stand-in mother for his son and a home which would give him some regular continuity in his young life, blighted so early by the death of his mother. The coroner, the jury and members of the public, which by now had grown as those eager to hear what happened were packed into the small, almost airless room, listened intently and silently as Mrs Breeze, unaccustomed to the glare of public attention, quietly and carefully related how, months earlier, she first met Charles Higginson and his son.

'About 11 weeks ago Charles Higginson came to my house with the deceased and asked me to take care of the child for him and said he would pay one shilling and sixpence a week. He paid for the first seven weeks. When he brought the child he told me he was in the employ of Mr James James. About a week after he paid me he called at my house and said he had left Mr James' and I told him to look out for another place for the child. He said he would and left the home.

'He called again on the Sunday following and said he had provided a place for his child at his brother's. (This was at Knightley, another small farming community about five miles south.) He appeared to be very fond of the child. He called again on Sunday, 2 April, and said he had come to take the child to his brother's.

'I packed the child's things and his father took him away about 10 o'clock. Charles Higginson and the boy breakfasted with me before they left. I did not perceive any alteration in the conduct of Charles Higginson or anything particular in his manner.'

The next witness was George Cooper, a shoemaker from Cheswardine, and one of five men who found little William's body in his small grave. He told the coroner he knew Charles Higginson but had not seen him for about two years. He related that because of rumours that had been spread about, he and four friends decided to take

it upon themselves to go Bishop's Wood on Wednesday, 11 May – the day before the inquest opened – to find out how much truth there was to the stories that had spread rapidly from village to village.

In his words, he told Mr Fowkes, the coroner, and the jury, what they found after he and his friends entered the wood. 'After looking around for about a quarter of an hour I saw something that attracted my notice. I went to it and found it to be a clod turned up and looking particularly at the spot I perceived a number of clods and laid out rather in the form of a grave. There was a little fern thrown over the place as though to conceal it.

'I pulled up one or two sods and then called my companions who immediately came to see me. We removed the sods and after digging to a depth of nine or ten inches I saw the sole of a shoe. We carefully removed the soil with our hands and soon to the body of the deceased lying on the right side with his arms and legs bent up and the right hand under the right cheek.

'There was a quantity of fern over the face and a bandage over the mouth. I assisted to remove the body to the house. (This was George Adams' cottage about one mile away at Fairoak where the inquest was originally opened.) I saw no bruises on the body but it was covered with dirt. The clothes he had on did not appear to have been torn.'

There was a numbing silence when Mr Cooper finished his evidence and people looked at each other, unsure that such an awful thing could have happened to the small boy.

Mr C. J. Greatrex, a surgeon who lived at Eccleshall and who carried out the post-mortem, then known as a pathological examination, went into the witness box after Mr Cooper and told how he saw the body of the the boy and 'examined it most carefully.'

He realised how important his evidence was to be and he carefully went through each stage of his examination so that no-one would miss anything. He said the boy was about five years of age and estimated that little George Higginson had been dead for about a month to five weeks.

'There was a bandage over the eyes and mouth and strong marks of pressure caused by the bandages. The bandage over the lower part of his face was tied in a knot just over his mouth and the bandage over the eyes was fastened over his temples,' he told the coroner.

Mr Greatrex said that from an external examination he could find no evidence of wounds or fractures, although a bruise over the right eye appeared to have been caused by a blunt instrument. But there was no evidence of other external marks of violence. He then went into detailed evidence of the internal examination he carried out and, in a careful and articulate way, left a lasting impression on the minds of the jurors and public who packed into a small house to hear the gruesome evidence.

'On removing the skull I found the vessels of the brain congested and a fracture of the inner table of the frontal bone. I have no doubt that the injury I have described was the cause of death and that it had been done by a blow from a blunt instrument or a kick. The legs and arms were drawn up and the body had the appearance of having been placed in a small grave. The injury on the frontal bone and underneath it corresponded with the external marks of violence which were over the right eye.'

The first day of the inquest ended and was adjourned until the following morning, to enable people who worked with Charles Higginson to take their place in the witness box and tell what they knew of him.

When the hearing resumed, many more members of the public turned up and the interest of the public had by now increased, as the story of the man who killed his son rapidly reached many of the small villages round and about Eccleshall. They crowded into the small room used for the inquest and, as they stood squeezed together trying to get comfortable, Mr Robert Fowke resumed this inquest and the eight locals chosen for jury service made themselves comfortable for another day of disturbing evidence.

George Sambrook, a bricklayer, arrived from his home at Hinstock several miles away. He looked around at familiar faces among the onlookers, and smiled and nodded at some of those he recognised, before making himself comfortable to give his evidence.

He told how, three weeks earlier and not long after the little boy had apparently died, Higginson was given a job at Doley, another small village where little Charles Higginson lived with Sarah and William Breeze for the last days of his short, young life.

'When he first came to work for us he said he had been married and lived at Parkheath, that his wife was dead and that he had a child who he had take to his father at Knightley who would keep it (sic) for him. A few days later I met Higginson at Doley and he began to tell me about his child. He said someone had brought him word that the child was dead and buried. I said "It is strange that they should not let you know if it is so. If it was a child of mine I should go and see" but he made no reply.'

Another workmate was Samuel Reeves, who spoke to Higginson and was apparently overheard by the bricklayer George Sambrook to say: 'Charles, there is some pretty damn talk about you and this child. I don't hardly know what to make of you. We have been hearing so many tales about it. You told me when you first came that your child was at your father's house and you told me last night that the child was at Wednesbury (a part of Wolverhampton). I doubt you have done something with it.'

George Sambrook was recalled to continue his evidence and told the coroner and the eight jurors that Reeves had told him that Higginson was silent for a while then looked up and was 'very red in the face.' Sambrook said Higginson told Reeves: 'I'll go. I can soon clear myself.'

Sambrook said that Higginson then went to another part of the farm to carry on work in a building. Later in the day, Higginson and Sambrook were working together when the young widower proclaimed he had received a letter which disclosed to him the death of his son a few weeks earlier.

Sambrook told the coroner what he said to Higginson. 'Charlie, I hardly know what to make of you. You are hearing so many tales about it. I think it will be best for you to tell the truth about it. If you will tell the truth it will be all the better for you.'

He said Higginson walked away to collect some bricks and mortar and later returned. Sambrook explained carefully that Higginson's attitude appeared to have changed and gave the impression that he was about to confess to something. He

claimed Higginson told him: 'If you will not say anything about it I will tell you all about it and the truth. I was going to take the child to my father's and was taking it through Bishop's Wood. The child was very bad and died in my arms and I buried it there.'

Sambrook told the coroner: 'I said to him: "Charles, if it died, how came you to bury it there? Why did you not take it to some house?"' He said Higginson replied: 'What could I do? I had no money to bury it with and I could not carry it.' Sambrook said he told Higginson: 'Well, I don't know. If it is so, it is a terrible job.'

Sambrook continued his evidence and said that, in the evening of the same day, he went with Higginson and two other friends to the local Wheatsheaf public house where they shared ten pints of ale. They stayed for a couple of hours and when they left about 8 p.m. one of the men stopped Higginson and asked him if there was any truth to the rumour and gossip going around the local communities about the death of his son.

Whenever people talked to Higginson about the youngster he always answered them by referring to the boy as though he was an object; something someone possessed – something without life or feeling. The dead youngster was always 'it', never 'William' or 'my son.'

But it was about this time that Higginson's conscience was beginning to take over. While talking to one of his drinking friends the truth began to manifest itself and he confessed: 'I have told George (Sambrook) all about it. I was taking it through the wood when it died and I buried it. If you chaps will go with me in the morning I will show you where it is.'

Even at this stage Higginson was unable to bring himself to refer to his dead son as William. He still insisted on call the boy 'it' and at no time did he ever explain why.

The inquest continued the following day, in front of Mr Fowke and the jury, and witness after witness took their turn to go into the witness box to give evidence, but what they had to say added little to what was already known of the incident a few days earlier, and took the matter no further.

It was now the duty of the coroner to sum up and go over the pertinent facts of this deeply sad case and point what he thought were the special facts. He then invited the jurors to consider their verdict – which he directed that, based on the overwhelming evidence, could only be one of deliberate killing.

The eight male jurors talked among themselves, for what they considered a respectful length of time, and then unanimously returned a verdict of 'wilful murder' against the absent Charles Higginson, who was on the run.

By now, many people in the small local farming communities dotted around the central part of Staffordshire began to take in the enormity of the jury's verdict, and the hue and cry was raised as word spread that Charles Higginson must be caught, and very quickly.

He had disappeared very shortly after his son's body was discovered. His description was circulated to police forces throughout Staffordshire and the neighbouring counties of Shropshire and Derbyshire. Communications between one force and another were non-existent, and the only way policemen could keep in touch was by messengers on horseback and so it was a credit to the local

constabularies that it was not too long before the runaway murder suspect was eventually arrested and taken back to Staffordshire.

A policeman stationed at Newport in Shropshire was sent to Winster fifty-four miles away in Derbyshire which would have taken him several days with a good, strong, reliable horse. He had received a report that a man matching Higginson's description had been seen in the locality. When the policeman from Shropshire eventually arrived he was taken by a member of the local constabulary to a field and there he met Higginson 'and supposing from the description he had received that he was the man' he arrested him.

Higginson was tired of running and gave himself up without any fuss. He confirmed his identity and that he was the boy's father. All he said was: 'I suppose you want me about my poor child?' It was the first time he had not referred to William as 'it.' He was arrested and taken back to Staffordshire, where he was put in a cell at Stafford County Jail, where he remained until the start of his trial at Staffordshire Assizes in the Shire Hall situated in Market Square, on 5 August, 1843.

THE TRIAL

It was a hot, dusty and uncomfortable day when the summer sun drew the crowds into Stafford from miles around for the trial of Charles Higginson. It was one of many on the list before the Honourable Sir William Maule, a Justice of Majesty's Court of Common Pleas at Westminster. He was on a regular assize circuit to deal with the most serious crimes on the criminal calendar.

Every crime known to man was on the list of cases to be heard and, with no such thing as legal aid, defendants would be thrown to the lions and left to their own devices. They had little, if any, help to try to cope with the intricacies of the law and eventually disappeared under something they could not understand and so little time would be wasted on them in dispensing what was then quaintly known as 'justice.'

The list of sentences was endless and varied from death at the end of hangman's rope, to transportation to Australia for petty theft offences, with little hope of ever returning to their families, because they would never have enough money to return the thousands of miles home.

The list of crimes was as endless as those who committed them and punishments inflicted were as varied in their extremes as the lawmakers in their wisdom could devise in a land the line was wide between social classes. The haves with wealth and endless comforts were so far divided from the have-nots that they rarely if ever gave any thought to those at the bottom of the pile and would never contemplate their plight.

The aim of the legal machine was grudgingly to 'protect the children of the poor and punish the wrongdoer' and so often it seemed the wrongdoers were the poor and those who did not have anything.

The imposing Shire Hall was built in 1798-99 at a cost of £5,000, which then was an astronomical amount of money and at the time the expense was considered 'lavish' – if not extravagant. It included a judges' house. There were four semi-doric

columns supporting a pediment in the centre on which stood a figure of Justice, and the front of the building was 120 feet long. Justice and possessory assizes were held regularly in the town from about 1228. From August 1575, following a royal promise pledged by Queen Elizabeth, Stafford was firmly established as an important legal centre in Britain.

It was here that Charles Higginson was to be tried for the murder of his son. There were two courts in the Shire Hall and his trial was to be held in Court Number One. It was here that the public gallery was jammed as the curious struggled for places at what was looked upon as one of the busiest and greatest social gatherings of the year. Friends met with those they had not seen since their last visit and looked upon the trials as a great measure of entertainment.

With a cast as different as the crimes they had committed, the wrongdoers waited in the wings for the curtain to raise on a bizarre stage, in which their performance presented an amusing and pleasurable feast of experience, enough to satisfy even the most demanding of uncultured tastes.

The babble of the rabble in the public gallery was silenced to a low whisper as the voice of a gowned and imposing figure boomed and demanded silence. The eyes of the rabble turned towards a small door behind the judge's chair opposite the public gallery, and as it opened in strode Mr Justice Maule in his red robes and ceremonial wig, with all the attendant pomp and pageantry befitting the role of a judge of the High Court.

Mr Justice Maule carried his nosegay posy of flowers just a little way below his nose to protect his delicate olfactory sense from any unsavoury smell which might attempt to pollute the air around him.

He was followed by his clerk, the High Sheriff of Staffordshire, there in his historical role of protector; the Under Sheriff, and the vicar from the nearby St. Mary's Collegiate Church, who would pray for Divine guidance for the judge to properly and fairly dispense justice.

There were more to come in the form of local dignitaries who solemnly trooped in to stare in wonder and unaccustomed amazement like visitors to a zoo, who never before had been so close to the smell and obscene goings on of lesser mortals.

The court clerk wore his black robe which was adopted as official court dress at the beginning of the seventeenth century, when at the funeral of Mary II in the late 1690s was believed to have been worn as mourning dress. He wore a white wig with thirty curls – twenty-eight on the crown, back and sides and two on a tail or queue hanging from the back.

He demanded silence and called for the prison officers down below in the cells to bring up Charles Higginson and put him in the dock. Higginson was on his own, a miserable sinner whose life and future lay in his own insecure and inexperienced hands. There was no benefit of learned counsel for the wretched, bewildered Higginson. He was a tortured soul in a legal wilderness who must take his chances against the might of the law.

The court was silent for the arraignment as the clerk read the charge from an indictment: 'Charles Higginson you are charged that on 2 April, 1843, you murdered your son, William. How do you plead?'

Higginson faced the judge and replied: 'I am guilty and I beg for mercy, if you please.'

It was a signal for Mr Justice Maule to lean forward in his seat on the bench and look towards Higginson. Irritation lined his miserable, florid face and laid the way for a reprimand as he told Higginson: 'Prisoner, listen. If you plead guilty I must pass sentence upon you and you will be hanged.' He made sure his words lay heavily on Higginson who stood bewildered in the dock and ordered the clerk to put the indictment again.

The clerk stood up, took the indictment in his hand and once again faced Higginson to repeat his question. 'Do you plead guilty or not guilty?'

Higginson looked up, paused for a moment as he considered his reply, and told the clerk: 'I am guilty. What I did, I did for want.'

Again the judge looked at Higginson, totally agitated by his reply, and admonished the young father for not replying correctly to the question put by his clerk. 'I can take no special plea. If you persist in pleading guilty you must take the consequences.'

At this point a Mr Brutton, the governor of Stafford Jail, who had sat quietly in a specially reserved seat at the side of the dock on the prisoner's right, turned towards Higginson and after a quiet but brief conversation, the accused man faced Mr Justice Maule and uttered, in what was later described by observers as a 'dummy way', the words 'not guilty.'

It was now the turn of the prosecution represented by a Mr Corbett. He stood and faced the jury and, with little skill, impressed on the twelve people, who would have in their hands the future of life or death, of his judicious, dignified authority and explained simply that it was his duty to acquaint them with the horrible facts after which he was convinced they would need little time to convince themselves of Higginson's guilt.

Mr Corbett made himself comfortable, put his papers in order and prepared to set the scene as the wheels of the lumbering legal system ground into gear and gathered momentum towards its inevitable conclusion. He looked at the jurors and said: 'The prisoner was a widower who was left with one child,' he said, impressed at the way he attracted the jurors' attention.

'He had been a farmer's servant and lodged at the house where his child had a nurse. He got into arrears for the child's maintenance and was told that unless he paid he must take the child away. In a day or two afterwards he said he had arranged to take the child to his brother's at Knightley which he would on the following Sunday.

'On the morning of Sunday, 2 April, he borrowed a spade early in the morning and left the house. He returned a little before eight o'clock and he and his child having breakfasted left the house about 10 o'clock and went in the direction of Bishop's Wood which was not a direct way to his brother's residence. He was seen to enter the wood with a child and watched until he was lost sight of going in the direction where the body was found.'

Mr Corbett paused in his narration to allow time for the impact of his last remark to have its desired effect on the jury and was pompously pleased so far with the presentation of his case. People in the public gallery were quiet as they leaned forward to catch every word. He continued his story in a way which compelled even greater interest.

'Nothing more occurred for several weeks when he began to give different accounts of the child's death which ultimately led to the discovery of the body

buried in Bishop's Wood. The prisoner left the neighbourhood and was apprehended in Derbyshire. You will hear evidence of the seriousness to the manner in which the child came by his death and it will be for you to a verdict to this case. The facts will be to plain to admit without any doubt or difficulty,' he told the jury.

One by one, witnesses who gave evidence before Mr Fowke, the coroner, were called on to repeat their stories to the jury. William Breeze, who with his wife Sarah, looked after little William Higginson, showed their nervousness as they gave evidence and added new information which was not disclosed at the inquest.

He told how Higginson asked for a wake-up call at five in the morning of Sunday, 2 April, 1843, on the day William Higginson was killed. 'He asked for a spade and said that Mr Reeves wanted him to do a job but he returned without the spade,' said Mr Breeze, somewhat overwhelmed by his surroundings.

Farmer Samuel Reeves followed Mr Breeze into the witness box and denied vehemently under oath that he had never asked Higginson to come to his house on the morning of 2 April and had never even seen him.

Gradually, Mr Corbett called a steady stream of witnesses to build up his case against the wretched Higginson. Maria Higginson, the defendant's sister-in-law, travelled from her home at Knightley to tell her story of how her husband's brother arrived at her home about dinner time on Sunday, 2 April. She said he turned up on his own and, when asked where his son was, quietly told her he was dead.

She said Higginson told her the boy had a bad eye and Mrs Higginson said she told him she had 'never known anyone dying from a bad eye.' She claimed Higginson told her it had been 'bad for a long time with inflamation and mortification and had take place.'

The case against Higginson was to take an amazing turn for the worse when Eccleshall surgeon and pathologist, Mr C. J. Greatrex, who carried out the autopsy, was called as an expert witness. He told the court that he had examined the body 'which was not much decomposed' and found severe contusions on the right side of the head but observed no further marks.

He said he had the boy's body washed before he made any further detailed examination of the skull. He said there was a bandage over the eye and another over the mouth 'tied very tightly which produced considerable indentation of the muscles of the face.

'On removal of the scalp there was a bruise corresponding with the external injury and also a fracture of one of the small bones behind the eye. The bruises were calculated to destroy life and they appeared to have been inflicted by some blunt instrument. A spade would produce such injuries.'

It was here that Mr Justice Maule made his first interruption and decided it was time he asked a question. He leaned over his desk with hands clasped in front of him towards Mr Greatrex, who stood in the witness box slightly to the judge's left hand side, and inquired: 'I think the injuries could not have been inflicted by a fall?' Having made his statement the judge gave Mr Greatrex no time to answer.

Higginson, throughout the morning and the flow of prosecution witnesses, remained quiet with his head bowed most of the time. But it appeared that now Higginson was about to convict himself with an outburst of conscience guilt 'that produced an involuntary sensation of horror through the court.'

Mr Greatrex looked at the judge and decided he would now answer the question and said: 'There was no mark only on his right hand side.'

As the prosecution moved in a relentless way to convict Higginson, the judge asked if the prisoner wanted to ask Mr Greatrex any questions. Higginson stood and replied: 'I put the child in alive. That is all I want to say.'

The remark shocked the court and the clerk called for order and silence. Mr Greatrex recovered his composure much quicker than the judge, jury and the public and, as the effect of the sudden and condemning outburst subsided, he said the wounds he had discovered 'were not of the nature to cause immediate death.'

By now Mr Justice Maule had begun to show some considerable agitation, at what he felt was the singular inability of an expert witness who he thought was unable to answer a question. He thrust his face forward towards Mr Greatrex and exclaimed: 'That is not the point. I wish to know whether, in your opinion, the injuries you observed were the cause of death?'

Mr Greatrex, somewhat flustered and embarrassed at being publicly taken to task in front of an audience, decided it was time to stand up for himself and give a straightforward answer: 'I do not think they would have caused immediate death,' he said. 'The lungs were highly congested and that might have been caused by suffocation.'

Mr Justice Maule controlled his growing anger and insisted on a simple answer to what he thought was a simple question and repeated with a firm directness: 'What in your opinion was the cause of death?' Mr Greatrex replied: 'I think the child received some injury and was then put into the grave alive and died from suffocation. It might be so and I think his death was not produced in any other way.'

After a sustained judicial reprimand a relieved Mr Greatrex completed his evidence and hurriedly turned and left the witness box to walk out of the court building. He was followed by others called to prove the boy's clothing, including the constable who arrested Higginson and described in detail how he took him into custody in the Derbyshire field.

Mr Corbett told the judge that his case was complete and left the way for Higginson to give his version of things on his own behalf or even call witnesses. But left adrift in a sea of legal obstacles Higginson had to defend himself and was not allowed the luxury of a barrister's skilled advocacy.

Like thousands of other hapless prisoners up and down the country who regularly appeared in courts, Higginson had to rely on his non-existent ability to try to defend himself against overwhelming odds spawned of an uncaring legal system. Parliament in its wisdom had decided he was not allowed to give evidence on his own behalf on oath because it was feared he might perjure himself. However, legislators did an about turn, and by 1893 allowed defendants to give evidence.

Mr Justice Maule turned to Higginson and asked if he had anything to say. As all eyes in court turned upon him waiting for his reply Higginson finally condemned himself and muttered: 'I have nothing to say but what I have said. I put the child in alive.'

The judge, apparently satisfied with the answer and unwilling to help Higginson create some form of defence for his action, decided after about two hours'

prosecution evidence that enough was enough for one day, and so proceeded to sum up the case to the jury to help them reach a verdict.

He explained to the twelve jurors that the case was of simple fact and left it to Higginson's peers who sat in judgement to consider all the evidence and the comments from the defendant in his own defence, to reach their own conclusions and return a verdict.

Mr Justice Maule said the circumstances were 'so plain as to require no comment. Did the prisoner kill the child in the manner stated?' It was as simple as that and required little on the part of the jury to eventually reach what they considered was the right and proper verdict after a fair trial.

But before the jury was asked if it had reached a verdict Mr Justice Maule was handed a note from the dock which suggested at the latest stage possible that Higginson 'was of weak intellect.' He asked Higginson if he wanted to call anyone but by now he realised his fate was sealed and there was little if anything he could have done.

However, in a moment of change in attitude Mr Justice Maule decided it would be of little harm if three prison officers and a surgeon from Stafford Jail less than half-a-mile away, who knew Higginson, should be allowed to give evidence on his behalf. They suggested in their evidence under oath that Higginson's low level of intelligence may have created diminished responsibility at the time he killed the boy.

The judge explained to the jury: 'The object of this testimony is to raise a question whether the prisoner was insane when he committed the deed. If a man knows what he does, he is responsible for his actions. If he destroys his child in the manner described then I think you will have little doubt that he knew what he was doing.'

The jurors listened intently. But it took them less than a minute of deliberation and discussion in open court to convince themselves that Charles Higginson, a widower at the age of twenty-six, was a cold-blooded killer who had murdered his little boy and buried him alive to suffocate to death. A decision of such speed and unfairness that it would have made twelve angry men even angrier.

In the days of the Higginson trial, judges were looked upon with awe by ordinary mortals and jurors very rarely spent too long in reaching a verdict, although it was accepted that the lack of adjournments for refreshment drinks or lunch breaks did encourage them to reach a hurried verdict

But the verdict had been reached. The court clerk called for silence and warned those in the crowded public gallery of the pain of imprisonment if they ignored his proclamation. The jury foreman stood, and quietly but firmly said: 'Guilty.'

Mr Justice Maule put on the dreaded black cap and addressed Higginson. 'Charles Higginson you have been found guilty of murder, of taking away the life of your child and certainly, from what appears, with little motive for so dreadful an act. Your object seems to be to save yourself from some little expense and inconvenience.

'Your act appeared to have been of the most deliberate determination that can be conceived for when you borrowed that spade in the morning you must have contemplated your purpose. You appear to have taken this innocent child where you prepared its grave and having knocked him on the head then covered him up and finished the work by suffocation.

'You knew what you were about when you destroyed your child and, therefore, nothing is so absurd as to say you were insane and not conscious of what you were doing. I can hold out no hope. In your case you can expect no mercy in this world.

'You will be attended in jail and I hope will make a proper use of the instructions which you will receive from those who are appointed to attend upon you which is the only thing of importance in your circumstances.

'It remains for me to pass upon you the awful sentence of the law which is that you be taken to the place from which you came and thence to a place of execution and there to be hanged by the neck until you are dead and your body buried in the precincts of the prison and may the Lord have mercy upon your soul.'

Higginson was removed the dock and taken away 'unmoved and with a firm step' for his execution less than three weeks later on 26 August and a little less than five months after he killed his son. He was still news even though his trial had finished, and a week before he was due to be hanged the Staffordshire Advertiser provided enough in its columns to feed the insatiable appetite of a public anxious to savour with ghoulish delight every morsel written about the 'condemned culprit.'

As the day of judgement drew ever nearer the newspaper's reporter gleaned information from sources within the prison and wrote: 'Higginson for several days was in a very hardened and incorrigible state of mind but the Reverend B. Buckeridge, the prison chaplain, has exceeded at length on making an impression on him.

'He acknowledges the justice of his sentence and is sensible of his awful condition. Although a man of obtuse intellect he appears to have received a tolerably good, plain education. He can read well and refer to any passage of scripture in a moment.'

But his knowledge of the bible could do nothing to put off the inevitable and as the appointed day of execution on the 27 August dawned with a clear blue sky, a hot summer's day expected, a growing number of people began to flock into Stafford from nearby villages and towns to gather around the gates of the town's county jail in a carnival-like atmosphere. By eight in the morning Higginson was ready to meet his Maker and the crowd outside was more than willing to give him a good send off.

The *Advertiser* reported: 'The murderer, Higginson, this wretched individual, underwent the awful penalty of the law on the drop in front of the county jail. At eight o'clock the knell of death announced the approach of the miserable culprit and in a few minutes he ascended the scaffold attended by the Reverend B. Buckeridge, the governor and other officers of the prison.

'His appearance indicated great mental agony and his wasted energies were scarcely sufficient to keep him from falling. The executioner, having adjusted the rope and placed the cap over his face, drew the fatal bolt and the unhappy man was launched into eternity. The body, after hanging the usual time, was cut down and buried within the walls of the prison.'

The public, who had waited with great anticipation for the last few minutes of a man's life, stood quietly while William Calcroft, the executioner, a stout man with an extremely proud, bushy beard, who wore a white smock for his work,

carefully placed the noose over Higginson's head with the knot just under his left ear for maximum efficiency as a killing machine. After he carefully fitted a cap over Higginson's face to shut out forever his last day on earth, he checked his handiwork.

Satisfied that everything was in order the bolt was pulled and Charles Higginson dropped to his death, his body suddenly brought to a rapid stop by the rope and his neck cracked. He died within seconds. Higginson twitched and twisted and paid with his life for the life he had taken.

Calcroft, who travelled from Dudley thirteen or fourteen miles south of Stafford for his gruesome job, was paid £10 a time to despatch some wretched human into eternity. He was an impressive, powerful looking man whose appearance must have added a little more fear for those waiting to have their necks stretched at the wrong end of a noose.

Calcroft must have enjoyed instilling fear into his victims because, not only was he the official executioner, but there was another part of his character which seemed to enjoy violence. It was his job to flog miscreants in the prison who had broken the rules and needed cruelly teaching a lesson.

There is nothing on record to show anything of the life of William Calcroft. Record offices at Staffordshire County Council archives and the William Salt Library in Stafford only have references of his appearances at some hangings. Dudley Metropolitan Council has nothing about a man who was a local citizen.

The man was also elusive at Stafford Prison where a governor said he could not find any records on someone who played a special part in the lives of people on their last day on earth. For someone who held such an important position within the judicial system it is surprising that information was not available regarding his life in Dudley and what he did while waiting for his next appointment at the county jail.

Charles Higginson was buried within the walls of the prison but there is nothing to indicate his final resting place. The original site which would have had only an arrow and a reference in a book has long since disappeared.

The law, in its role of protector of the poor and punisher of the wrongdoer, had cruelly avenged the death of little William Higginson. He was buried in the grounds of Eccleshall Holy Trinity Parish Church 10 miles from Stafford County Jail, on the morning of 12 May, 1843, at a service conducted by the curate, the Reverend C. J. Sale, five weeks after his father killed him.

There is nothing to be seen all these decades later which could mark the spot for his final resting place in a pauper's grave somewhere in the corner of the church cemetery. He was a little boy who had very few to mourn his passing. All that remains to commemorate his short existence on this earth is a record of his burial to be found in the Eccleshall Parish Register.

HANGING

The noisy, boisterous crowd was growing steadily larger and eagerly excited as more and more folk, intent on a pleasing and excellent day, streamed out into Stafford from hamlets and villages around the county town, to join thousands of others to watch people being executed.

There was nothing like it, on a hot summer's day, to see another human swinging from the gallows, and to hear their neck crack as the rope took the full weight of a body, with hands and legs tied and a hood over their head. Their feet twitched as they twisted and turned, hopelessly fighting the coarse rope which cut into their neck and slowly strangled them. They very rarely died immediately, but instead had to endure the indignity of being watched by so many people as they paid the ultimate price for the offence they had committed.

A hanging day was a chance for friends to meet up with those they had not seen for maybe months, and gossip about what had been going on since they had last seen each other. People in the eighteenth and nineteenth centuries thought nothing of going with the family, including children, and friends from neighbouring homesteads to the county town, for the festive atmosphere of a hanging.

As the time drew nearer for another wretched victim to meet his fate, ghoulish onlookers squeezed together by the thousands and looked on in silence until the executioner, Thomas Calcroft, arrived from his home in Dudley, around twenty miles away in the West Midlands, to perform another deadly service for which he was paid around £5 to £10.

He took his place at the top of the gallows, waiting for the latest convicted man, who was manacled and chained and surrounded by the chaplain and prison staff, to make his way up the steps towards the noose, a small circle of rope that waited to bring to an end his short life on earth. Calcroft was a big, bearded, patient man who enjoyed his work and the regular pay days it brought him.

The hopeless, condemned prisoner, supported on either side by a prison officer, waited for his appointment with death as Calcroft placed a white hood over his head. The grisly scene set, the executioner moved quietly forward and pulled the lever that dispatched another wretched victim into eternity. As the body dropped

and slowly turned, the crowd broke into cheers and clapped as if it was a wake rather than an execution.

If the body failed to fall far enough to kill the condemned man the executioner's assistant was encouraged to move forward and grab the dying prisoner by his feet, to add some extra weight to pull him down and speed up his death.

This was a so-called deterrent sentence, set in the hope that others would stay away from crime. Then, like now, the mantra 'deterrent sentence' was frequently used to send out messages to those intent on making crime a livelihood, but which more often than not fell on deaf ears. The message was to stay away from crime and all would be well. The judiciary, from their high places – just like those today – were convinced that passing such sentences would make others think twice and hold back from entering a life of crime. The deterrent was about as successful as a snowball's chance in hell.

Ever since Cain murdered his brother, Abel, nothing has stopped people killing each other. It has gone on for centuries and more likely than not, will carry on for many more centuries to come. People did things and, until the abolition of the death penalty, gave little thought to the consequences and the possibility of facing death at the end of a hangman's rope, the electric chair or any other form of state execution.

A criminal's life in the 1700s and 1800s could only be described as a cheap commodity – the victim of what was nothing more than a cruel, callous, sadistic and perverted legal system where counterfeiting currency, house breaking or even bestiality was a crime, on a par, as far as the sentence was concerned, with murder. Break the law and lose your life.

How stealing livestock or counterfeiting currency could be deemed as serious as killing another human being should have been clear to our lawmakers; the sentences were totally out of proportion to the crime committed. It should have been obvious that for murder – the ultimate crime one human being could commit against another – capital punishment was the only sentence. To hang someone for stealing sheep or cattle begged the question – why?

A. J. Standley, a retired prison officer at Stafford Jail, spent thousands of hours on a labour of love, writing and compiling what must be the most comprehensive and in-depth history and anthology of the prison ever put together.

His work covered two centuries of a place of incarceration that was built near the town centre and opened in May 1793, to replace a gaol and house of correction then at the North Gate of Stafford. The first execution was carried out on 17 August, 1793 and by the time of the last one on 19 March, 1914, various hangmen had despatched 120 victims into eternity to meet their Maker.

One third of those who died on the gallows were convicted of murder during excuses for trials that were nothing more than a disgrace and normally lasted less than a day at the regular assizes in the town centre, Shire Hall in Market Square. They were show trials; places where judges were supposedly there to be impartial arbiters and referees, qualified and able to be fair and make sure the defendant was treated fairly and able to present his case on a par with the prosecution.

But such things did not happen. Human rights did not exist. The unfortunate defendant was grist for the mill. Judges did not care. They had a chance, while

on circuit, to meet up with the local gentry, the county's nobility, the aristocracy and upper crust, keep good company and eat well. The job was something of a nuisance which had to be completed in the quickest time possible, but also giving the impression they were doing it properly.

The defendant – he or she – was more or less an onlooker at a hearing, where their life was at stake and they took little, if any, part in the proceedings. They were not allowed to give evidence on their own behalf because Parliamentarians, in their wisdom, felt they would leave themselves open to committing perjury by being allowed to go into the witness box and give evidence. But that changed in 1893, when Parliament decided to introduce legislation which enabled a defendant to give evidence on his or her own behalf.

But the legal killing for murder did not stop there. A wretched diverse group of others also met their fate at the end of a rope and were hung for an assortment of ten-a-penny offences like burglary, horse, sheep and cattle stealing, counterfeiting coins, and the more violent who took part in highway robbery, assault and robbery, forgery, arson, housebreaking, rape and bestiality. Nothing much has changed in today's society. It is safe to declare that the stories are the same. The only difference might be a variation on theme but sadly the cast is not short of identical.

The first person to die at the end of a hangman's rope in Stafford was a twenty-one-year-old soldier, Ebenezer Colston, on 17 August, 1793 for the murder of a man at Wolverhampton. On the same day John Hackett, a forty-year-old cordwainer, met his death for burglary. On 11 April, 1795 labourer Thomas Jones, aged fifty-five, was hung for horse-stealing, followed rapidly by Joseph Foster, aged forty-two, and William Nield, aged thirty-eight, both labourers, also convicted of horse stealing.

The law enjoyed imposing capital punishment for offences that nowadays are so common, if the gallows were still part of our legal system, there would be a never ending conveyor belt of human souls heading for a one-way trip. On 11 August of the same year, twenty-nine-year-old Joel Lunn, who worked making guns, was executed for housebreaking and his wife was transported to New South Wales, Australia, never to return.

It was not until March the following year that executions became the flavour of the month. On the same day – the 26th – outside Stafford Prison, the thousands who flocked in to the county town from villages and hamlets in the outlying countryside, for this regular, big social event, were treated to watching four poor souls mount the steps to the gallows.

Michael Dorricutt, a twenty-four-year-old labourer, was hung for murder. After he was despatched into eternity, he was followed by a twenty-five-year-old labourer, Thomas Brown, who was convicted of counterfeiting coins. Two burglars then took their place on the first steps that led to the noose – John Horton, aged twenty-nine and his co-accused, James Nightingale, only a year younger.

For nearly four months the hangman was off duty and the gallows were not used. But on 28 August, 1797, surgeon-apothecary, Thomas Millwood Oliver, just twenty-eight years old, died after two attempts were made to hang him. He was convicted of murder at Burslem, Stoke, and sentenced to death with the execution fixed for a few days later, but when he waited for his last few moments and he prepared to travel into eternity the gallows broke.

The huge crowd, who had turned up to watch, gasped as the wooden contraption gave way and crashed to the ground. Calcraft the hangman, his assistant and the prison chaplain escaped unhurt. Prison staff moved quickly forward, hastily re-erecting the gallows, and on the second attempt the hanging was successful and Oliver died.

Oliver's execution was the only one in 1797, but in April and August of the following year two men – one nineteen and the other twenty-one – were hung side by side following their joint conviction for highway robbery. In August, a young soldier was executed for assault and robbery, and on the same day a thirty-seven-year-old butcher, Edward Kidson, was hung for stealing cattle – an offence which carried the same sentence as if he had murdered a fellow human being.

And so they continued, with the executioner being busier in some years than others in the name of justice. 28 March, 1801, was a busy day with three men hung – one for assault and robbery, another for uttering a forged note and the third for sheep stealing. Four months later in August five men, aged between nineteen and thirty, were hung on the same day; their offences were stealing sheep and horses. And so the hangings went on for murder, bestiality, horse stealing, forgery and counterfeiting.

On 21 March, 1817, twenty-eight-year-old Ann Statham was jailed for the murder of her infant daughter. As Ann knelt in prayer on the platform, the scaffold on top of the Lodge gateway at the prison gave way, and she, the chaplain and several prison officers fell to the roof below. The scaffold was hastily reassembled and the execution was carried out.

The hangings continued on a regular basis until 1914. By 1832, the death penalty was abolished for the crime of stealing goods to the value of five shillings or less. Nine years later offenders were no longer hung if convicted of rape but the death penalty was retained for treason and murder. In 1868, public hangings were abolished and 40 years later, in 1908, children below the age of sixteen were no longer executed.

And so changes in the law gathered pace, as attitudes to capital punishment were reviewed and by 1931, the execution of pregnant woman was banned. A year later, Parliament introduced new legislation, which ended the death sentence for people under the age of eighteen.

In 1965, the Murder (Abolition of Death Penalty) Act became law and executions were suspended for five years. Within a year, the House of Parliament, supported by the House of Lords, agreed to abolish the death penalty for murder and end a long period in British history, which saw hanging as a cruel and barbaric method of punishing people written out of the statute books.

CONFESSION OF A DOUBLE KILLER

The bright early morning sun shone through the square window of John's prison cell, lighting up the drab, small brick room and casting a shadow of the bars on to the wall nearest the steel door with a peephole for warders to keep an eye on him. A metal bed, with its prison issue sheets and blankets, was against one wall, with a wooden desk and a few personal belongings alongside the other.

The beginning of each day was virtually the same but as the seasons came and passed, the imperceptible dawn of each morning changed lightly and subtly as the warm summer days moved into the coolness of autumn then the colder, dark days of winter.

For John very little would change as time, regularly, monotonously and patiently ticked by counting off the seconds, minutes and hours that turned into days, weeks and becoming months and months, turning ominously into years, with his life stretching before him into a dark, dreadful and foreboding future that held little hope.

It became a numbing trespass on his senses and a daily reminder that he would never be a free man again. John had killed with extreme violence. Not just once, but twice he had savagely taken the life of two human beings in a frenzy of anger, sending them into early graves that accepted them well before their allotted time should have ended in the world of the living.

He had haunting years to reflect on the enormity of his crimes. The torment of time, to think over and over again about what he had done and the twenty-nine years of self-imposed purgatory, of wasted years he spent in prison for his first murder when he killed his teenage girlfriend who taunted him about the lack of his sexual skills.

During those days his life inside was ruled by the grinding routine of meals, work, recreation and sleep until he became a numbed and institutionalised member of a society that would ultimately transform his life, overseen by others, in an environment which controlled everything he did.

His initial opportunity to leave prison came after he had served only eight years of his life sentence. But for reasons he never explained, he refused to admit the fact that he had killed and so regular chances for him to accept his culpability and go into the outside world came and went. But he continually did not want to accept what he had done. But, as time moved slowly and he began to grow old, many more years passed before the Parole Board decided it was safe, after nearly three decades, to move him back into community and civilisation and a society with which he had little in common and even less of the skills and ability to cope.

At the normal release time of early in the morning he left the prison and at last stood outside the high walls that had imprisoned him and provided a safe, quiet home for almost thirty years with the smells of cooking, polish and disinfectant as his daily companions.

He was un-nerved and frightened by a massive increase in the number of cars on the roads which moved past him at speed and numbers he had never seen. Mobile phones were unheard of when he last had his freedom. Computers, super-sized supermarkets, many more houses and the disappearance of friendly, familiar landmarks imprinted themselves on his mind. There was no one to meet him. Those he knew before he went into prison had either died or had abandoned him to his fate, not wishing to know or be associated with someone who had killed.

But above all there were more people who hurried past, taking little if any notice of him, as he stood outside the massive double wooden gates of the prison which had slowly closed behind and shut out life as he knew it. Their presence scared him because in his enclosed society he mingled only with other murderers, rapists, robbers and those who shared with him the same lifestyle of a self-imposed existence of despair, desolation and wretchedness.

In the new world outside, the confines and protection of his prison cell and the high walls that would let him see only the sky, he would become a stranger and something like a child – having to learn all over again in his bid to cope. He was fifty-four years old and had spent the major part of his adult life behind bars unaware how dramatically society had changed. He now had the freedom to move among strangers and those he did not know. The world had become different and a more frighteningly violent place – a place in which he would inevitably become part of.

To eventually be free and hopefully cope as a stranger in a virtually alien environment cast a dark, deep shadow over John as the day of his ultimate release drew ever closer and the prospect of meeting the unknown became a frightening reality. His time came and John left the prison, but not before probation officers and social workers had put together a plan they hoped would carefully and gradually introduce him to that strange, new world and its many and vast changes. A place so different from the day he left it thirty years earlier.

But John had become institutionalised; someone who had become used to the organised stability of his carefree world and ultimately unable to properly fend for himself and unable to tune into a modern-day life without friends and relatives he had not seen for years. He had lived in a place designed not to just punish him but also to rehabilitate him. All he had were his overworked probation officer and social worker assigned to his case, in the hope they might be able to help him find

a job and a place in which he could live, along with the hope and encouragement to fit into a society so dramatically changed.

This new, frightening world had temptations – drink by the gallon and drugs if you knew where to find them and his newly found freedom with which he was finding it increasingly and worryingly difficult to survive. The wrong people entered his life and without the knowledge and social skills he needed to exist in a day-to-day living, John began to become a victim and began to slide down a slippery slope of his own making and a destiny predetermined by fate. He was moving rapidly on a collision course of events that would end in the inevitable tragedy and deprive him of his freedom for ever.

One person he befriended in a relationship fuelled by drink and drugs became his second victim almost a year to the day of his release from a sentence that had taken twenty-nine years of his life. John killed as he desperately searched for money hidden in his friend's bedroom. As his victim woke to find a man he thought of as his friend looking for money, he protested and challenged him. But John turned on him in a wave of uncontrollable rage and violence and battered him to death with a champagne bottle. As the lifeless, blood drenched body of his friend lay on his bed, John continued to search for the money and found, hidden in a bag, £8,000 his victim was looking after for a friend who had gone on holiday.

Some people put forward that life was unfair to them from the day they were born. They argued that Fate had dealt them a hand which would never have given them a chance. They felt that life, over its now accepted 80 or more years, was predetermined and nothing that they or anyone else did could change anything that had been decided. That no power here on earth or elsewhere would change the journey of lifelong turmoil that would follow the life mapped out for them.

People like John treated their life as though it was nothing more than a cheap commodity. Something that should have been precious they had no idea how to use; to create for themselves a space in society where they might have been welcomed by others. But to them it was nothing more than a convenience in a troubled state of existence between the day they were born and until the day they died.

They did what they wanted and to hell with the consequences. To them, life was something akin to a knockabout dodgem car ride with the minimum amount of control and someone else to blame if something went wrong. Something that could be cast aside with little, if any, thought of the consequences because their argument was they were part of a lottery, so why bother.

It did not take the police long to catch John. Experience of criminals, where they are likely to be found or who knows where they may be is part of a detective's armoury. The majority of criminals feel they can beat the system but they leave behind clues that soon have detectives on their trail and lead to their eventual arrest.

Within a short time, John was charged with murder, appeared before the local justices and committed to Stafford Crown Court for trial. It was strange to see a man, just fifty-four-years-old, in court for his second killing knowing that the only future for him was to be incarcerated for the rest of his life and being moved from prison to prison all over the country at a moment's notice.

He was called into the dock and when arraigned by the clerk of the court, pleaded guilty to the murder of a thirty-five-year-old man in the Stoke area virtually a year after he was released from his long prison sentence.

Mr Nigel Baker QC, prosecuting, presented the case concisely to Mr Justice Nelson and said: 'The victim was an easy target for someone who wanted to steal and commit violence. The partly decomposed body of the dead man was found in his flat in August 2006. He had depressed fractures to his skull and bleeding on the brain. There were no signs of defensive injuries.'

The man who died was asleep in bed but was disturbed by John who was rifling through his property looking for something to steal. Not fully awake, he challenged John who turned on him and repeatedly beat him on the head. 'He survived for at least twenty-four hours and could have survived up to at least four days before finally dying,' said Mr Baker.

Mr Baker said the dead man's partner had gone on holiday with her son and left £8,000 with him to look after. The two men befriended each other and John stayed at the man's home. John knew about the money and decided to search for it. His friend was asleep in bed when John came in. He woke and John grabbed a champagne bottle and hit him on the side of the head.'

Mr Justice Nelson told John as he sentenced him: 'You will spend the rest of your days in prison. This was a brutal assault on a man for the purposes of theft and he was left to die. You stole money which was spent by you on a shopping spree. This was a dreadful offence. It was a brutal killing of a former friend. You struck him over the head to steal a substantial amount of money.

'You left him until he succumbed to death. Murder is a dreadful crime and what is truly shocking in your case is that this is the second time you have committed it.'

Mr Anthony Barker QC, who defended John, told the judge: 'He is resigned to the fact that he will spend the rest of his life in prison. This is a picture of a man who has effectively thrown his life away. He had a terrible childhood and was sexually, physically and emotionally abused. He is unable to control his impulses. He takes full responsibility for his actions. He is deeply ashamed of what he has done and feels deep remorse for the suffering of the deceased's family.'

John listened to the judge. He knew what was to come and accepted his sentence without any sign of outward emotion or distress. When the judge completed his remarks John turned to his right in the dock to make his way down to the cells and was later taken to Birmingham's Winson Green Prison – the first jail of many to become his home until the day he dies.

From then on I spent many hours thinking about John – the man who wasted his life, and so I decided to contact him and was told by many people not to waste my time on someone involved in the extreme of violence. I would be better, they insisted, worrying about people who needed help. It defied comprehension and understanding why a man would to choose to lead a life which ended up with his permanent incarceration. I wanted to find out why John had become the person he had. When John was first jailed for life in the early 1970s he could have left prison after six years and be placed on life licence which meant he would risk being recalled to prison for the slightest misdemeanour.

But he turned down the chance to become a free man and start a new life and

instead began a bizarre pattern of behaviour, which led to him escaping from prison three times; twice from open jails, once where he had been transferred on trust and once from a closed establishment.

I have seen many killers – some of them guilty of the most extreme forms of violence and others who derived pleasure just for the sake of killing. It was something I had seen often but ignored it because it was part of my job as a journalist working at the Old Bailey and other courts. But as far John was concerned – having reported on both cases when he was jailed for life – I spent a lot of time thinking about someone who had killed twice and without thinking about it was prepared to spend the rest of his life behind bars. Not only had he taken away the lives of two people he knew but the thought of losing his freedom until the day he died did not seem to bother him.

I decided to write to him at his prison in Birmingham to find out why he had wasted his life. I told him it was the most difficult letter I had ever written. I knew what I wanted to say, but how do you ask a double killer what it feels like to know what he had done and that he would never again live in the outside world among other free people?

A reply to my letter came in October 2007 about five months after he started his full life sentence and covered three sides of prison issued lined notepaper. This is what he said:

'Dear Michael, thanks very much for your letter. To say that it came as a surprise and what you asked of me would be an understatement.

'This is the first time anyone has asked something like this of me. To be honest, Michael, I am still not sure what to make of your offer. I am willing to meet you, though, and listen to what you have to say. To meet you may be a good thing for me as I now have no other contact with anyone in the outside world.

'In the past and even more recently people like my probation officers have said why don't I put down my experiences of prison and my life down on paper. But I have always thought I am not a Kray or anyone else notorious, so why should people be interested in what I had to say. I have never looked for any kind of publicity before.

'Even if I did want any of this I would never know how to start and to me I have led a boring life. Well to me I have. I couldn't even tell you yet how I feel about never being released from prison. I will tell you one thing, Michael, I am ashamed of my life and the things that I have done.

'Yes, Michael I will meet you and listen to what you have to say before I make any decisions. I will have to get you on my visits list. I don't know how long I shall be here now as I have been told I am going to Long Lartin jail (a top security prison in Worcestershire). But if I do move then I will let you know. They don't tell us when we are being moved. They just come in one morning and say pack your kit. I look forward to meeting you whenever that will be.'

It was soon after this that trouble started and I began to find out how scared and paranoid the prison service was about journalists. I e-mailed the Ministry of Justice press office prisons department and, without holding anything back, told them who I was and what I wanted to do. I explained carefully that I wanted to interview John with the possibility of writing a book about a man who had served one life sentence for murder and was now facing the rest of his life in jail for a second killing. I made

sure I was honest and above board and that I had nothing to hide. I asked if I would be allowed to use a tape recorder and had no objection to a prison officer being present during the interview to make sure nothing untoward might occur.

The press office reply was almost immediate and it was made abundantly clear that a visit by a journalist to a prisoner would not be countenanced. There was absolutely no way that I would be allowed into a prison. It made no matter how I pleaded. Forget it. Don't ask again. You are a journalist. Journalists, prisons and prisoner do not mix.

Then I received my second letter from John this time from Long Lartin in October 2008. 'Dear Michael. I received your letter today. It was sent on to me from Birmingham. I was surprised to hear from you again as I thought you had gone off the idea of being in contact with me.

'After reading your letter I came to realise the bollocks you had with Birmingham. But when I think about it shouldn't really surprise me what they would get up to at that jail. They certainly went about things there in a childish way it seems though nothing that goes on with the prison service really surprises me. (I received a mysterious call one evening at home from a young woman which I traced to Birmingham prison. She made some comment about me writing to John, laughed and hung up. It turned out she was a prison officer).

'I had special delivery of your letter from a senior officer here. Obviously the censors had picked up on the contents of it. I have been told that you can come to visit me as a friend and that I have to put a governor's application in about you visiting. She also said that you would have to sign some kind of confidential agreement regarding the visits – the prison service being paranoid about prisoner's involvement with the media. But this is the first time I have experience of it. Yes, Michael, I will put an application in about you visiting. I don't mind that at all. But I will still reserve judgment about what you really want from me. I will meet you whenever that happens and listen to what you have to say.

'I can't phone you at the moment because I have been here 10 weeks and have only just got a job. I don't have people outside to send me money in anymore. I am not looking for sympathy here, just stating a fact. This jail is much different than the Green (Winson Green Prison, Birmingham). Everyone is doing a long time in here and as you probably know it's all about security and these type of facts.

'Well, Michael, I will close now. I think you have to book visits by phone. As I said I will put a governor's application in about the visit though why I have to do this is beyond me because I know I can have anyone I like to visit me but I will do it their way.'

The visiting order, as promised, eventually turned up and in accordance with prison regulations I phoned the prison three days in advance of my visit and was booked in for Sunday, 4 May, 2008. There was an accompanying letter from John and he said: 'Sorry that it took me so long to get back to you but I've been waiting to hear about the application but I've not heard nothing so I'm sending you a visiting order and see what happens.

'After all you can visit me as a friend. I tried to phone you tonight but it seems that your number is no longer on my list of people to phone. What is strange is the numbers I had from Winson Green are still on my list. I never thought it would be

this hard to be in contact with you but I live and learn from prison practices. I do hope you will be able to come.

'I would really like to see you as I have a lot to get off my chest. We will see what happens. As I said I am sending you a VO with this letter so we will see what happens. All you have to do when you get the VO is to ring up to book a visit.

'I have settled in here now. It is not a real good jail, but I have no choice about it. I have just got on with it – it's all I can do.'

With the visit booked all I had to do was set off from my home to Long Lartin to meet the man who had killed twice and would never come out of prison until he died. If he lived to his middle eighties in an environment where there was no pressure and with access to top class medical facilities if ever he was ill, then he was likely to serve at least sixty years of his life behind bars. A tragic waste of life, no doubt, and observers will say he brought it on himself. There is no argument about that. John killed in his early twenties and had three decades in prison to think about what he had done. But the seed which urged him to kill lay dormant and was waiting to manifest itself into a savage outburst of violence which took the life of another human being in just seconds.

People often asked me what a murderer looked like and I always replied by saying look around – he or she could appear to be anyone in a crowd. I had seen John so I knew what he looked liked but there was still a feeling of trepidation, the butterflies and a slight uneasiness. But it was still a visit I was keen to make.

The day before the visit I had gone shopping and when I returned home there was a message from John on my telephone answering machine. He told me the governor had ordered him to contact me to say the visit was off. The governor must not only have enjoyed banning the visit but then the added pleasure of telling John to make the call to let me know. In any prison there is the obvious level of power but then there is also the added satisfaction and gratification of making someone do something.

On the Monday following the cancellation of the visit I phoned Long Lartin Prison and asked to speak to the governor. The telephone operator asked who I was. I gave my name and the operator said the governor did not want to speak to me and disconnected the call.

Three days later I received another letter from John. He said: 'Sorry that the visit never happened. All I know is that on Saturday morning I was called to the office and told that the governor had changed his mind about the visit. There was no explanation or anything. They let me have a phone call to you to let you know but you weren't in so I left a message.

'It seems that the powers that be don't want us to meet up for whatever reason. By the time you get this I might be in Whitemore Jail (Cambridgeshire). They are shutting a wing down here and want volunteers to go there so I put my name down for it as I've not settled here. If I do move I will write to you from there as soon as possible.

'I will also ask about a visit from you once there. I can't see the problem if you are visiting me as a friend.'

Prisoners have rights. Many people will argue that once inside the four walls of a jail prisoners lose whatever rights they may have had on the outside. But they have

certain freedoms made clear by the European Court of Human Rights. One of those rights is to be allowed to have some contact with the outside world – which means visits. Prison regulations also make it clear that an inmate must be allowed visits to maintain some connection with those on the outside.

I was retired by the time I again approached the Ministry of Justice press office to say I wanted to visit as a friend but was told that because I had made my first application as a journalist they felt they could not trust me and would not allow me to see John inside Long Lartin as a friend. By now not only was John banned from phoning me at home – I had received two calls – but following contact between governor grades at Birmingham's Winson Green and Long Lartin I was banned from visiting him; so much for rights.

Towards the end of May 2008 I received another letter from John, this time from Whitemoor Prison where he had been for two weeks after his transfer from Long Lartin. He said: 'I received your letter which was sent on to me from Lartin. The day before I was actually given your letter I was pulled to see one of the governors here. The first words he said to me were what do you think about your visiting me. Obviously they knew you were a journalist.

'I explained how I came to know you and all that. At the end I asked if I was going to be allowed to see you but all he said was we will see. But like you said before, Michael, they can't stop you visiting me as a friend and if they try to I will have to seek legal advice. If it comes to this do you know of a good solicitor?

I can't believe all of this palaver over a visit from you. Just shows you how paranoid prisons are about the press.'

The next letter from John came a couple of days later and it was the first time that he began to open up and disclose some of his feelings. He said: 'I thought I would let you know that you are banned visitor for me. How I found this out here is that I put an application in to have your phone put on my PIN then I got a paper back saying I can't have your number as you are banned.

'From what I gather this came from Long Lartin. So I can't even phone you now. When I next go to the library I will be looking up the Prison Service orders book about correspondence with journalists and see what the rules say on it.

'I never thought there would be all this crap about it. But I am never really surprised about what the Prison Service does as I have had plenty of experience with it. So it looks like that for the moment. It will just have to be written correspondence.

'I know that in the few letters that I sent you that I've not really said too much but that's what I'm like until I get to know somebody. You probably want to know how I feel about what has happened to me after already serving near enough thirty years of one life sentence then getting another life with no chance of parole.

'All I want to say about that at the moment is that I got what I deserved. I don't really know how I feel at the moment as I just seemed to have blocked it all out. I had a year out before I came back but it doesn't feel like I have ever been out there. That year is like a blur now.

'I had a lot of hopes for when I got out but I blew it all away. I think the reality of being out never reached my expectations. I have a lot of regrets, Michael, the main one is that I've just wasted my life on nothing. I don't think I've ever found out who I really am.

'In here I just exist but I would still like to have a purpose in my life. Perhaps one day I will put pen to paper and write me own story if nothing more than to show young people who go wrong in their lives not to do it; to show them what a fruitless life I have led.

'You said in your first letter how maybe you could compare my situation with someone in a hospice but at least those people have probably led a decent life where I have not. I have always made the wrong decisions. We all have decisions to make and I always go the wrong way. Anyway, Michael, enough chat for one day. Hope to hear from you soon.'

I wrote several times to John but that letter on 29 May was the last time I heard from him. Whether he was banned from writing begs the question. He was told he could not phone or receive me as a visitor, so what else was left to the prison governor but to ban him from writing? So, the governors from three prisons decided to keep each other informed of whenever I contacted John. It shows how fearful the Prison Service is of journalists. It creates an increasing number of problems for itself and makes the press only more determined to try to break down the bureaucratic wall that is automatically built.

James Shanley, the governor of Winson Green – John's first prison – at least had the courtesy to write to me instead of passing the parcel to the Ministry of Justice Press Office. He talked about my desire to write a book of general interest on John but because there was 'no miscarriage of justice (following full exhaustion of the normal appeals procedure) then we are not able to facilitate your request to hold interviews or have telephone calls with him.'

He said I could write to John but I needed to be aware that there were 'strict rules' about the content of what John would be allowed to write back. Mr Shanley said John's letters must not contain information about his crime or past offences or those of others.

(John is a real person but I have changed his name to protect his identity and to stop the Prison Service from imposing further sanctions upon him.)

VENGEANCE OF THE LAW

The criminal justice system in the United Kingdom during the 1700s and 1800s was cruel, harsh and on many occasions inhumane. There was no hope for the condemned. It was to punish the wrongdoer with a malevolent vengeance. There was no such thing as pity or compassion and the sinner was punished with the full power of the law.

Justice in those days was swift and so rapidly carried out that prisoners had little or NO chance to comprehend or come to terms with sentences that were passed. Prison with hard labour took control of the lives of people if they were convicted of or admitted horse, sheep and cattle stealing, counterfeiting and even housebreaking. The punishment never did fit the crime but people suffering hard lives with little money still carried on breaking the law hoping they could beat the system.

But the system always won. Others were transported to Australia for fixed periods of anything from seven years to life, to be kept virtual prisoners in the bowels of small ships that plied their trade in human lives from one part of the world another, parted from their families for ever.

Conditions for these people packed in the holds of small ships were unimaginable. They were chained together in stinking conditions and made to cope as best as they could in storms when the little vessels were thrown about like matchboxes. But once they had completed their forced period of exile they could never return. Not because they were unable to cope with the long voyage, but because they were never able to save the money they needed to pay for their passage back to Britain.

Those probably better off were the unfortunate souls sentenced to death by hanging. Retribution was swift and within days they were being convicted. By the time they realised what was happening it was too late. They had little time to think what would be in the hereafter, as the judicial appointment drew close for them to satisfy all the legal requirements as they prepared meet their Maker.

The hangings were barbaric and carried out in front of thousands of thrill seekers who regularly made for the same spot in the fields in front of the prison walls to watch some poor soul drop through a trapdoor. If the hanged man did not die quickly because he had not fallen far enough, there were always those in the background

willing to run forward to grab his legs and pull him down to make sure his neck cracked and snapped and death was not delayed for longer than necessary.

People came from far and wide for a day out. They walked or came by cart. To see someone as the victim of an American-style 'necktie party' was a date on the calendar they would not miss. It was a big social event and gave friends chance to meet up for the day and catch up with the news.

The first public hanging outside Stafford Prison was on 17 August, 1793, when a twenty-one-year-old soldier named Ebenezer Colston was executed for murder. On 22 August, 1795, Joe Lunn was sentenced to death for housebreaking. If that was not bad enough his young wife was transported to Australia – not that it made much difference to her husband – and she became another person forced to travel to the other side of the world to begin to help populate an emerging Antipodean nation. The last public hanging was in 1914, of fifty-eight-year-old Josiah Davies for the murder of Martha Hodgkin of Wolverhampton.

The death penalty was abolished in 1966.

Nowadays things are a lot different. Take the present court system as an example. New buildings are created by people who do not have much idea of what goes on behind those four walls. Buildings are so clinically designed that villains who turn up for a taste of justice cannot believe how everything is created for their benefit.

High-ceilinged rooms with up-to-date modern furniture and comfortable seats in the dock. If they are in their very early teenage years they are made to feel at home; wrapped in cotton wool by the system which decided they should sit in the well of the court with their parents beside them so they would feel safe and not overwhelmed by an alien situation.

They came to court to be punished or at least steered back onto the right side of the road. But there was more to come. Barristers and judges would remove their wigs so that teenage thugs – and there are some young ones – would feel at ease and not be pressured by a system that was designed to punish them.

Courts should be places which put fear into the hearts of the wrongdoer, not places where they are mollycoddled. A lot of people who see and hear how young people are treated in court call for the stocks to be brought back into fashion so that villains who terrorise victims could suffer at the hands of decent members of the public in the local market square at a weekend.

The birch was outlawed many years ago because it was argued that those who felt its sting would be humiliated, humbled and shamed. And that it was just not the right thing to do. Policemen used to be able to give someone a flick with a rain cape or a clip around the ear. But the powers that be assured everyone it was not fair because it breached their human rights.

At Lancaster Crown Court, inside the local castle on a wall going downstairs to the cells is a branding iron with the letter 'M'. It stands for malefactor and was heated and applied to the hand of someone who broke the law. It was a short, sharp, stinging pain but it left its mark for ever. How novel would that be in the twenty-first century?

Judges at all levels, from the High Court to circuit members of the judiciary, want to pass tougher sentences but because of strictures imposed by Parliament they rightly complain that their hands are tied and they must stay within recommended

sanctions. This is a pity because our lawmakers do not realise that they have created legislation and punishments which do not always fit the crime. Take knife crime as an example. Judges were told they had to send criminals away for five years but very few impose that sentence and go for the softer option of two or three years

Judges involved in the cases in this book did not hesitate to use the full power of the law and urged defendants to make their peace with God if they had any problems. All the murder stories here have one thing in common – a suspect appeared in the frame within twelve to twenty-four hours. Investigation was limited and a few days later a case was made, usually by a coroner's jury who found a man or woman guilty of 'wilful murder' and committed them for trial.

My research revealed a fascinating insight and understanding of the way the lower classes of criminal were dealt with. They were overwhelmed with the full force of the law and suffered harsh, Draconian punishments that far exceeded the seriousness of the offences they committed. However, that did not apply to murder because there was only sentence.

Imagine being sentenced to death for burglary, stealing horses, cattle or sheep. The extreme force of the legal system gave these people no chance, at a time when it was hard enough to eke out a living in poor conditions. Then the 'disgusting vice' of bestiality also attracted the death sentence. It begs the question as to why burglary and rustling should attract such a dire and drastic way to solve a problem.

In today's courts, the majority of people who appear only make one visit and then for the rest of their lives behave themselves. Sadly, it is only a handful of persistent, recidivist offenders who continually cause trouble. Put them in prison with hard labour and anything tough that will make their stay in jail a memorable experience; a haunting, timeless encounter that will leave an indelible mark on their soul and spirit.

The legal system and the sentencing policies seem to create more problems. Send persistent offenders away for a long time because sparing the rod spoils the child. Let them atone for what they have done and let the environment in which they serve their time behind bars be as tough and rigid as possible so it stays in their minds from the day they complete their sentence free to take their place in again in the outside world.